A
Journey
of the
Imagination

The Art of James Christensen: A Journey of the Imagination

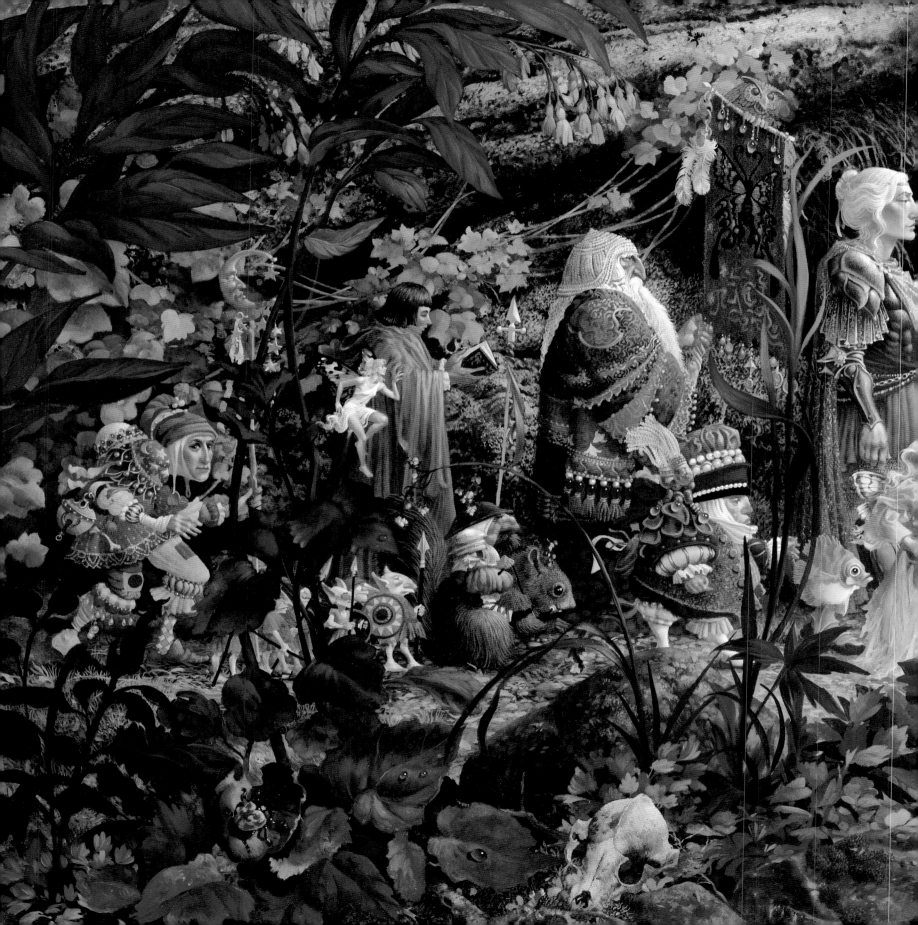

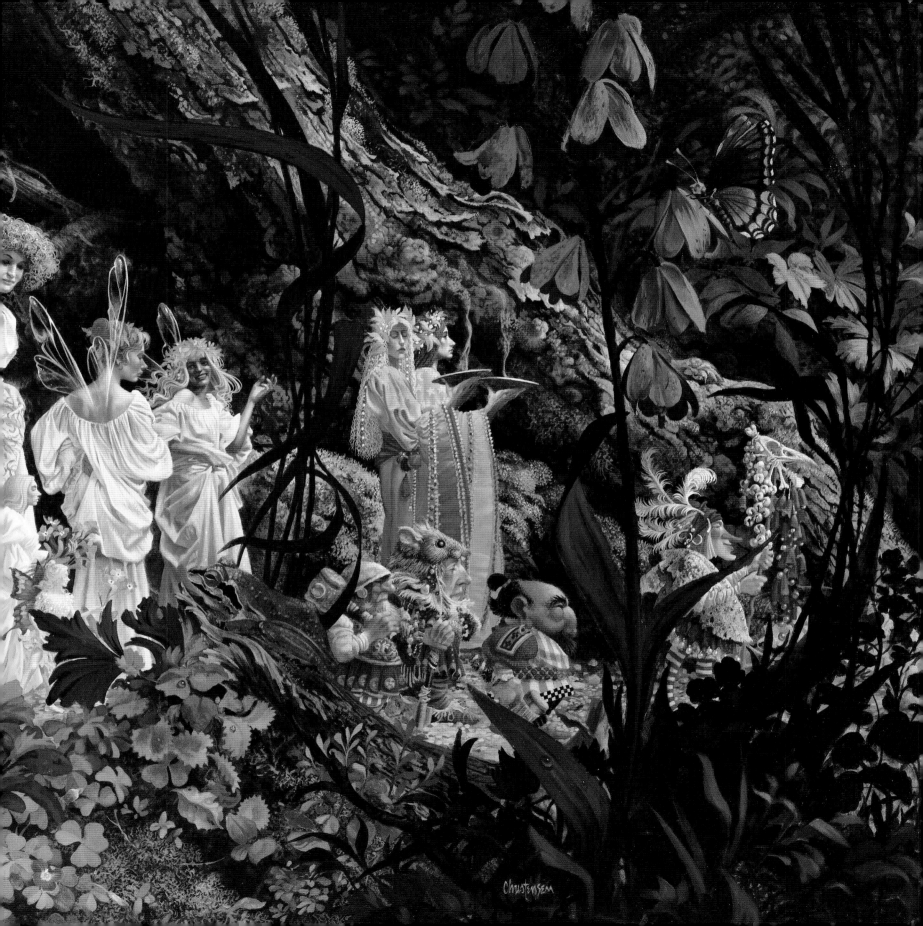

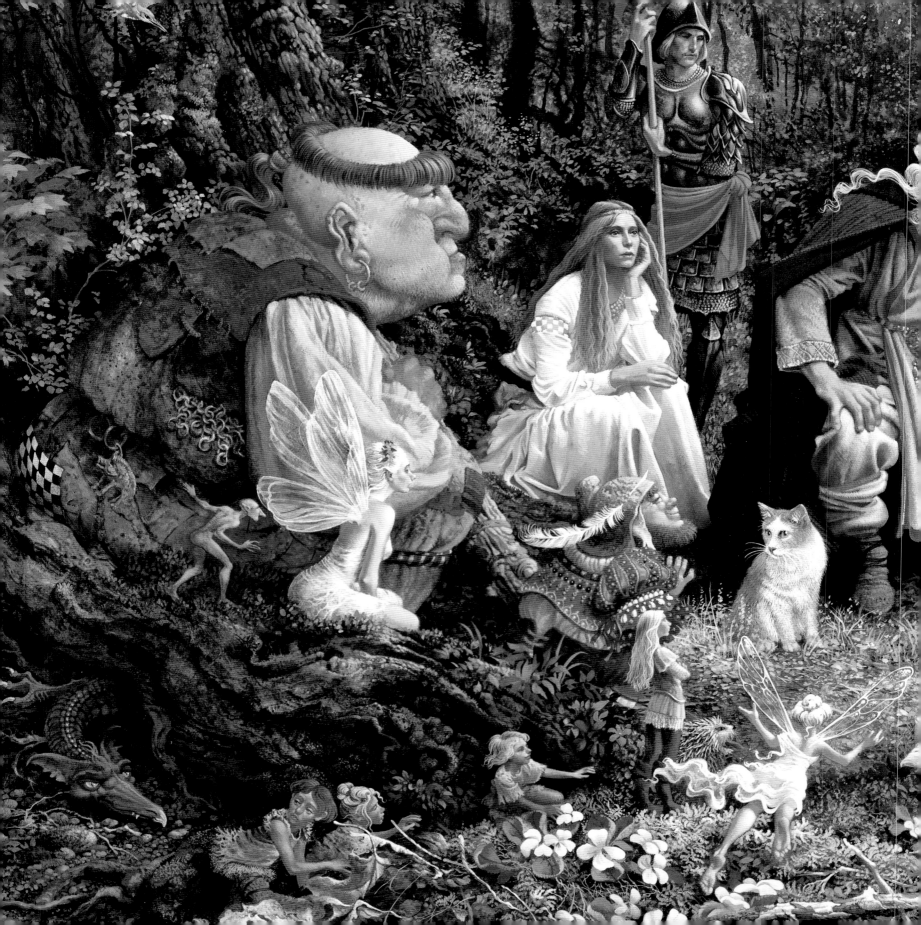

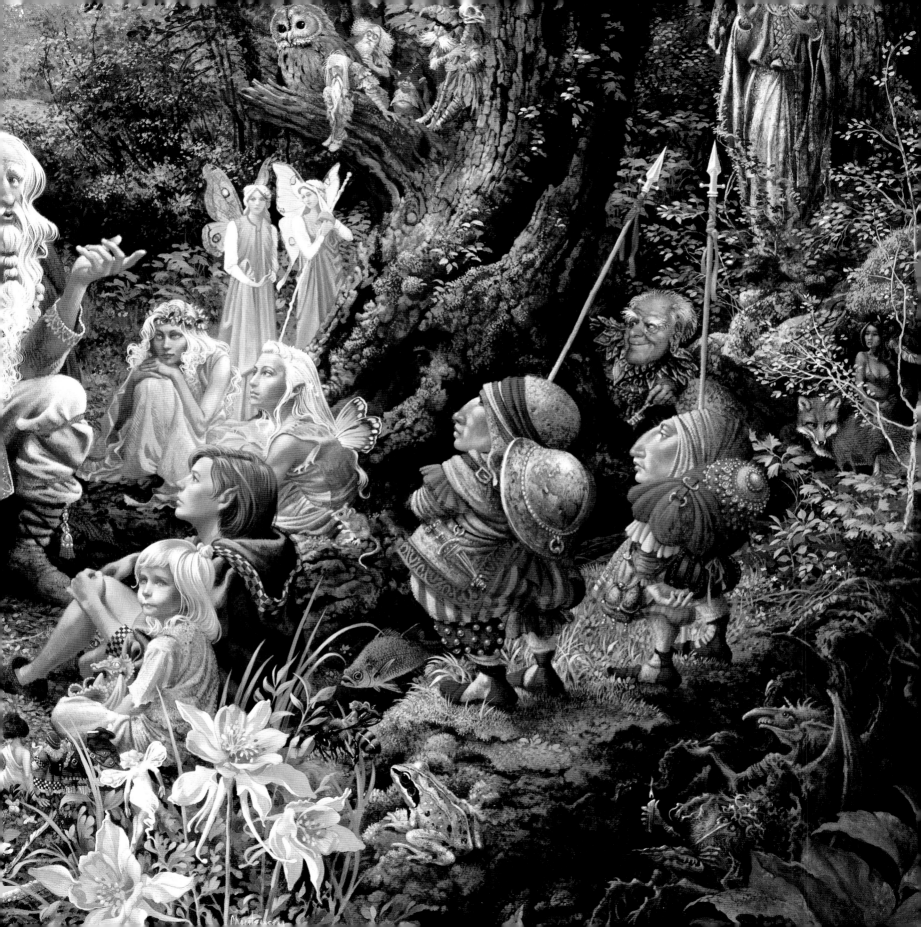

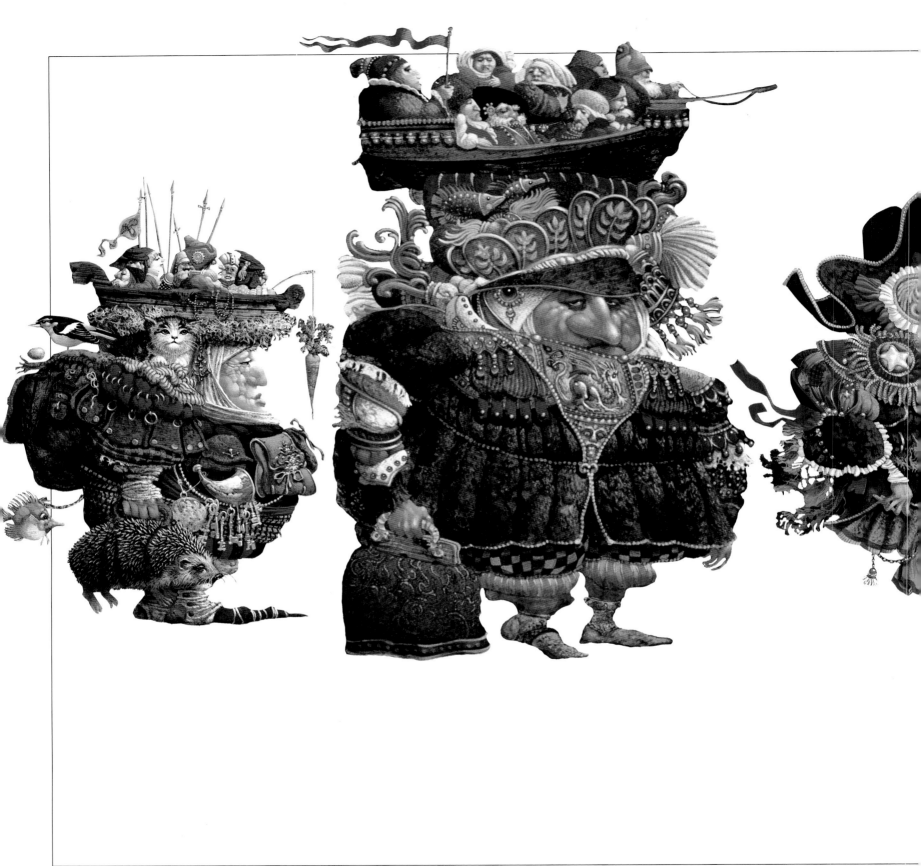

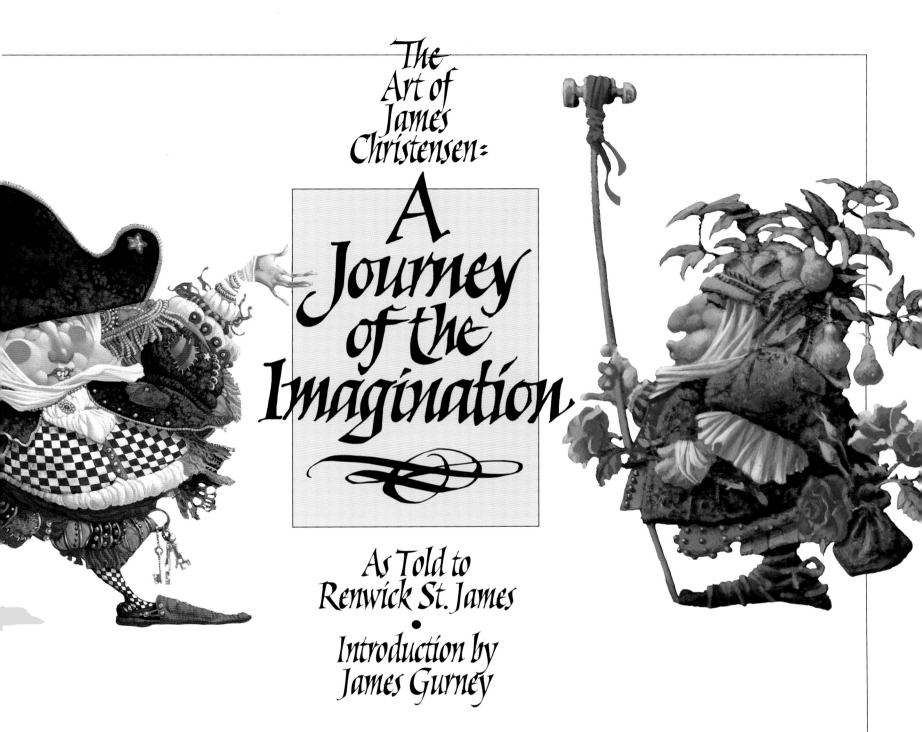

The
Art of
James
Christensen:

A Journey of the Imagination

As Told to
Renwick St. James

·

Introduction by
James Gurney

The
Greenwich
Workshop

This book is dedicated to my wife and children,
for sharing the odyssey

ACKNOWLEDGEMENTS
The artist offers special thanks to Brigham Young University's
Martha Peacock for answering a lot of art history questions, and to the many
people at The Greenwich Workshop—especially Scott Usher, Peter Landa,
Wendy Wentworth, Kate Liba, Karen Cipressi and Judy Turziano—who
cared about and assisted with this book each step of the way.

The sketches throughout this book were selected from
the artist's journals, which span twenty years.

A GREENWICH WORKSHOP BOOK

Library of Congress Cataloging-in-Publication Data:
Christensen, James. A journey of the imagination: the art of James Christensen / with Renwick St. James; introduction by James Gurney ISBN 0-86713-021-0
1. Christensen, James, 1942- --Themes, motives. 2. Fantasy in art. 3. Science fiction--Illustrations. I. St. James, Renwick, 1954- II. Title.
ND237.C4943A4 1994 759.13--dc20 94-14086

The author and publisher have made every effort to secure proper copyright information for works cited in this book. In the event of inadvertent error, the publisher will be happy to correct it in subsequent printings.

The Greenwich Workshop is grateful to the following for permission to reprint quoted matter: p. 41 Loreena McKennitt, for the quote by Ms. McKennitt which appeared on the cover of the CD *The Visit,* produced by Loreena McKennitt and Brian Hughes, copyright © 1992; p. 103 excerpted with permission of Macmillan Publishing Company from Robert Frost's introduction to *King Jasper* by Edwin Arlington Robinson. Introduction copyright 1935, and renewed 1963, by Macmillan Publishing Company; p. 127 Alfred A. Knopf, Inc., for the quote by Thomas Mann from *The Magic Mountain,* copyright © 1927, 1952; p. 149 Lloyd Alexander, for reference to his article "Wishful Thinking—Or Hopeful Dreaming," published in *Horn Book Magazine,* August 1968; p. 157 for the quote reprinted from *Walking on Water: Reflections on Faith and Art* by Madeleine L'Engle, © Crosswicks, 1980. Used by permission of Harold Shaw Publishers, Wheaton, IL; p. 170 from "Escaping Into Ourselves" in *Celebrating Children's Books,* edited by Betsy Hearn and Marilyn Kay. Copyright 1981 by the Zenna Sutherland Lectureship Fund. By permission of Lothrop, Lee & Shepard, a Division of William Morrow & Company, Inc.

FRONTIS ART
2-3 Detail from *The Royal Processional*
4-5 Detail from *Conversation Around Fish*
6-7 Detail from *Once Upon a Time*
•

Book design by Peter Landa
Calligraphy by Philip Bouwsma
Manufactured in Japan by Toppan Printing Co., Ltd.
Published simultaneously in the United States and Canada
First Edition
94 95 96 0 9 8 7 6 5 4 3 2 1

· Contents ·

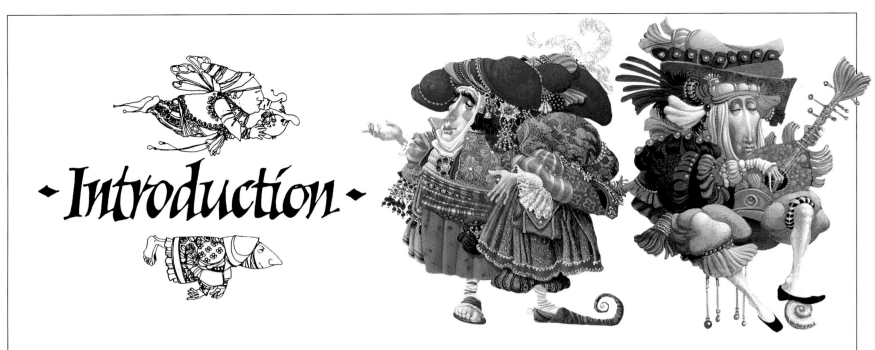

-Introduction-

Your train arrives at the station. You step onto the platform, carrying a briefcase and a duffel bag. The train swims into motion again, transforming into a school of salmon. Something lurches in your hands. The briefcase has grown turtle legs, and the duffel bag has become a badger. Two short men with boat-shaped hats argue in Latin, their bobbing heads tossing the boats as if in a storm. A woman glides toward you on gossamer wings. She curtsies, raises her wand in a fine flourish, and touches you with a whiff of stardust.

The sign on the building says "Imagination Station." That dapper fellow with the impish grin is your tour guide. "My name is James Christensen," he says. "Welcome to a place just a little left of reality."

Is this his dream world or yours? You may never know for certain, because Mr. Christensen has a remarkable gift for provoking each of us to daydream. Looking at his pictures invites us to board the train, yet each of us disembarks at our own hometown. He leads us into the enchanted corridors of our collective unconscious. The symbols and images reside deep in all of us, familiar but forgotten, like the faces of the king, queen, and jack on an old deck of cards.

I first became acquainted with James Christensen and his work at the 1983 World Science-Fiction Convention in Baltimore. Inside the grey exhibition hall, hanging from industrial pegboards, little paintings of elves and dwarves and faeries were attracting a crowd of enthusiastic fans, me among them. Somehow the artwork seemed to dispel the drabness of the convention hall and fill the air with the aroma of clover, pine, and moss.

In 1985, Christensen's work began to appear as limited edition fine art prints. The community of fantasy artists celebrated the fact that one from our midst was establishing a new trail into the world of galleries and fine art. In the decade since then, his fans have grown to include a wide-ranging and

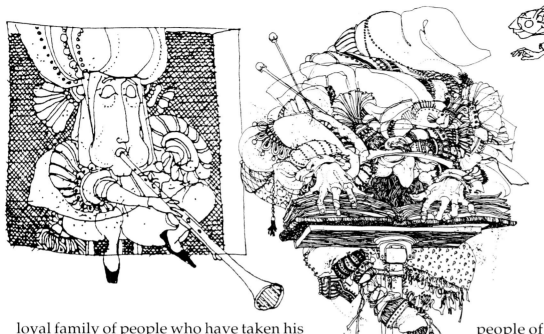

"The margins are populated by a host of "doodlefolk," little people of pen and ink, half-formed but brimming with life."
—James Gurney

loyal family of people who have taken his tour into the wonderland of myth and magic.

As an artist, he gives us pleasure on many levels: fine shapes that often juxtapose compact forms against delicate elements; an organic logic to texture and pattern; rich allusions to the heritage of art history; a sense of whimsy and irony in the arrangement of parts; and most of all, a compassion for the foibles and follies of human life that lies at the heart of all his work. His art serves not only the eye, but also the mind and the spirit.

This book is a long-awaited gift —not only to seasoned travelers of the Christensen train, but also to those who haven't yet stepped aboard. The pictures are accompanied by his own witty descriptions of the meanings behind meanings. The margins are populated by a host of "doodlefolk," little

people of pen and ink, half-formed but brimming with life. Taken directly from Christensen's personal notebooks, these carefree sketches pull you into the creative vortex, close to the dark, mysterious center from which ideas charge forth. You cannot help but follow his advice to listen for the impulse and feel the stirrings of the dream world inside yourself, to nourish it, water it and place it in the sunshine, where it will burst forth in flower.

Handsome as this book is, you might wish to give it a home on your coffee table. But I recommend that you place it at your bedside. With the busy chatter of the day behind you, open it at random, ride the train for a while, and get ready to jump off with briefcase and duffel when you know you've reached your own station.

James Gurney

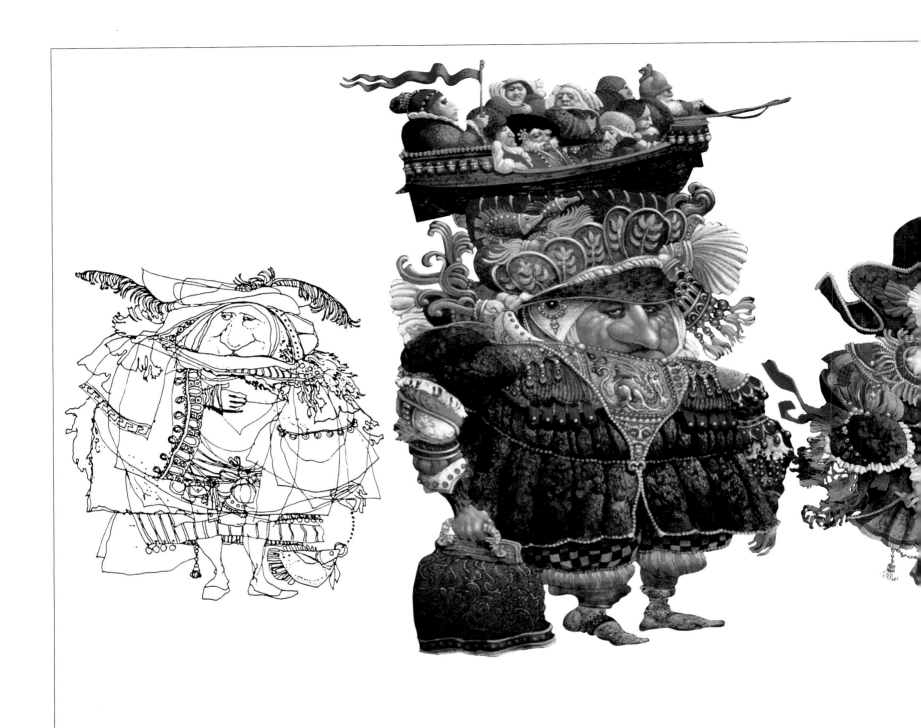

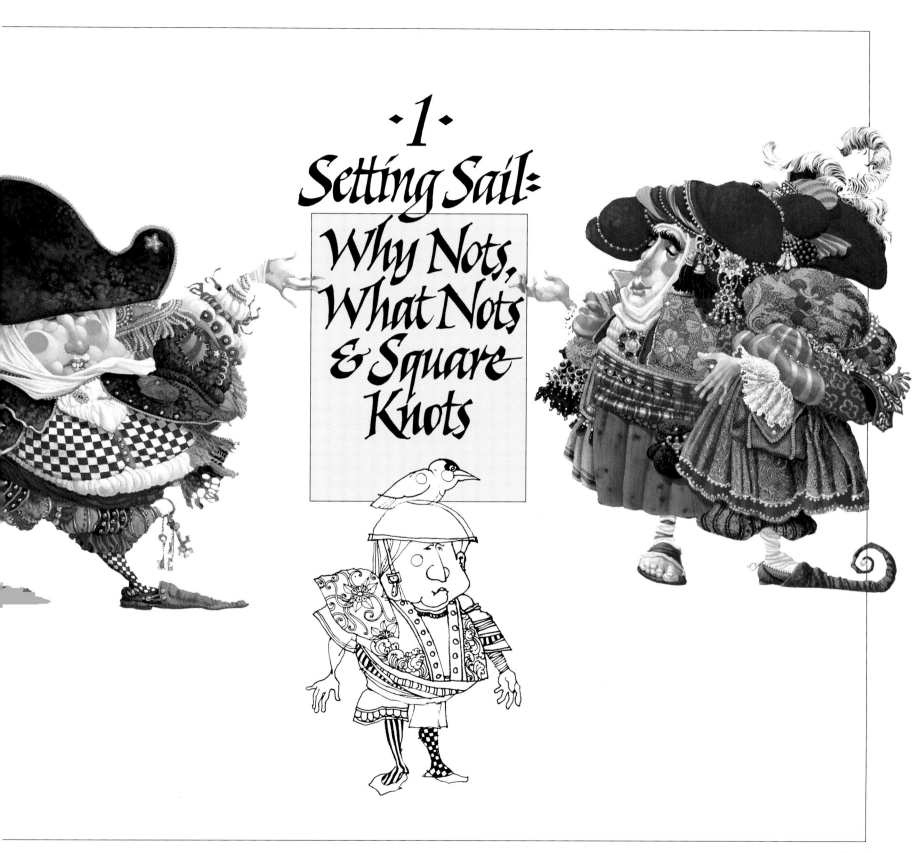

·1·
Setting Sail:
Why Nots, What Nots & Square Knots

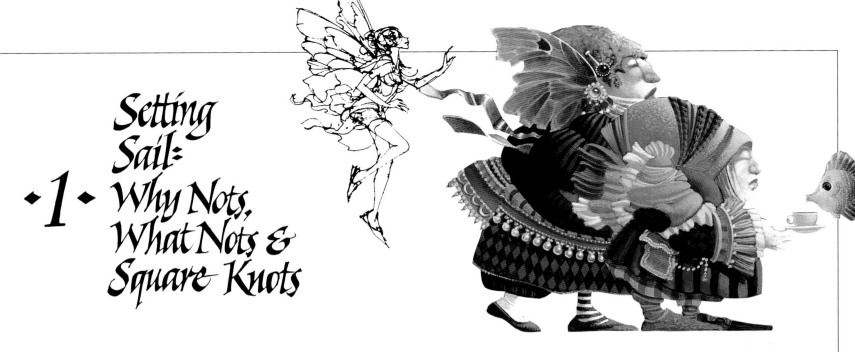

Setting Sail:
·1· Why Nots, What Nots & Square Knots

About twenty years ago, my good friend Ralph Reynolds mentioned to me that he never took his thirty-minute drive home the same way twice. I laughed, thinking about him driving by way of Australia, and asked him if it didn't take an awfully long time to travel home each night. He laughed too, and said, yes, it probably did take a little longer, but it was far more interesting, and he never knew what he was going to see.

That resonated in my own life. Like many people in this age of getting there faster, I sometimes lose sight of the journey in light of the goal. What my friend had done with a simple change in his routine was to leave space for the unexpected within the bounds of an ordinary life.

Life requires schedules and clocks, and it's easy to get caught up in the routine and to omit anything outside of the ordinary, anything that slows us down. It seems that a lot of our education and life experiences involve memorizing a known set of solutions: The fastest way to get from A-ville to B-ville is highway C, and that's the end of the story.

That's not all bad (you don't want to button your coat or tie your shoelaces a different way each time), but it can undervalue learning the flexible, open-ended art of problem solving.

My friend Ralph found a simple way to keep his evening drive from becoming routine. I like that idea, that within an ordinary life you can leave space for noticing the world around you and keeping alive the inner universe of the imagination.

I think many of us view imagining as being lost in the clouds and not in touch with reality—and if it's passive or escapist, it can be—but the positive, active side of imagination has immense energy and potential. As soon as we step out of the rutted path of known solutions and begin to exercise active imagination, we are given the reward of understanding that we have a far greater range of possibilities than we had known before.

Imagination is necessary. The brightest and best of our thinkers, creators and inventors began as dreamers and visionaries. Trying out new ideas, unexplored connections and different combinations is useful in solid, practical ways. When we allow ourselves access to the treasures and raw

"Imagination is more important than knowledge."
—Albert Einstein

materials in the imagination, we can meet *any* problem—whether it's fixing a jammed window or dealing with a bereaved parent—with new, clear-seeing eyes and a broad, fresh approach.

Using imagination is a journey that works like taking a different route home each night—only more so. In the universe of the mind lie treasures and surprises, fertile soils and elegant creations, new angels and old dragons, visions of other worlds and the quiet contemplation of death.

 There is no secret to undertaking such a journey. Anyone at all can make the voyage. No one is born without an imagination. Each of us possesses a boundless inner universe, some of it shared and some of it unique to ourselves.

How we begin depends, of course, on our favorite mode of transport. Certainly great literature and poetry take us there. Music, films, theater and even daydreams are first-class tickets. Art—whether we're looking at the cubist forms in a Picasso painting or the extraordinary sculptures of Michaelangelo—

stimulates the visual sense, reawakens old memories and gives birth to new connections.

One of my aims as an artist is to provide a point of departure for the viewer's imagination. Too few adults realize the rich potential of active imagining. Many of us never take time to participate in the wonder, contemplation or reverie that leads to new creations and inventions. I think exercising the imagination makes perfect sense in a world where there is so much to feel bad about. Even if all you do is increase your sense of pleasure in using your inner eye, it's worth it.

When I paint, I want people to participate. I want to share something of my own life and ideals, but I want people to bring to the viewing of my artwork all their varied and unique life experiences, too. For me, the art process is not complete without the viewer. I can't create paintings and just put them in the basement, because I need the reaction of the viewer to complete my artistic experience. With that aim in mind, making use of visual metaphor, symbols and allegory becomes integral to opening the doors of communication between the art, the artist and the audience.

Much of the art we see today is abstract and obscure, and requires formal education to comprehend. When art critics bandy about phrases like "self-referential abstract identity" or "ontological density," most of us cringe, or yawn, or at least get a little insecure about our opinions.

When that happens, we stop thinking and wait for the authority to tell us the meaning of a work of art, rather than exerting our own imagination and bringing to the artwork our own ideas and life experiences. This is why some artists are hesitant to talk about their art. If someone looks at an image and comes up with a fine-sounding meaning that the rest of us blindly accept, the art is limited to just that single interpretation.

The biggest problem I see with waiting for the experts is that the viewer becomes accustomed to thinking, "I can't figure this out on my own." So we wait for someone else to tell us what the metaphors and symbols mean, and never take our own fresh approach. As the art becomes more abstract, the language used to talk about it becomes more obscure. That makes the artwork less accessible and we're put off, feeling that we're outside of the group who understands art. At that point, art, which is a rich and wonderful means of communicating, takes huge strides away from the larger culture. When that happens, I think both the art and the audience lose out.

Art and its inner meaning weren't always seen this way. Five or six centuries ago, most of the people in Europe, whether rich or poor, were illiterate. The images and symbolism were ways the artist helped people to "read" a painting and receive its message. Most symbols used were commonly understood, since they were part of the culture. Certainly, there were a few symbols that were meant to conceal rather than reveal, but in the main, symbolism allowed communication to most of the people.

Today, especially in America where so many different cultures meet, these early symbols are no longer universally understood. But even with our cultural diversity, we have symbols common to all of us. For instance, the simple sign used by the

Red Cross has become known the world over as a symbol of aid to people in need. Within that symbol are a range of individual interpretations. One person, when seeing the symbol for the Red Cross, might think of the volunteers handing out blankets in a school gym during a flood; another might see ambulances on a battlefield, and someone else might merely think of giving blood. But each of them needs only to see that red cross on a white field to "read" all of those possible interpretations.

Symbols work within a given culture. That's why a group of largely illiterate people from the year 1452 could look at a painting and understand several messages that might confound us. Someone not wearing shoes may be a reference to Exodus 3:5, "...put off thy shoes from off thy feet, for the place whereon thou standest is holy ground," in which God appears to Moses in the burning bush. A candle symbolized the presence of the Holy Spirit or the light of God. A dog was a symbol of fidelity, and fruit meant fecundity.

There are a few symbols that transcend both time and culture. No matter where you travel, a skull is a symbol of death. In most cultures, a key and a lock carry a wealth of symbolic interpretation. I enjoy adding such symbols to my own work, thereby creating layers of meaning within the image. Having gained entry, there's plenty of room for you to explore the different layers of meaning over time. Or perhaps the humor or colors or intricacy will draw you in, and from there you will return again and find that the image resonates within your own life. You don't have to be an art history major to enter into the painting, although if you are, there's a level of interest for that student, too.

What is most important is to bring yourself to the art. If you appreciate the paintings just from a design sense, enjoying the color and patterns and shapes, that's great. If the humor and whimsy capture your attention, wonderful. And if you become involved in the image, returning again and again to look, to ponder, to participate, to challenge the known solutions, to make connections, and to recharge your own creativity, that's really what a journey of the imagination is all about.

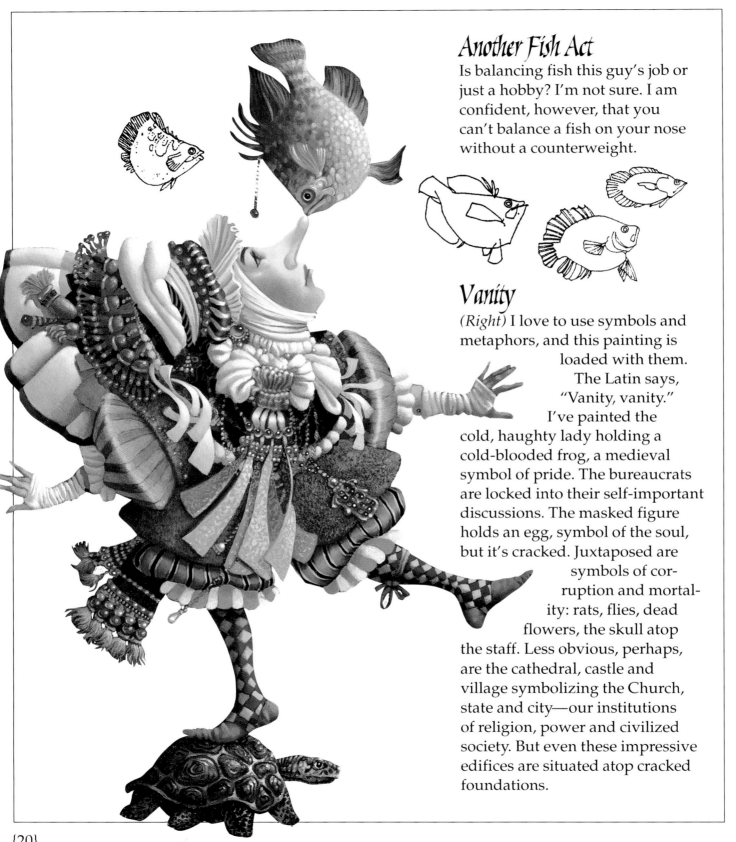

Another Fish Act

Is balancing fish this guy's job or just a hobby? I'm not sure. I am confident, however, that you can't balance a fish on your nose without a counterweight.

Vanity

(Right) I love to use symbols and metaphors, and this painting is loaded with them. The Latin says, "Vanity, vanity." I've painted the cold, haughty lady holding a cold-blooded frog, a medieval symbol of pride. The bureaucrats are locked into their self-important discussions. The masked figure holds an egg, symbol of the soul, but it's cracked. Juxtaposed are symbols of corruption and mortality: rats, flies, dead flowers, the skull atop the staff. Less obvious, perhaps, are the cathedral, castle and village symbolizing the Church, state and city—our institutions of religion, power and civilized society. But even these impressive edifices are situated atop cracked foundations.

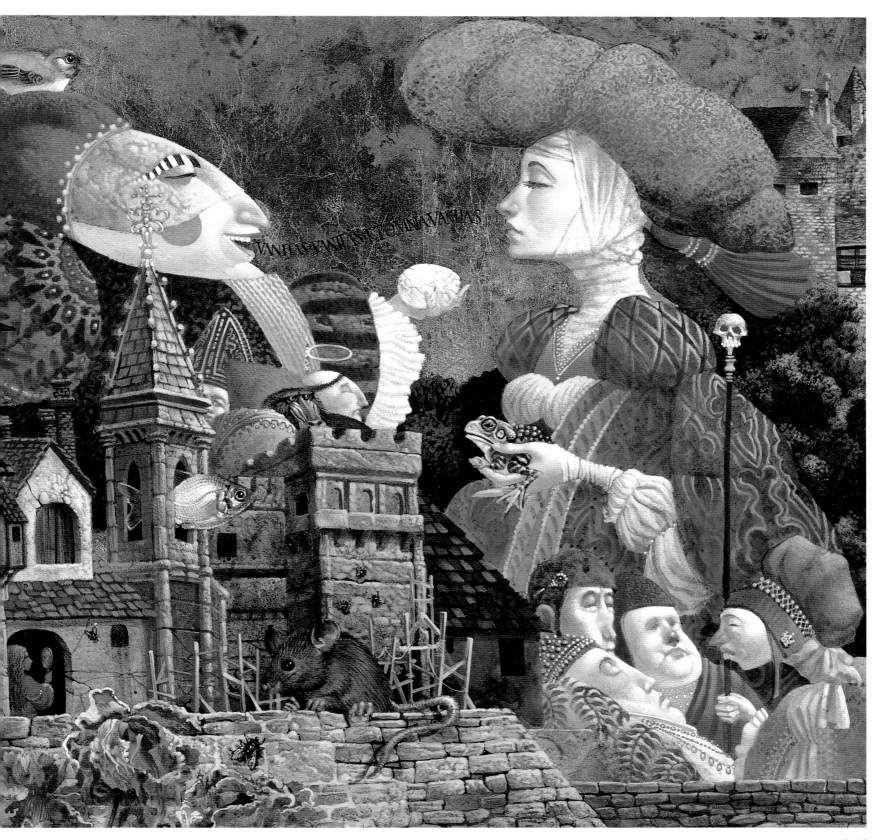

VANELAS VANELNE TOMNA VANIAS

At Reality, Take a Left

 This journey has no nameable ports of call, no identifiable destination, no placement in time and space. It is not a location, but a thought. It's a voyage of the mind to a world that is just a little to the left of reality.

The imagery isn't historically accurate; it's not meant to be. The feeling is one of being in another place, another time—but it's a time and place that have never really existed. Birds, toads, butterflies, fish and other creatures are usually inhabitants of this world, but they aren't governed by the same set of rules. They are tied to, but not restricted by, reality. It's a fantastical world offering allusions and references to ordinary reality.

That bond between fantasy and reality is an essential road map for the voyage. Imagination, with its boundless, infinite space, offers clues and inspirations about the literal world. The quirks and oddities of perspective, scale and juxtaposition offer vantage points from which to survey the journey of life.

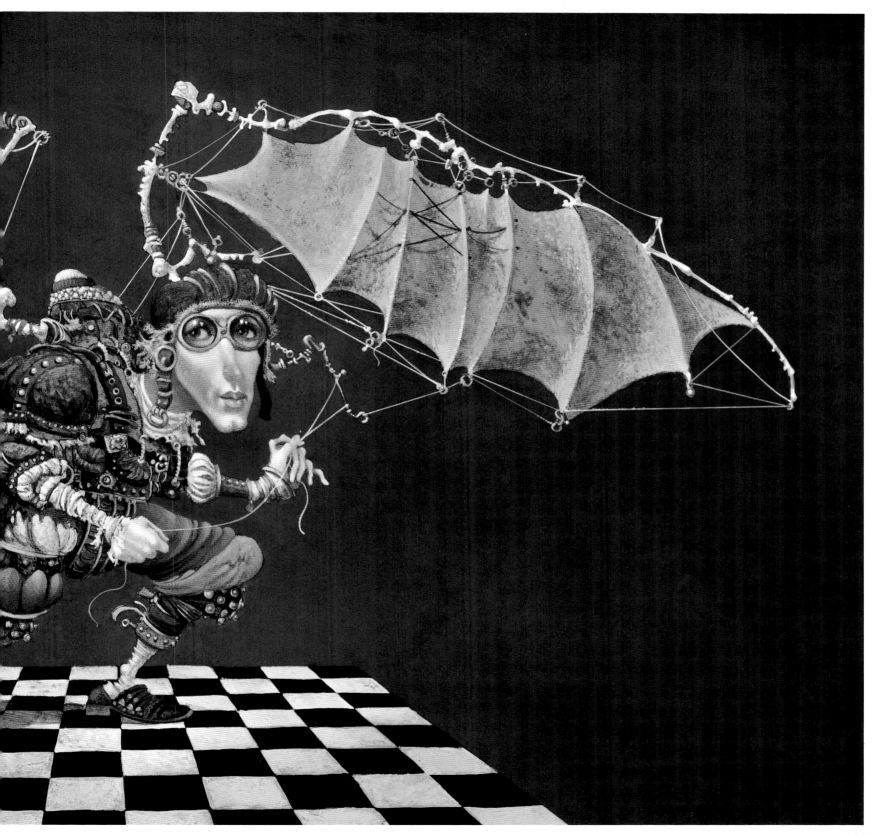

Icarus

(Preceding page) The kookaburra, a bird who's nothing special as an aerialist, laughs scornfully at man's attempt to fly. The bird seems to be saying that even a kookaburra is a better flier than a man. Despite the bird's derision, the character is prepared, for good or ill, to leap into the unknown.

The Magic Egg

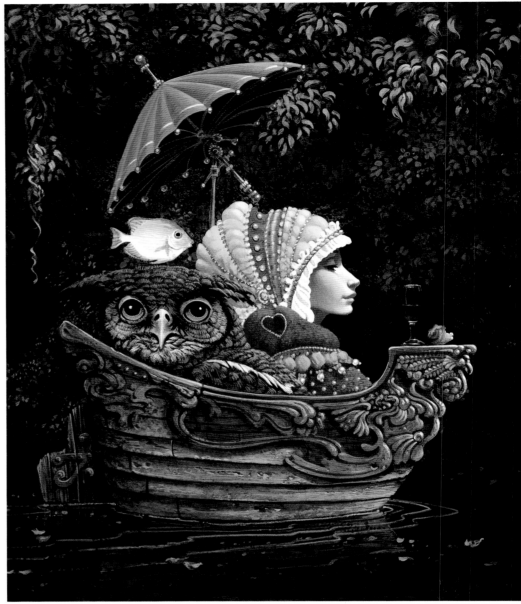

Afternoon Outing in a Small Boat With Owl

A minor alteration of scale and juxtaposition turns a pleasant outing—a Victorian picnic on a boat—into something special. The owl is nearly as big as the woman, and neither of them could really fit into the boat, but I like the way the image works together.

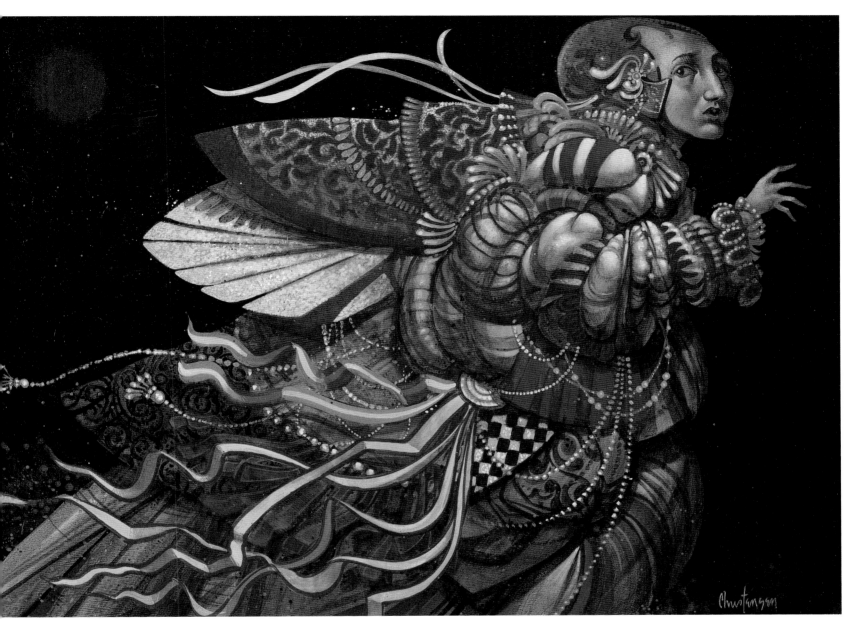

Sinner Fleeing Judgment

Direct inspiration was provided here by the Scripture, Revelation 6:12. "And I beheld, when he had opened the sixth seal and, lo, there was a great earthquake, and the sun became black as sackcloth of hair and the moon became like blood." The sinner's rich robes take on the shape of a beetle's wings. Wealth, power and prestige are meaningless now. The sinner flees, hoping to escape judgment. But there is no longer anywhere to hide.

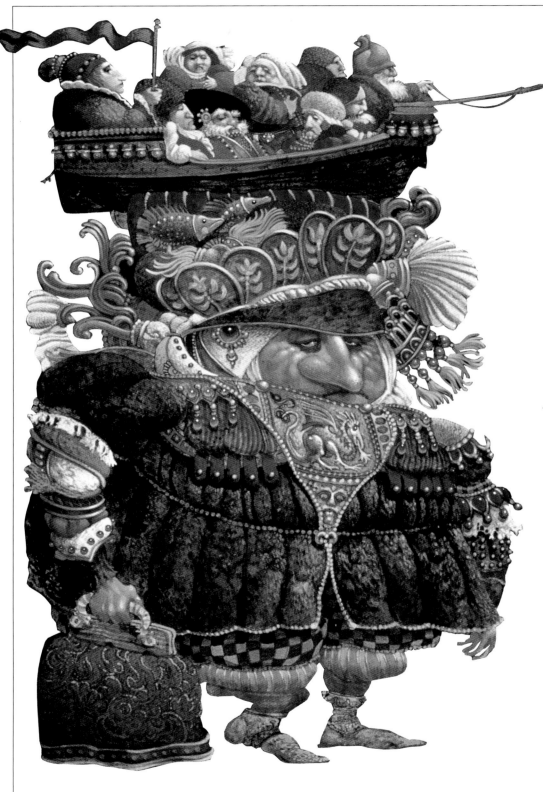

Carpetbag Man

(Left) The burdens of our lives can manifest themselves in myriad ways. This particular fellow is definitely in a period when he's not too happy with the baggage he has to carry around.

Tea Time

I like the idea of exploring the theme of conversation and communications among civilized beings. This painting is part of a series along those lines. I like the crow, but I don't know what he's doing there. He certainly doesn't look like he's paying attention to the conversation, though.

{26}

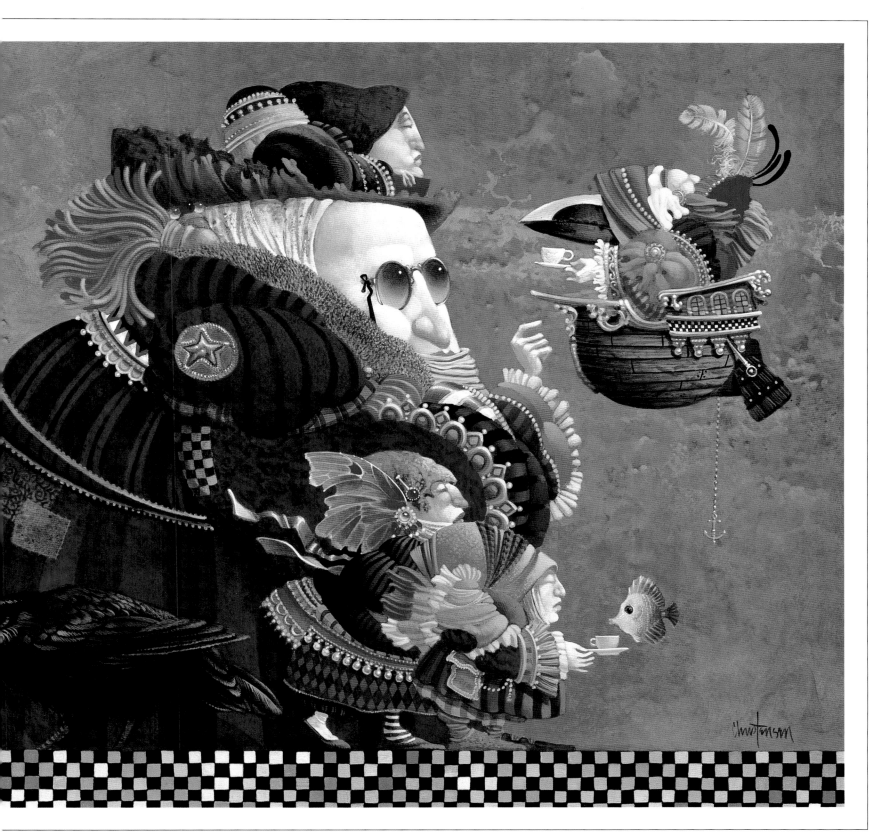

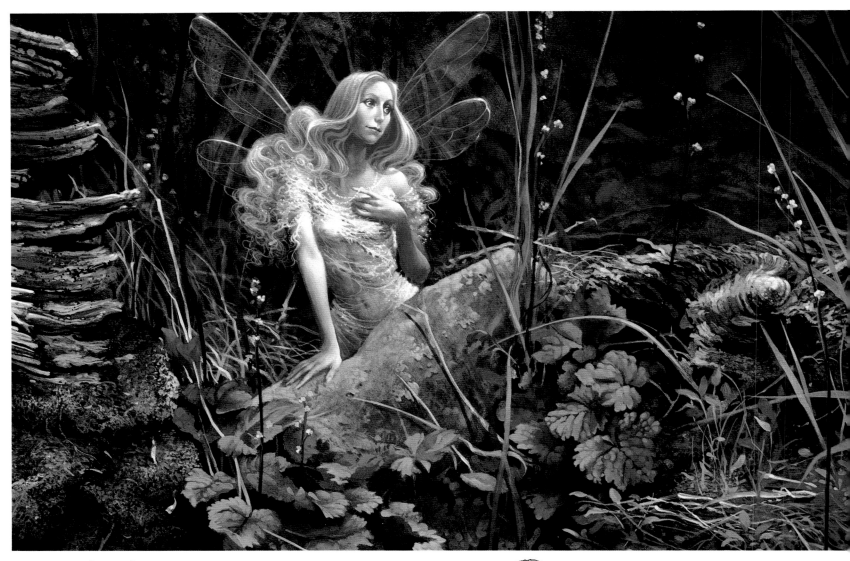

Waiting for Oberon

It's fun to think that even a faerie can be afflicted with a schoolgirl crush. Here she waits in the forest for Oberon, King of the Faeries, to pass by. This is a good example of a real landscape, one at a Boy Scout camp where I had gone to pick up my son, with a bit of magic added to it.

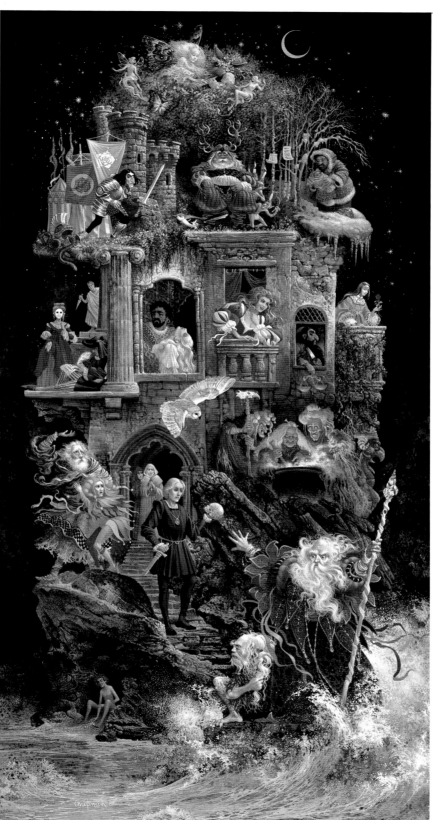

Shakespearean Fantasy

I've had a lifelong love affair with Shakespeare's works. The painting was done for a Shakespeare festival in Cedar City, Utah, and later the Folger Shakespeare Library in Washington, D.C., used the image for a poster celebrating the 223rd anniversary of Shakespeare's birth. I loaded it with references to his plays. Some of them are easy, but a few of them are pretty tough, so you really need to know your bard to get them all.

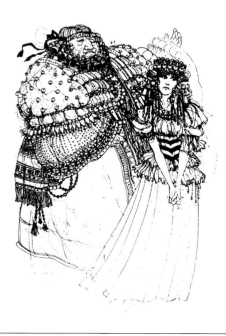

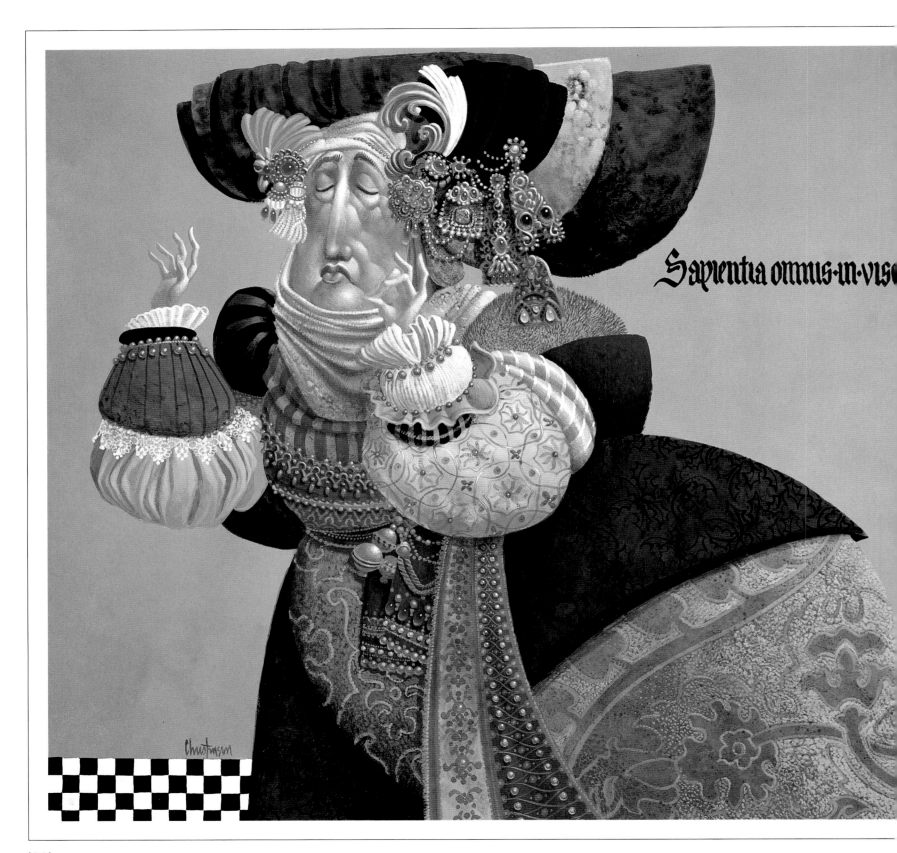

Sapientia omnis in·viso

Scatophagoi

Scatophages are the little fish that follow larger fish to feed off their excrement. But it's a perfect metaphor for some human activities. The larger figure is as caught up in his persona as his followers. The Latin inscription says, "All truth resides in my bowels." The scatophages trail behind, waiting for the big guy to pass a "pearl."

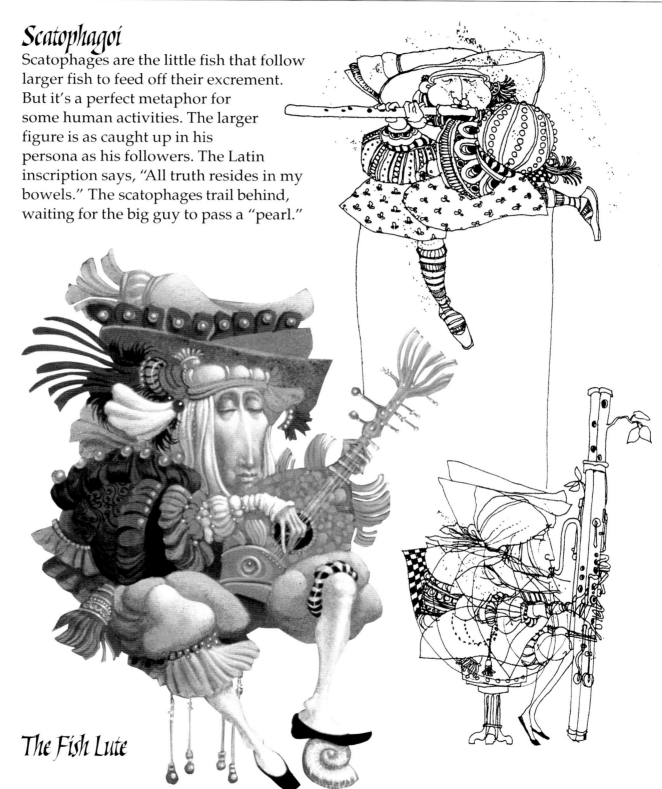

The Fish Lute

Something's Fishy

 Seeing a fish floating around the heads of a bunch of characters gives rise to many questions. What manner of place is this? Is the fish out of water? Are the people under it? How does it happen? What does it mean?

Asking questions is important to this body of work. The fish, the hunchbacks, the checkerboards, the multi-layered outfits of the characters do have meanings. The fish, for example, is a symbol of magic, a representation of all the strange and magnificent happenings beyond the edge of human reason. As such, the fish also becomes a symbol for a passage to higher understanding. But there is also a very simple symbolism at work: fish are lovely, colorful, graceful shapes, perfect examples of the unself-conscious beauty of the natural world.

It doesn't matter if each layer of meaning in a painting is fully understood. Moreover, it seems unlikely that anyone could discover everything, since each person brings a unique perspective to the art. Yet these singular views are also valid. In fact, when the images are allowed to spark the imagination and provide that fertile collaboration of reason, experience, intuition and epiphany, a far more potent experience arises.

So follow the fish. It's a guide to the magic.

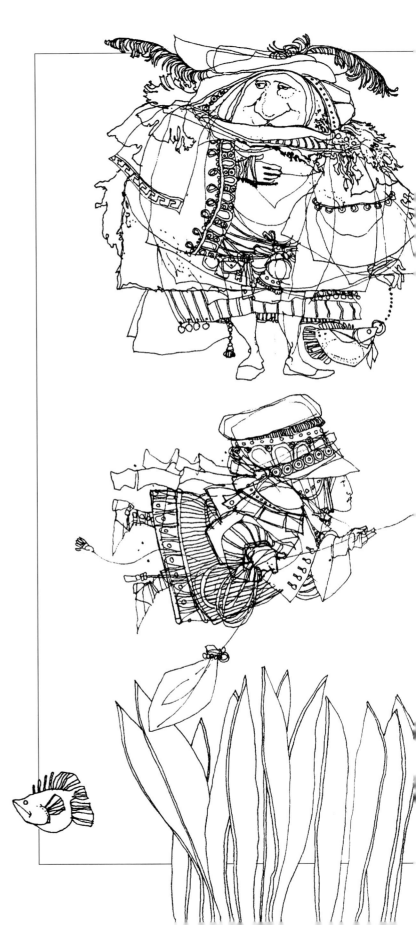

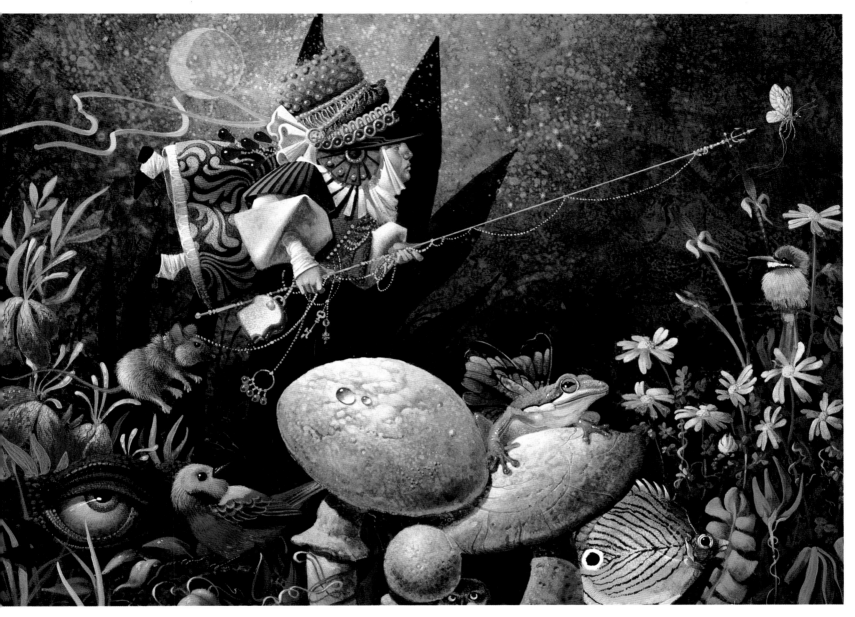

Forest Fisherman

This was my first commissioned fantasy painting. The neighbor who commissioned it stopped by every couple of days to see how it was going. One day, toward the end of the painting, he said, "Boy, you've got everything in there but his lunch." So the next time he came over, there was a jelly sandwich on a chain around the character's neck.

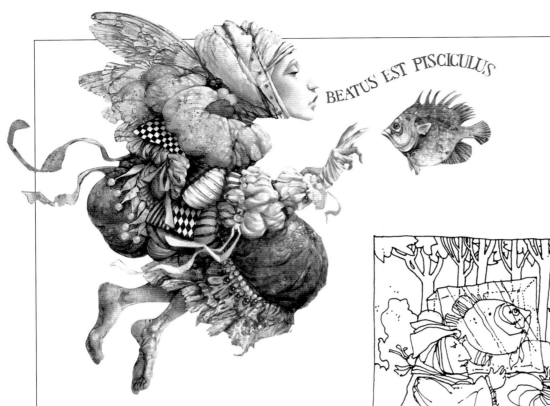

BEATUS EST PISCICULUS

Benediction

The Latin *beatus est pisciculus* means "blessed is the little fish." The fish is a symbol I use over and over, and this image is a kind of thank-you for a lot of the magic and the passage to places we wouldn't have gone otherwise.

FISH ASSASSIN

Voyage With the Ambassador

Life isn't an orderly progression, and it's frequently full of surprises. In this early boat painting, I'm beginning to explore the "life voyage." The disparate elements are meant to capture the chance encounters of life. Someone once said that the large figure looked like Henry Kissinger, so I called it "Voyage With the Ambassador."

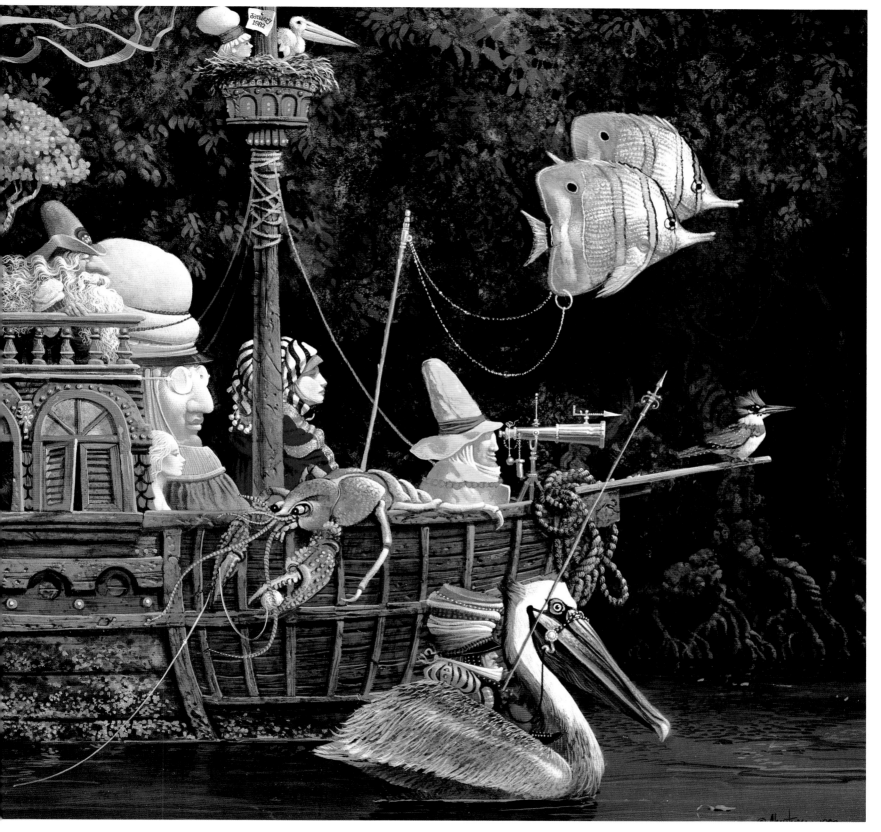

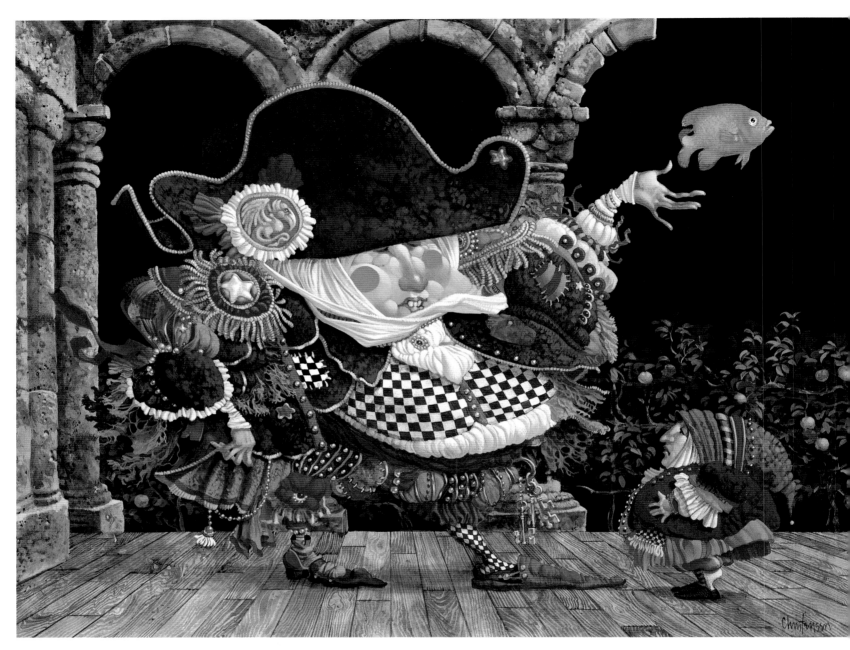

The Great Garibaldi

Look again. Paintings grow out of many things, and this one is from my love of things not being what they seem. The inside scoop is that the Great Garibaldi is the fish (the gold perch is called a "garibaldi"), not the impressive-looking mountebank or the little sycophant.

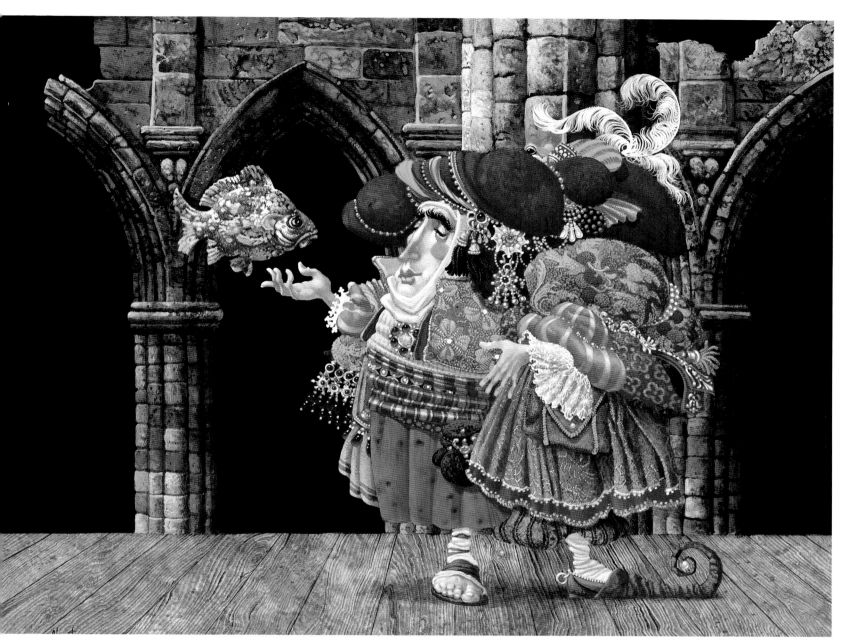

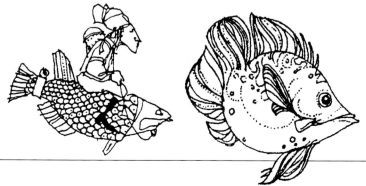

Levi Levitates the Stone Fish

Sometimes I try to paint as if I were looking at a theater stage, so that if you moved the view to right or left, you'd find this was a tiny, unreal set. I was having alliterative fun with the title, but other people made some interesting symbolic connections with the Levites, members of one of the twelve tribes of Israel.

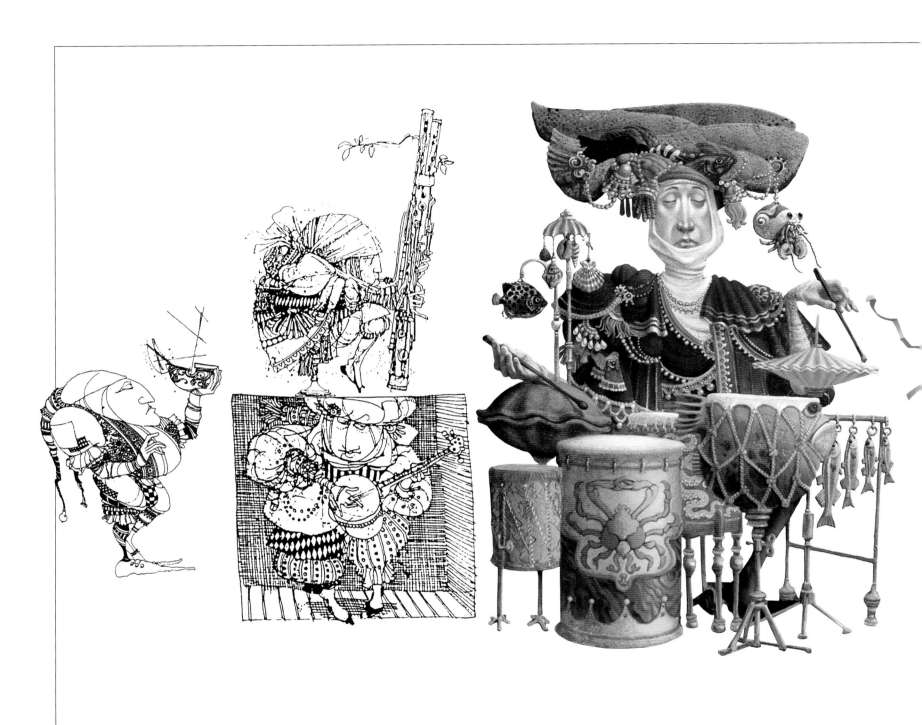

·2·
Cerebral Navigation:
History, Mystery & Everyday Life

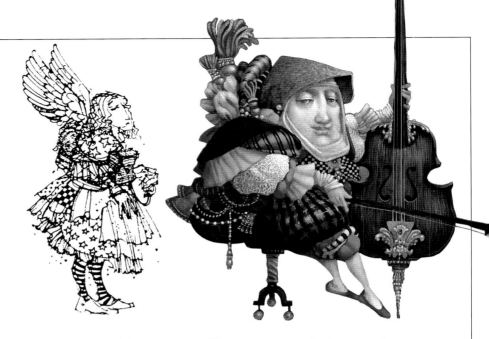

Cerebral Navigation: History, Mystery & Everyday Life

·2·

It seems that many adults see a voyage of the imagination as something reserved for artists, writers and other "creative" people. I don't agree with that. Yes, there are people with extraordinary talent. But creativity and talent are not the same thing. With practice, we all have access to creativity, no matter where our talents lie.

The way I see creativity and imagination is something like a library's card catalog, except that the cards are made up of concepts, ideas, visions, pictures, all the facets of one's personal life experiences. A single memory can create many different "cards." A book or a film that changes your thinking may create dozens.

Both inventiveness and fun come about by combining the cards in new ways. For instance, I've used the book *101 Things to Do With an Alligator* with students, as an exercise in imagination. It's always pretty easy to come up with the first five or six things to do with an alligator, like handbags or shoes or briefcases. But where do you go for number seventy-eight? To come up with the idea that

you could strap an alligator on each foot and use them for water skis means you have to go back to the card file and start mixing up concepts.

The alligator game makes a funny example, but maybe the people in the aerospace industry did something similar. They wanted a material lighter than metal, something that could handle the high temperatures that occur when the shuttle re-enters the earth's atmosphere. I can see somebody sitting at a computer working on a screen-filling equation. He or she picks up a coffee mug—flash! What if we used ceramic panels?—a couple of formerly unrelated cards are now side by side, and a whole new field of study begins.

I see the use of imagination as a two-part process: feeding and exercise. Developing your card file is the feeding part. Read, think, experience, look around and continue learning for your whole life. Everything that we now know is the sum of our collected experience. Nothing comes from nothing. If you don't keep expanding your card file, you will be stuck forever using limited options and resources, mired in the "we've always done it this way" mode of operating, and never getting beyond

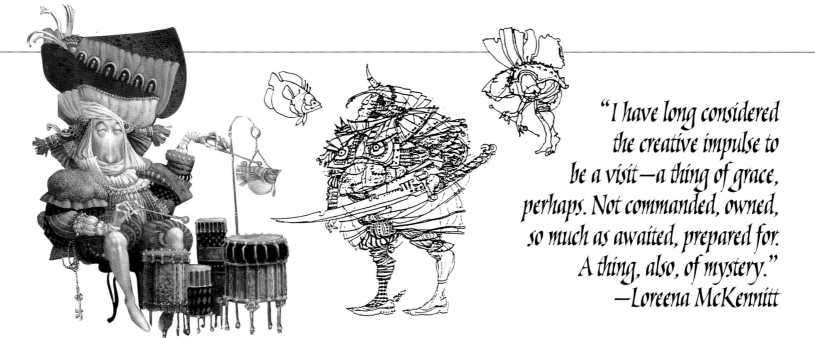

the known solutions that inevitably become obsolete for real problem solving.

The exercise comes about when one practices combining the cards and putting them together in new ways. All the Edisons, Einsteins, and da Vincis of the world were building upon stored information (cards they already had in their files), but they combined the cards in new ways. Their astonishing inspirations came about because they took what was known and saw it in a new light.

The really wonderful thing about using your imagination is that you don't have to be an artist or an inventor; it works for everyone. Active imagination works within your own life, expanding the scope of whatever endeavor you're involved in. Imagine an auditor regularly experimenting with her card file. She's going to be a whiz at her job because she'll also be using her inner eye while she's balancing numbers on her calculator.

I can't promise that you'll become an Einstein if you practice active imagination (though you might).

Inspiration is sometimes more like a cat than a dog: it doesn't always come when called. But I know that if you build your card file and practice making connections, your mind will start coming up with ideas on its own.

For an artist, there's encouragement to fill one's card file by getting to know the art of previous centuries. But in this century, the wealth of inspiration from the past has tended to get a little lost. It's hard to tell, looking at the very nonobjective works we see today, that we have this treasury of artistic endeavor. One of my aims is to allow the Northern Renaissance artists whose paintings I love to influence my own work.

This doesn't mean that I'm trying to paint exactly like Jan van Eyck or Albrecht Dürer. Over the past thirty years, I've been filling my own card file with stories, ideas, concepts and images. When I paint, such influences appear in my work, even though it s not always a conscious endeavor. In feeding and exercising my own imagination, I add to the layers of meaning in my art.

Looking at the "Nursery Rhymes" (pp. 44-45) triptych, someone who knew the work of the Bruegels

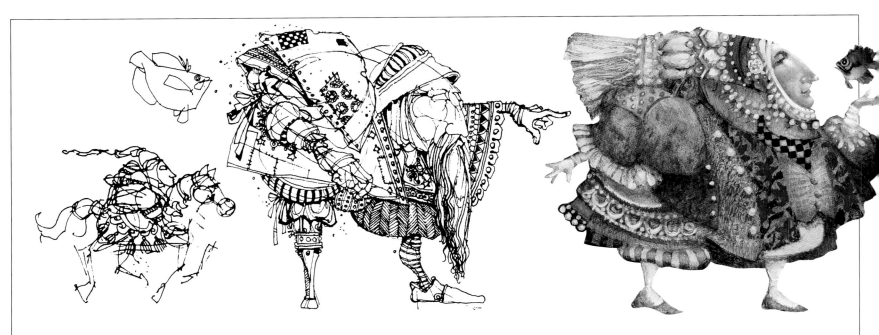

could see their influence in the tumult of activity taking place. Similarly, "The Betrothal" (p. 54) has elements reminiscent of the unicorn tapestries I saw during a trip to the Cloisters, while "Titania and Bottom" (p. 50) and "Queen Mab in the Ruins" (p. 48) have something of the feel of the 19th-century Pre-Raphaelites' work, such as John Everett Millais' "Ophelia" or the beautiful faerie paintings of Noel Paton. It doesn't matter whether you recognize every one of these allusions, though it's always nice if you do.

 The works of other artists are not, of course, the only avenue of inspiration. It isn't as if, on becoming an artist, one climbs up into a tower and only thinks about art from then on. I am a child of the 20th century, and Walt Disney's films, like *Fantasia* and *Sleeping Beauty*, and J.R.R. Tolkein's fantasy writings were a part of my imagination's development. I have a family and I'm part of a community, which also is intrinsic to my work. A great deal of

my inspiration comes from observing the day-to-day interactions of the people around me. I'm sure there are artists who could work in a tower, but I'd feel like I was missing far too much.

For me, art is a way of processing and sharing my particular view of life. Since life is a pretty complex subject, inspiration comes from the ever-widening sum of my experience. Again, I don't mean just erudite classical studies, but participating in the richness of life around me. I get a lot of energy from the natural world: hiking in the woods and mountains and seeing how nature handles life, death and rebirth; paying attention to the ways and means of the birds, bugs and chipmunks who live just outside my house; wondering why the deer find my dogwood and columbines so irresistible when there are perfectly good dogwood and columbines growing in the woods.

Sometimes a realistic natural setting will be my starting point. Often, these are actual little landscapes that I've found while walking. In paintings like "Queen Mab in the Ruins," you can see that I've used the natural world in much the same way

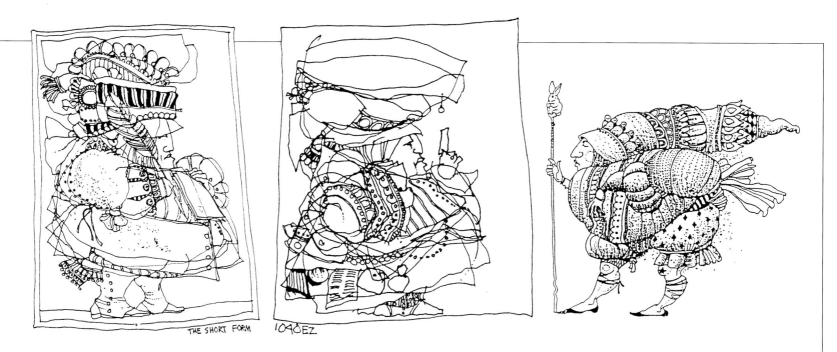

THE SHORT FORM 1040EZ

that I enjoy weaving some of the old medieval Christian symbols into my paintings. Sometimes the juxtapositions are purposeful; I've had an idea about interesting things coming together. Other times, the places I've been and the art I've seen show up in my work without conscious direction on my part. It's all there in the card file.

Again, this function of memory and imagination isn't some special or magical facility that only artists and other "creative types" have. Anyone with the desire can take part in active imagination. Time and again, I've had someone say, "My! What an *imagination* you have," as if I'd been twinkled by the Talent Fairy or something. Sometimes when I hear that I want to say, "It's not that *my* imagination is so extraordinary; it's that every day, everything you see and experience presents *you* with a terrific opportunity to awaken yours." If you let your imagination sit on a shelf, it'll get dusty and maybe you'll think you've lost it.

That isn't so. It's still there and perhaps it's not as easy as watching television, but anyone can do it. If you start putting things in the card file, if you make your brain practice juxtaposing new, untried connections, you'll be rewarded. Your imagination is already there. If you haven't been using it, you just need to jump-start it.

When people tell me, "I don't have any imagination," I want to grab them by the shoulders and shake them and say, "Yes, you do! Get out there. Learn some new things, pay attention, make connections, think about ideas. Watch the world around you. Stay curious. Make yourself think a new thought every day until your brain starts doing it on its own."

Painting is what I do to encourage that journey of discovery. I want to offer new raw material for the viewer's card file and provide stretching exercises for the imagination. When people participate, when I see that little light go on in their eyes, that's when I feel good. Then I know I've succeeded, not just in pleasing my own eye, but in connecting with other minds, other imaginations.

Rhymes & Reasons

In this work of art,
The center part
Originally led the way.
But the town was soon
 filled,
So the left panel spilled
To a scene from the break
 of day.
But even *that* got tight
So the right became night,
And a place for nautical
 play.

It's about Nursery Rhymes
From the olden times
And I've made it a kind of
 game.
Come, look around!
Well-known verses
 abound—
How many can you name?

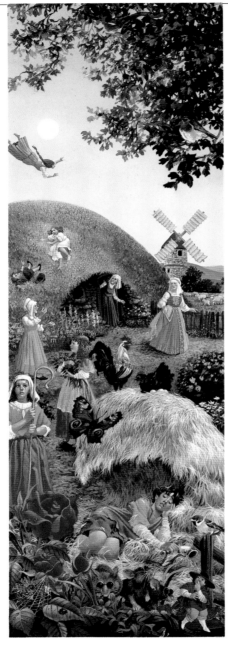

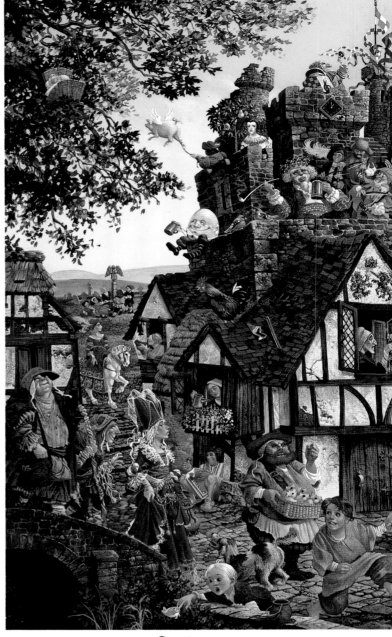

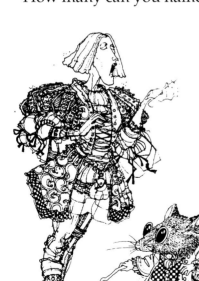

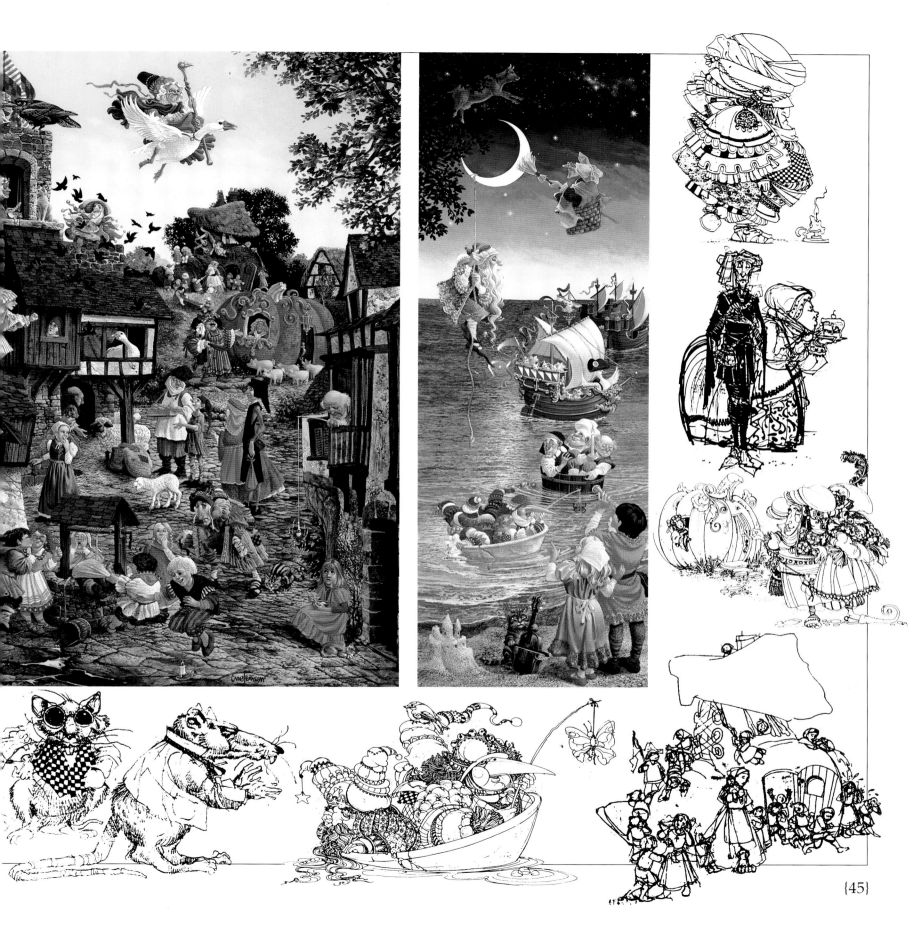

Musing on the Muses

 There are many images depicting the Lady of Shalott. This famous lady who died because she defied a curse is only a character in a poem by Tennyson. But she lives on (though often pale), immortalized by artists taking their inspiration from the verses that created her.

The connection between literature, legend and artistic inspiration may have been best expressed by a group of 19th-century English artists known as the Pre-Raphaelites.

"The Pre-Raphaelite Brotherhood," Christensen says, "believed that nothing of great value had been painted since the 15th-century painter Raphael's work. This didn't endear them to a lot of other artists.

"I admire them because they took their work so seriously. Many were devoutly religious people whose beliefs influenced their art. They went to great extremes of hyper-reality, creating images leaf by leaf and stone by stone. About his move away from such techniques, artist John Everett Millais wrote that he 'could no longer afford to paint for an entire day on an area the size of a five-shilling piece' (a coin a little larger than a quarter)."

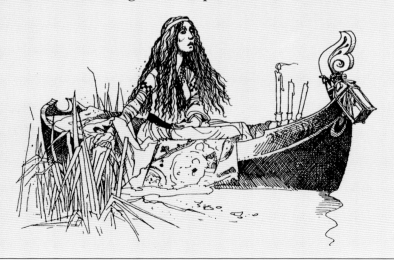

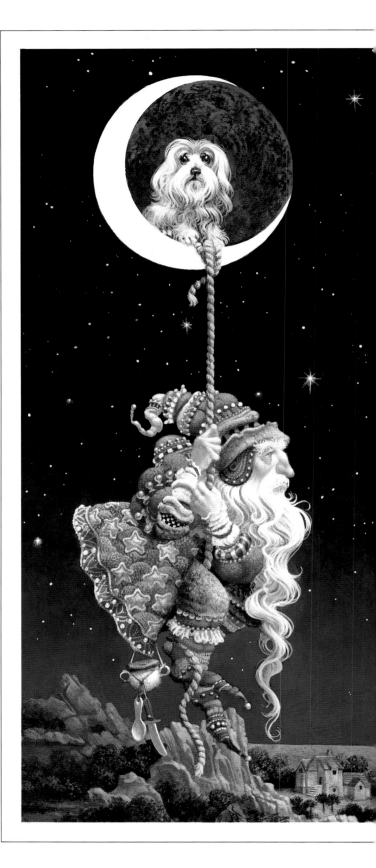

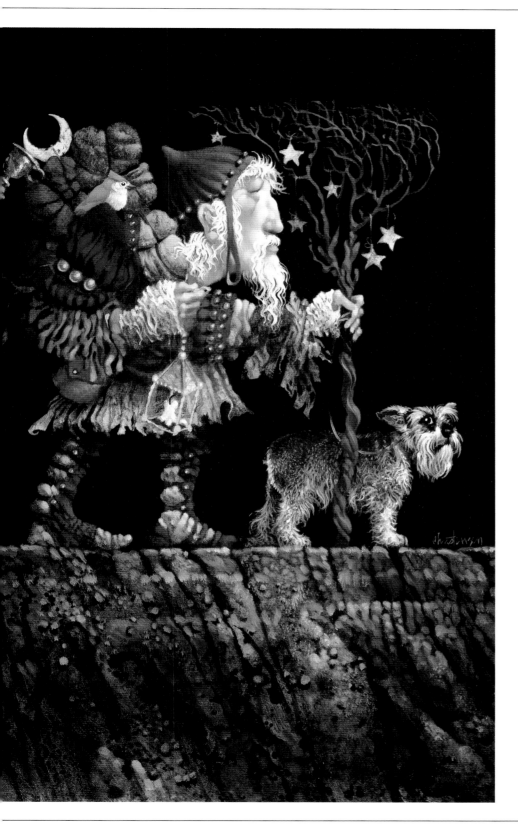

The Man Who Came Down From the Moon

(*Far left*) I liked the little guy from the "Rhymes & Reasons" so much that I decided to give him his own painting. The dog in the moon is one of my own pets who likes to get into places he shouldn't.

The Man in the Moon

Along with bits of man-in-the-moon lore, there's a reference to the little playlet near the end of Shakespeare's *A Midsummer Night's Dream*. The country-bumpkin character who plays the moon says, "All that I have to say is to tell you that the lanthorn is the moon, I the man in the moon, this thorn-bush my thorn-bush, and this dog my dog." Actually, it's my sister's dog.

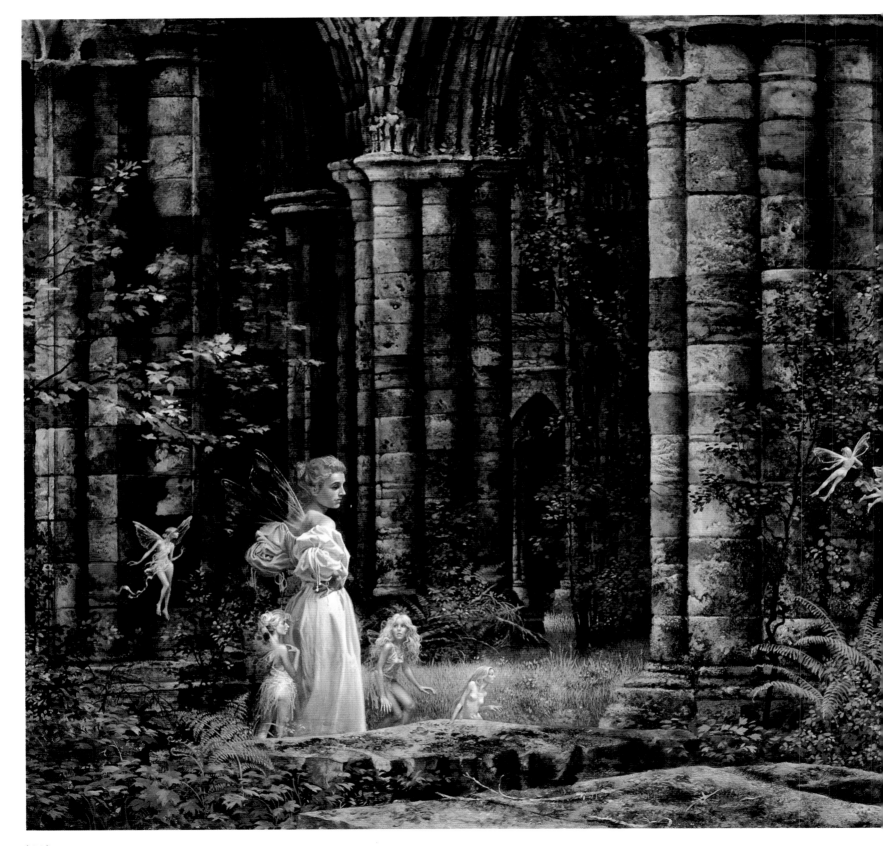

Jonah

(*Below*) One day I sat listening to a dispute over whether a literal or a metaphorical reading of the story of Jonah is correct. I went home and got to thinking, "If I were God, I'd make a really neat-looking fish." In fact, the Scripture does say that He prepared a special fish. So I painted what I thought it might look like. The thing to remember is that the window is a one-way mirror. If Jonah could see out, of course, it would be just another vacation cruise.

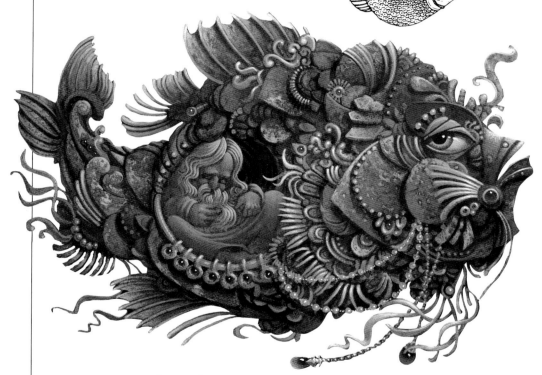

Queen Mab in the Ruins

During my travels, I've often been captivated by the extraordinary stone ruins of Europe. The structures in this image aren't taken from any one particular place. I just loved the idea of an ancient ruin in a great forest, a place lost to everyone but the mythical creatures. I wanted to paint a character from literature in the way of the Pre-Raphaelite artists. Queen Mab is one such legendary faerie character.

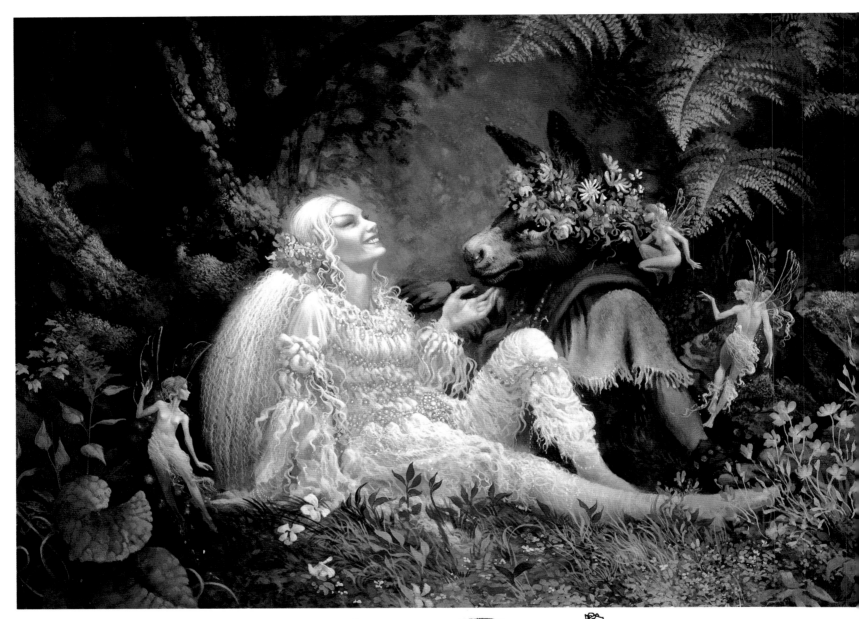

Titania and Bottom

After a stage production of *A Midsummer Night's Dream*, for which I had designed costumes, I asked two of the actors to pose in full regalia. The result was one kind of art imitating another. The magic is added for good measure.

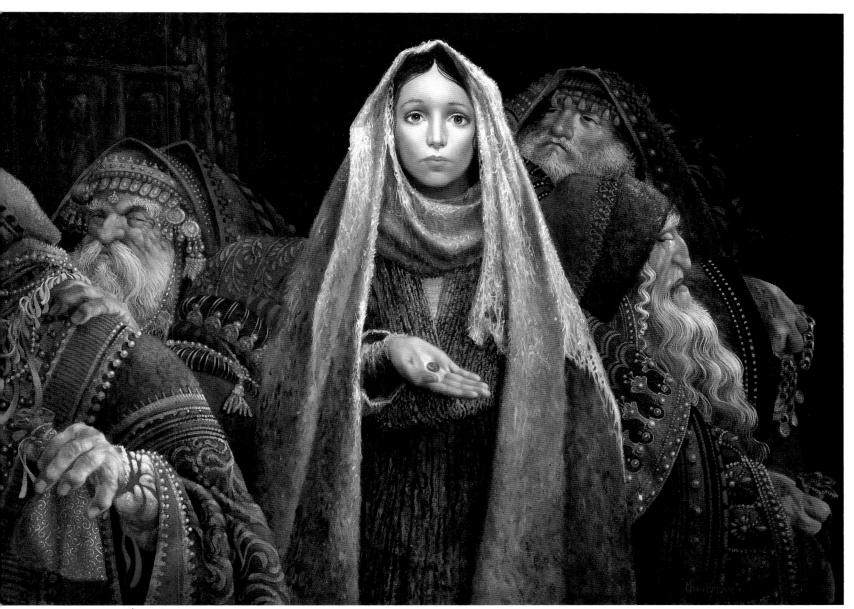

The Widow's Mite

The lights and shadows here are symbolic of spiritual and worldly power. The poor widow who gave all she had glows with an inner light, and even her ragged clothing becomes luminescent. By contrast, the rich men in their expensive robes fade into the shadows in the radiance of this woman's gift.

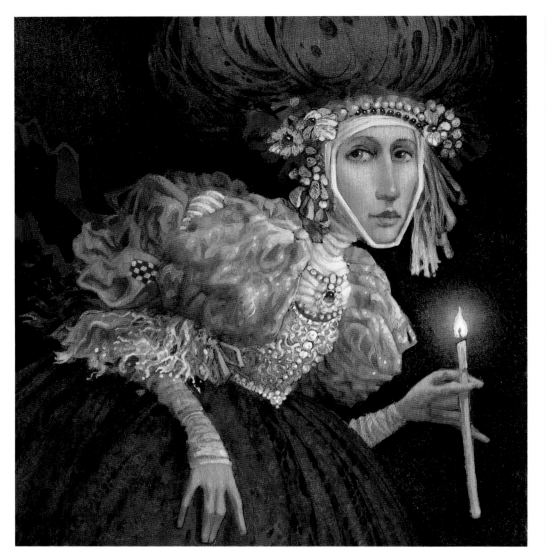

Candle at Midnight

A case for the means justifying the end: I was experimenting, using a Flemish painting medium that involves boiling lead, oil and a mastique varnish together. This isn't an image important for its symbolic content (though it's certainly open to interpretation), but an exploration of a different technique and medium.

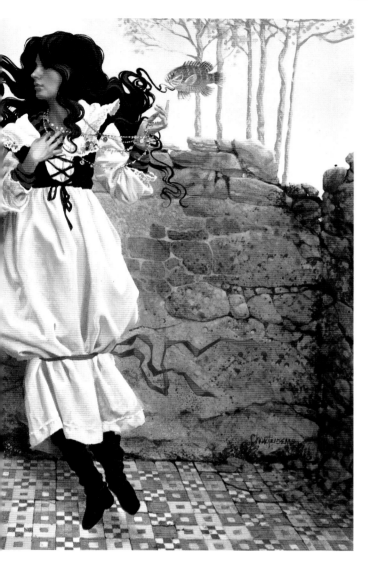

Music Over the Wall

An acquaintance saw this and said, "Jim, you paint the most beautiful women. You're as good as any 19th-century painter. But, Jim, put the feet on the ground and get rid of the fish." A few years later, he said that maybe he'd been wrong.

Jan van Eyck

"I often call Jan van Eyck my hero of heroes," says Christensen. "I'm drawn to his paintings because of his craft. No one understood paint better than he did. But it's also his sensibility that attracts me, the careful rendering of intimate interiors and his use of symbolic images to connect the physical world to the spiritual."

Van Eyck was a master in the use of symbolism. His "Marriage of Arnolfini" is a realistic scene. Yet spiritual symbols abound: A single lighted candle represents the Holy Spirit, the fruit represents fertility and the little dog, marital fidelity. These symbols lend the natural world an allegorical, unified spirituality.

As a craftsman, van Eyck has no equal. The soft radiance imparted by his layering of translucent and opaque colors has never been surpassed. During the five centuries since he made them, his paintings have remained in remarkable condition.

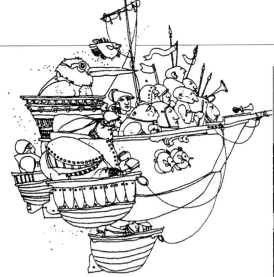

The Betrothal

Yet another homage to the past: I was enchanted with the unicorn tapestries at the Cloisters in New York. I liked the way the plants and animals were portrayed, so I painted them in the same style. I was also exploring the themes of fidelity and chastity and have drawn on some of the old medieval and Renaissance symbols.

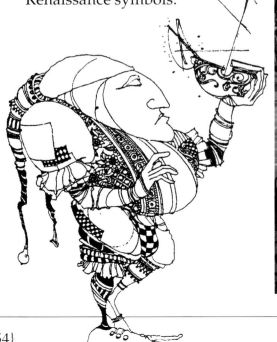

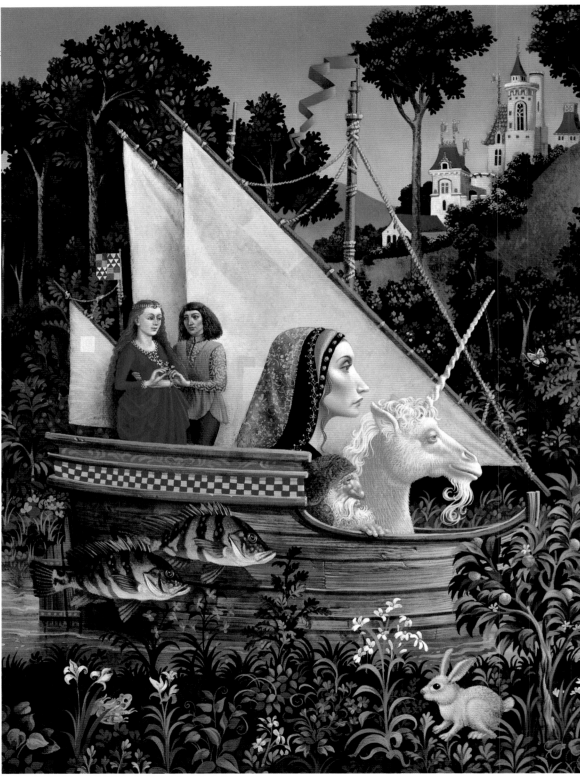

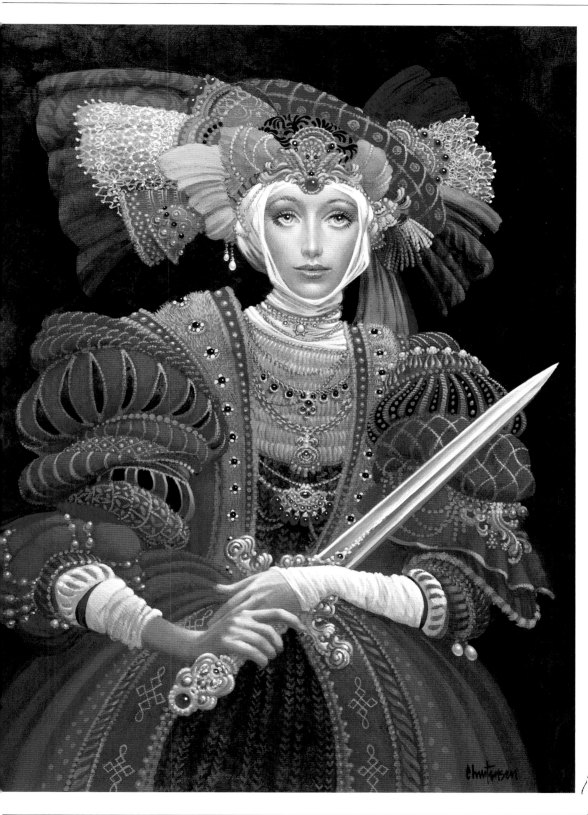

Judith

Judith was an early feminist hero chronicled in a group of ancient texts called the Apocrypha. During the Assyrian siege of Jerusalem, the Hebrew warriors cowered uselessly inside the city walls. One brave, beautiful widow decided to act. Slipping out of the city and into the Assyrian camp, Judith went to General Holofernes' tent. She said she'd do *anything* to avoid being sold into slavery. Then, before he could make advances on her, Judith got him drunk and cut off his head. She sneaked back into the city with his head in a sack, and the city fathers stuck it on a pole. The next morning, the Assyrians saw their general's head, lost their urge to fight, and retreated.

Lorelei

Legend tells of Lorelei, a woman who lured sea-men onto the rocks to be shipwrecked and drown. But this painting has nothing to do with her. I simply wanted to do a study of a woman in an ornate headress.

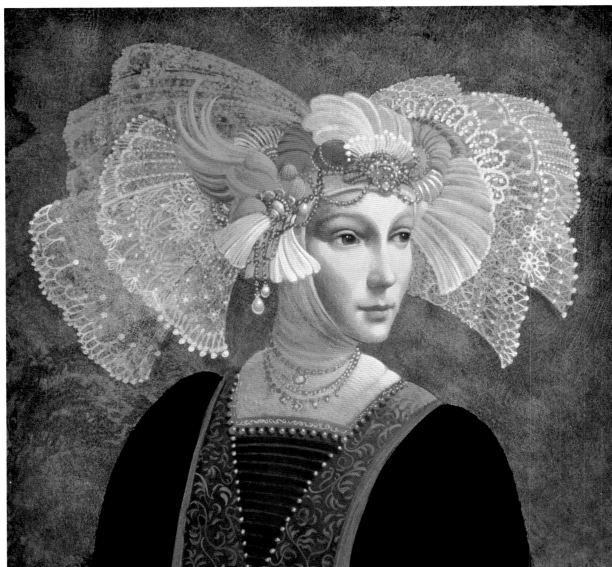

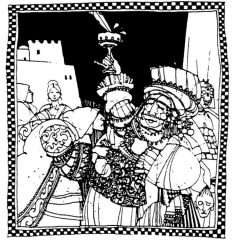

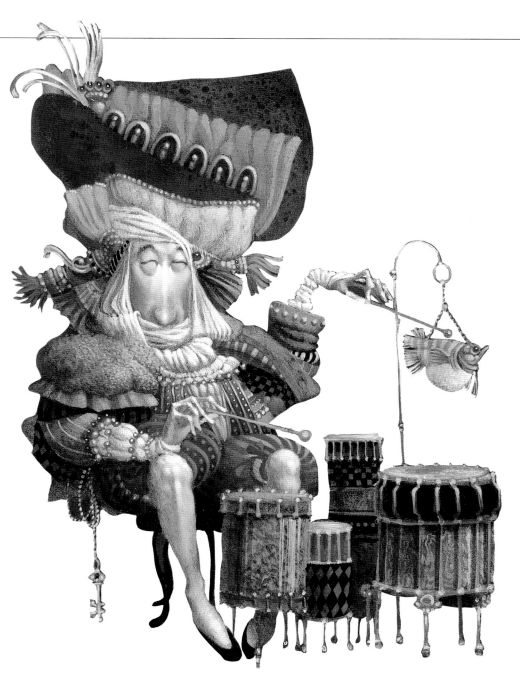

Piscatorial Percussionist I

Themes run through nearly every artist's work. Sometimes, a combination of themes creates a theme unto itself. This, the first of the fish drummers, combines a number of my favorites: music, fish and ornate, complicated costumes.

Little Windows of Poetic Illumination

 The images in this book are often intricate and intensely realistic, yet working with a scale or perspective that's slightly askew. This style is reminiscent of artwork by painters of the early Northern Renaissance.

To these Flemish and Dutch artists, paintings were ways to teach and inspire on a number of different levels. The precision, complexity and meticulous detail were part of their philosophy of reverence. Their realism was stylized (sharp and tightly controlled), but subject to the painting's meaning. For instance, a figure's size might be determined by its importance in relation to the rest of the image. The Virgin Mary would be painted larger than any surrounding shepherds or farmers. The Northern Renaissance painters were less interested in painting the real world as they observed it than in creating carefully realistic windows of poetic and spiritual illumination.

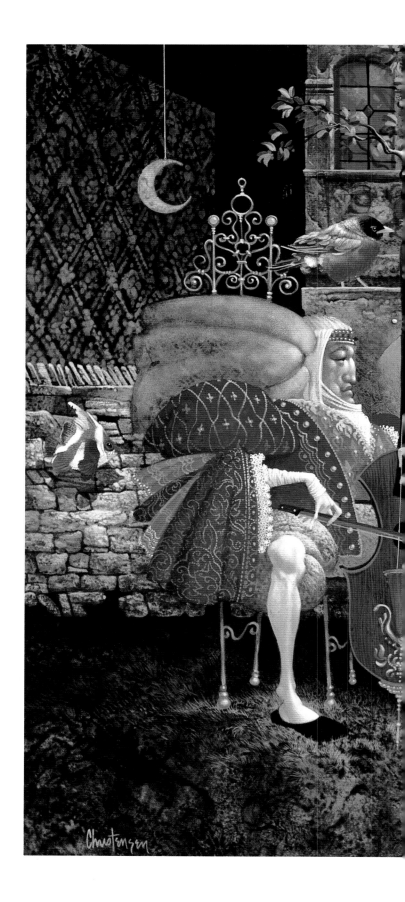

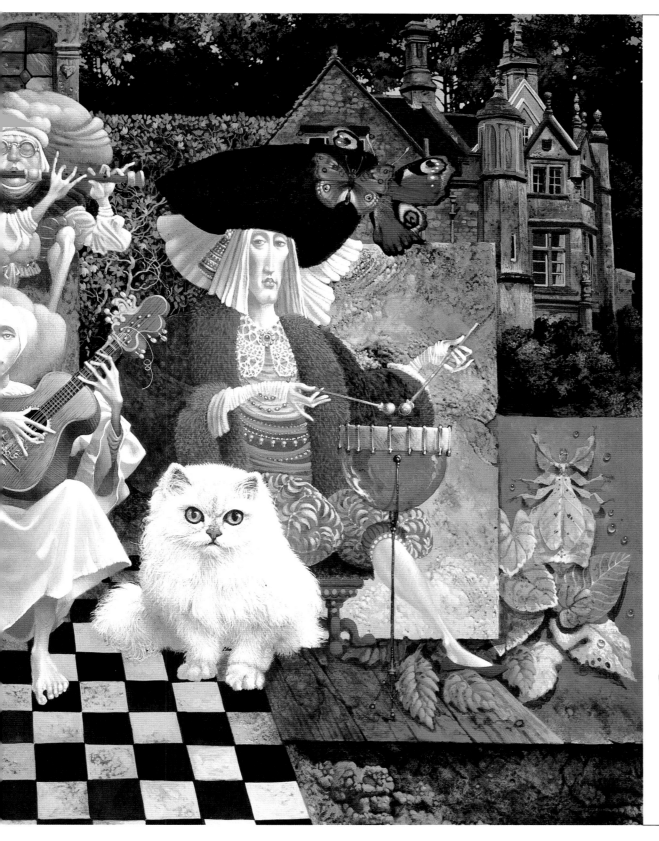

Quartet

This is a kind of stream-of-consciousness painting about music. The images appear real, but their treatment is very abstract and a little bit surreal. There are places where everything is flattened out, places with a semblance of a floor, other places where the figures seem to be floating in the air.

Feeding the Birds

Someone at a gallery show said, "At first I didn't get it. Then I figured it out: there's birdseed in his *hat*." Well, probably there are a few sunflower seeds, but that's just to get their full attention. What I had in mind was payback in kind, the music of the man feeding the music of the birds.

Concerto al Fresco

(*Far right*) One day I was listening to the birds outside my studio window, and I thought, who would be a more appreciative audience for an outdoor musical show than a group of birds?

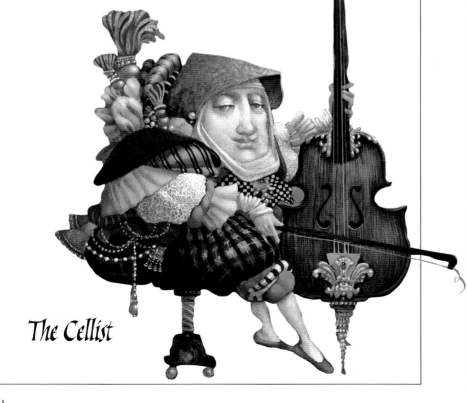

The Cellist

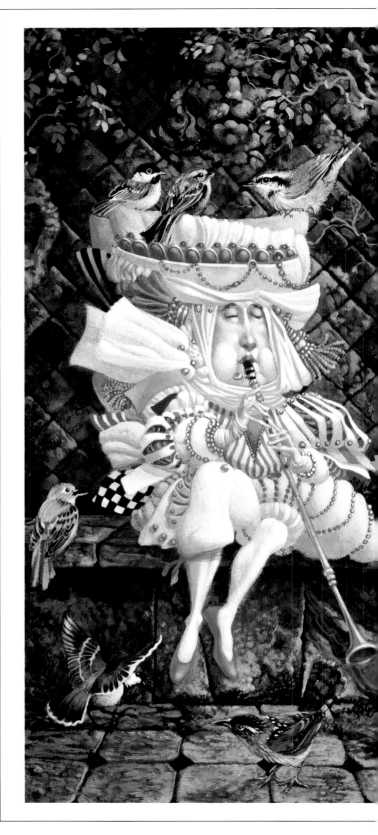

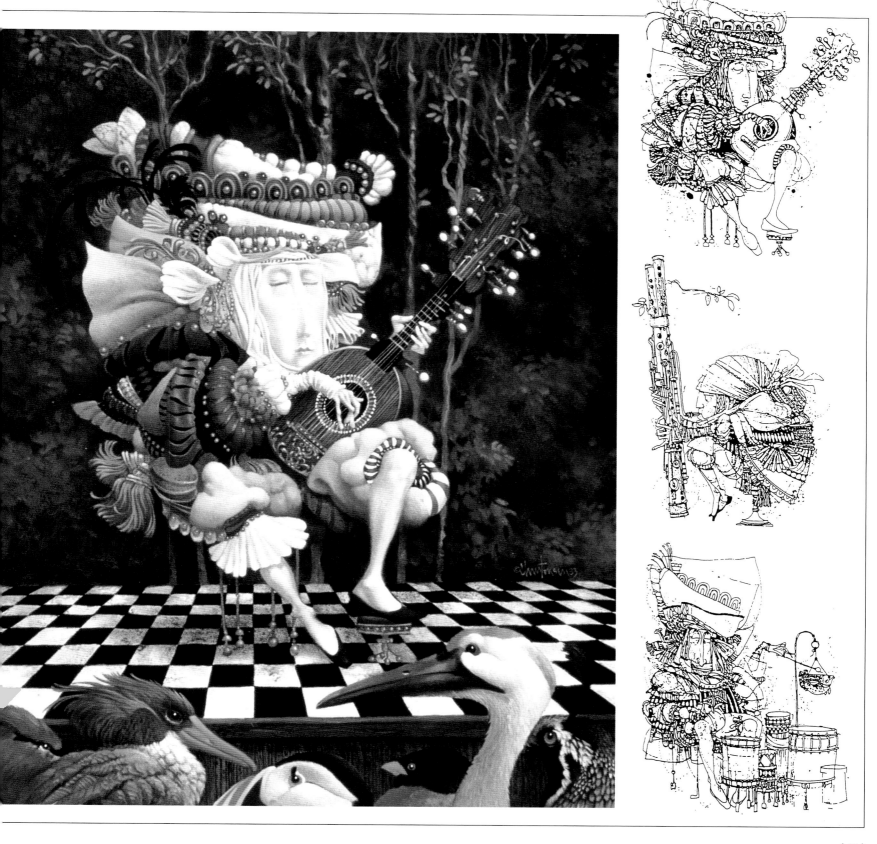

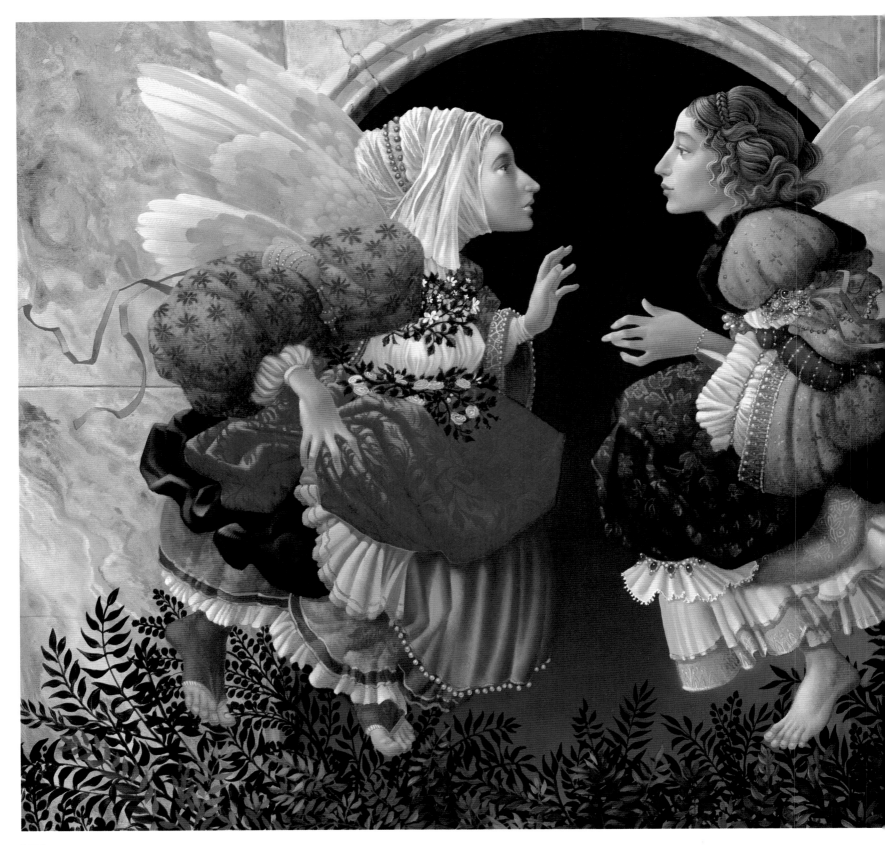

Two Angels Discussing Botticelli

Sometimes a reference takes over a painting. Looking at a book on Botticelli, I liked the hair on one of the characters in "Primavera" and decided to incorporate it into a painting. I started weaving in references to this artist, even using colors that reflect his palette. There are probably a dozen or so allusions to his art here, but you don't have to know them all to enjoy the image.

PRIDE GOETH BEFORE THE FALL

"BUSH" PILOT

Old Man With a Goldfish in His Pocket

The Emperor of Constantinople and Vanity on a Pleasure Cruise Across a Quattrocento Landscape

Perhaps this would be easiest to describe as a montage of art from art. I'd seen a painting of Vanity as a beautiful red-haired woman and decided to add her to an image of my own. Some art from the Middle Ages, especially like that found in the illuminated manuscripts, is featured as well. The real challenge was assembling the disparate elements and getting them to work together as a whole.

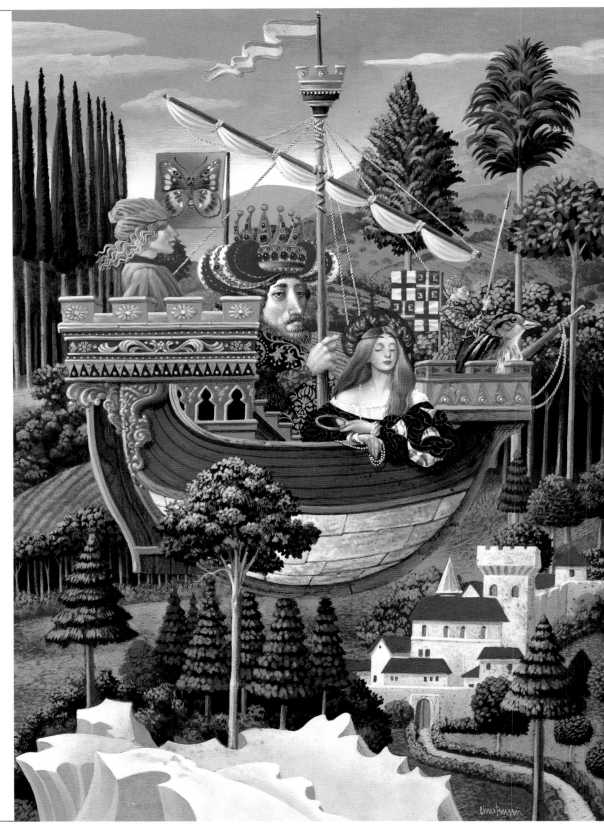

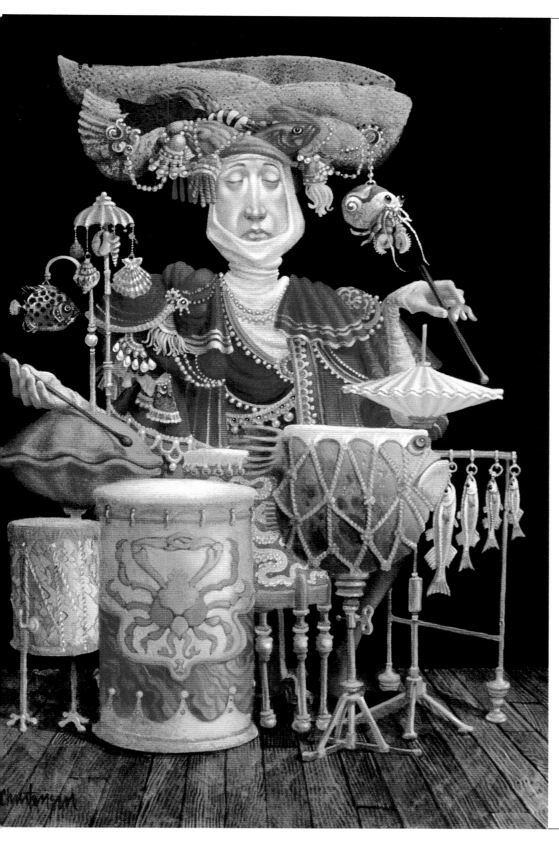

Piscatorial Percussionist II

I love playing with the idea
of odd or made-up instruments.
After the first fish drummer I
did, I got interested in the idea
of adding more and more
fishy instruments.

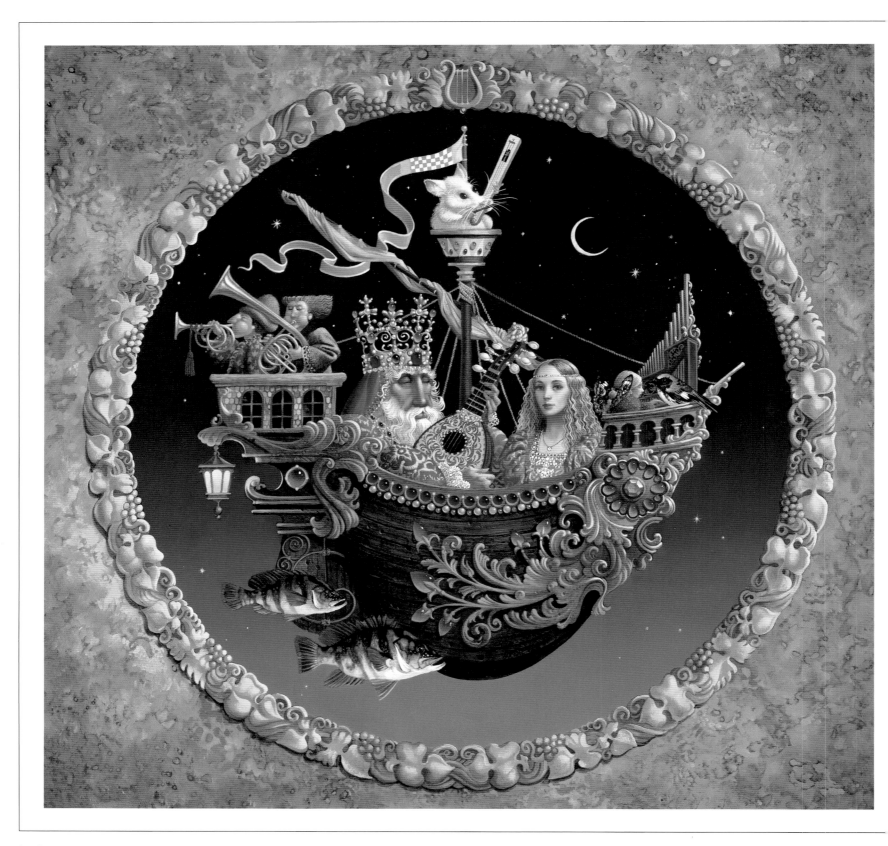

The Royal Music Barque

Musicians have a wonderful look when they play, and I wanted a boat that would complement a serenade. This is a kind of Fabergé boat: beautiful, delicate, full of ornate details and hung with gemstones.

Serenade for an Orange Cat

Why not?

THE JOURNEY IS MORE PLEASANT WHEN NO ONE IS SHOUTING

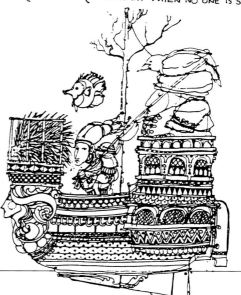

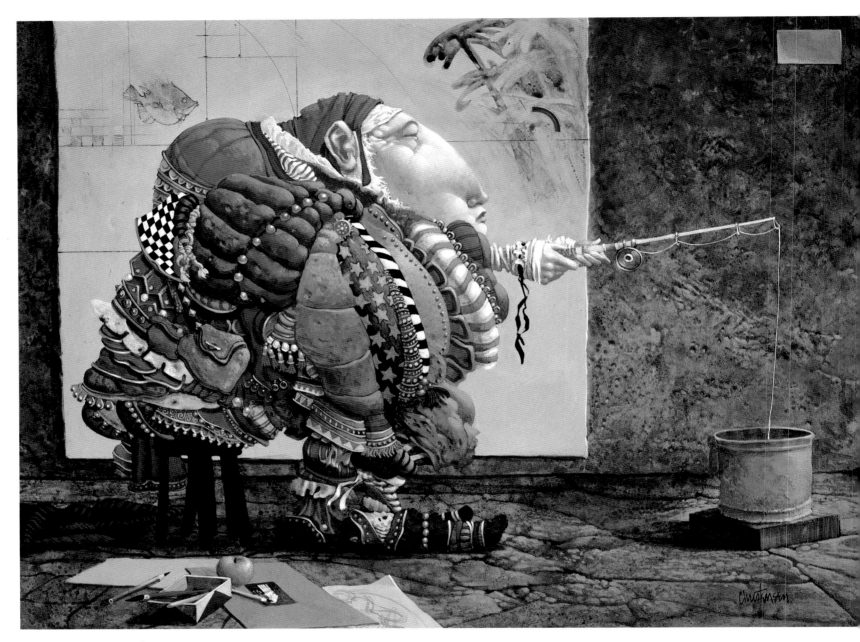

Fishing

At the 1987 BYU Faculty Art Show, I poked a little fun at myself
and my colleagues, and at the human tendency to return to the
same fishing grounds again and again. The green apple, striped
cloth and rainbow are references to my colleagues. And, of course,
there's my ubiquitous fish—which I sometimes find myself
planning into a painting just because it's expected of me.

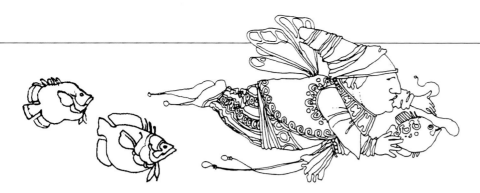

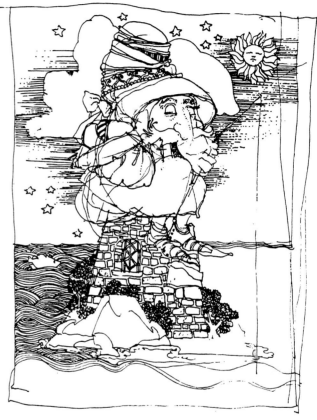

Blue Fish

I called this miniature painting "Blue Fish" because, well, there's a blue fish in it. I don't have a story for the image, but I'd be happy if someone brought his or her own imagination to the painting and came up with a good fish story.

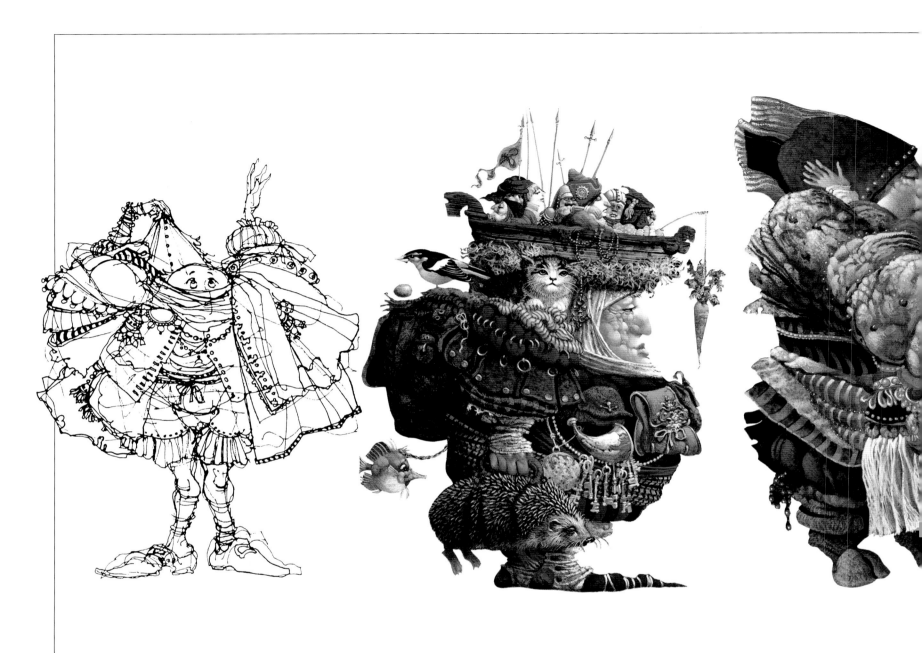

·3·
On Watch:
Common Muse & Personal Views

·3· On Watch: Common Muse & Personal Views

Many of my paintings evolve for me, both in terms of meaning and image, during the painting process. I think this is because active imagination is much more than the conscious, purposeful mixing of cards from one's card file. In keeping the everyday, awake part of the mind busy observing and absorbing new stuff for the card file, the subconscious section of memory storage begins mixing groups of cards all on its own. This means there can be almost as much surprise for me as for the viewer. There's a continual feeling of discovery about it, as if my hand, eyes and a quiet part of the mind work together, and my conscious, analytical mind has to ponder for a while to catch up.

I think this "othermind" creates another bridge between myself and the viewer. Apparently, we all know more than we know that we know, and whether we call it spirit or psyche or intuition, it looks as if we share some of it. Often, I begin with an idea I find interesting to paint, but still the concept must evolve. At some point, the painting will say—to me as well as the viewer—"Hey, look at this. This is us."

This doesn't mean paintings happen by chance. The way it feels to me is that the conscious mind, whose driving force is analysis and logic, rules the design. But the "othermind" distills the concepts, visions, ideas and memories in the imagination's card file. For instance, I spent all those hours poring over books about the Northern Renaissance painter Jan van Eyck. The stuff in the card file is there for me to access and to reinterpret in my own way.

Active imagination synthesizes groups of seemingly disparate things and ideas. For example, I love shadow boxes. They're small framed spaces, maybe four or five inches deep, with a painting at the back. A sense of depth comes from the shadow created by the box itself. I can see that in my work. I like working with a shallow depth of field and a confined space: a shadow box.

I'm also intrigued with the illusions created by movie sets. They look very real, but as you walk around them you can see what goes into creating the illusion. That also influenced my painting. I don't create a fully realized imaginary world. I make a little pool of illusion, a moment in space and time.

Like sets and shadow boxes, morality plays are small and contained. Made popular by the Church

"You cannot trust your eyes, if your imagination is out of focus."
—Mark Twain

in the 15th and 16th centuries, these little religious dramas used human actors to personify abstract qualities, such as Truth, Vanity or Death. Such allegorical performances were used to teach Church doctrine and show the consequences of right and wrong actions.

I see the synthesis of shadow boxes, movie sets and morality plays in quite a few of my paintings. One painting, "Visitation" (pp. 92-93), shows an angel and an ornately costumed character. The angel says, "*Mortua sum*," the Latin meaning "I am dead." Obviously, we are in the presence of something extraordinary. Yet the well-dressed person responds to this otherworldly personage with "How do you like my new clothes?"

On the surface, this exchange is comic. These guys aren't just speaking at cross purposes, they're on whole different planets. But it's also sad. Suppose you meet an angel and you never notice, because you're thinking about your new haircut? In the course of our lives, how many miracles do we miss because we're lost in preoccupation?

Using humor to tell a larger truth is an old art, personified by the figure of the wise fool. In medieval times, the king's fool was outside the courtly arena. Unlike the nobles, who were constrained to accept the king's pronouncements, the fool could caper, shout and make up lewd poetry, but mostly he could say the bald truth to the king. He provided the king with a *memento mori*, which means "remember that you must die." The fool's real task was to keep the king from becoming too identified with his royalty.

"Visitation" is also a *memento mori*. The well-dressed character gingerly holds a pear. He has bitten into it and found it's not very fresh. In fact, it's probably kind of squishy, but he's been eating it anyway. The decaying pear is a symbol for this character's mortality. Imagine if he could let go of his social mask and turn to see the angel.

I'm always on the lookout for angels, but I'm not as good at attending to earth-bound tasks. There was a point in my life a few years ago when I was feeling overused, underappreciated and stuck on the treadmill where everyone was taking and no one was giving. As a way of working through those feelings, I painted "The Burden of the Responsible

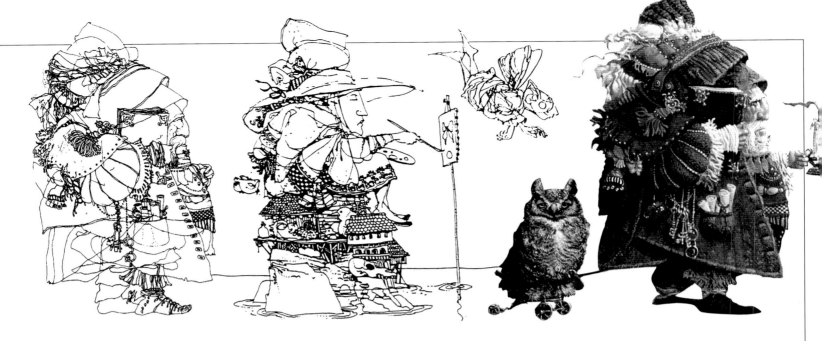

Man" (p. 80). I loaded that image with responsibilities, burdens and worries. People, pets and possessions weigh him down.

When I finished the painting and really looked at it, I realized that I wasn't painting someone whose life was unfairly burdened; I was actually looking at my own feelings of self-pity, my own brand of martyr complex. The little light went on upstairs. It made me stop and ask myself, do I want to run away from home or give away my kids? Of course not. I chose nearly every facet of this fairly complicated life of mine, and the burdens are a natural part of the life I want to live.

The most surprising thing to me was that this painting, which I thought I had painted from an entirely personal viewpoint, turned out to be one that a great many people immediately laughed at and said, "*Ohhh, yeah.* That could be me. I've been there." Apparently my feelings were not as unique as I had thought.

After that, people naturally said, "Well, what about the burdens of the responsible woman?" That turned out to be very different, because I wasn't painting from an internal personal view. One day I sat sketching, trying to get an image of a responsible woman's burdens. My wife, Carole, hurried into the studio, car keys in hand. "Wait a minute," I called to her. "I need you to tell me in what ways you're burdened." She gave me one of those looks and said, "James, I have to take Emily to music lessons and Peter to tennis practice, and drop Sarianne off at gymnastics and then I've got to do the shopping and run some errands before dinner. I don't have *time* to be burdened right now."

I love my wife and I think she does a great job. And that's the kind of off-the-cuff answer she sometimes gives me that we laugh about later, recognizing its truth as well as its humor.

"The Responsible Woman" (p. 83) grew and evolved as I worked. She became not a frumpy little downtrodden person, but someone who has all the same work, home, family and creative pursuits that the "Responsible Man" has, but who is also able to keep romance alive in the world. Responsible women shoulder all their encumbrances

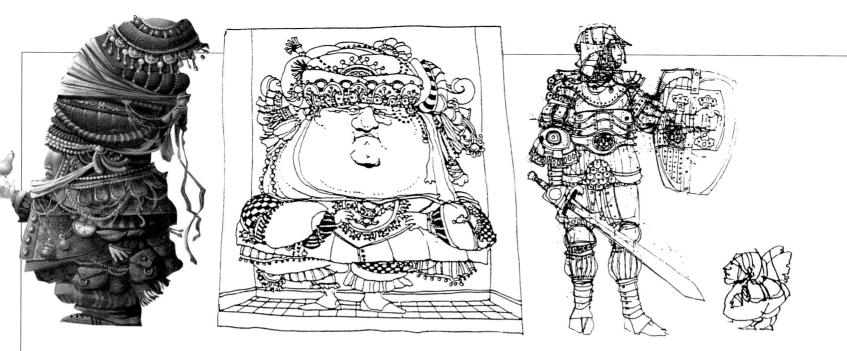

and they can still fly (albeit with a lot of neck strain from carrying all that stuff). Somehow they manage to hold aloft the candle whose light guides the family. This painting is a tribute, a little romanticized perhaps. But it's not all fun. There's also a little chip out of one lens of the rose-colored glasses. "The Responsible Woman" is getting through: on some days she's effortlessly pulling all the rabbits out of the hat, but on others she's hanging on by just the skin of her teeth.

When asked to talk about my art, I often find it hard to convey how a painting unfolds for me. I've had time by then to think about what it means, to bring to the image what I've learned from history, literature, art study and my spiritual training. I start out each time with my love of beauty and shape and patterns, and the idea of an image in which to use them. After that, the allegory, symbolism and multiple layers of meaning are part of my process of discovery, not just about painting, but about my place in the world.

There's always the question in my mind, "Will people understand this?" When I painted "Lawrence Pretended Not to Notice That a Bear Had Become Attached to His Coattail" (p. 91), I wondered if people would see just the funniness of the image, the weird juxtaposition, and then walk away. But everywhere I've shown this work, people smile and shake their heads at each other and say, "I've done that; have you done that?" I never had to say a word about ignoring one's problems.

That leap between mind and mind is a continual surprise and pleasure for me; communication between my art and my audience is necessary. But isolation and solitude are also indispensible. In 1992, I painted "Artist's Island" (p. 98). On the island are real things from my studio, things I like to look at and paint. In the image, the artist sits quietly, painting away, finding out what life and the artwork are all about as he goes. What you can't see is that on the other side of the island a small boat is moored, waiting for the artist to finish what he's painting, waiting to take him back to home, family and his community, who will see and share in the pleasure he takes in his work.

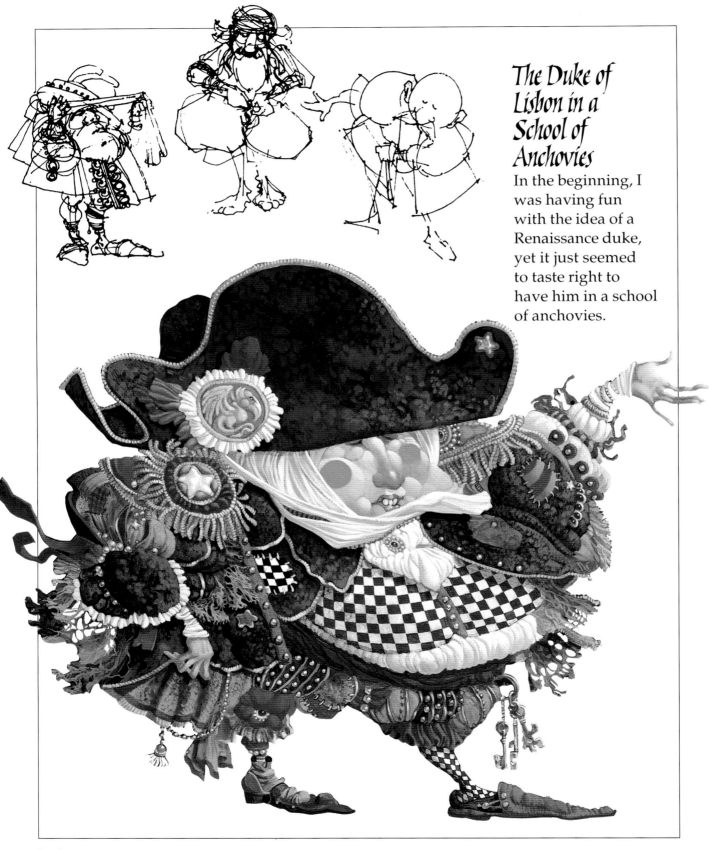

The Duke of Lisbon in a School of Anchovies

In the beginning, I was having fun with the idea of a Renaissance duke, yet it just seemed to taste right to have him in a school of anchovies.

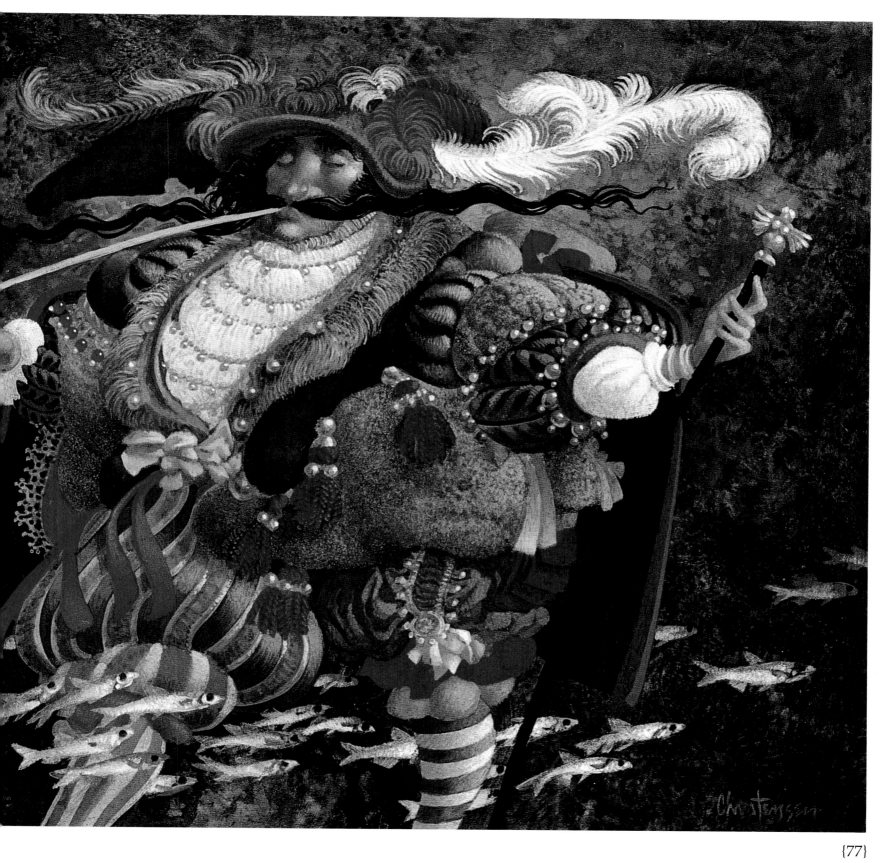

Actors, Aristocrats & Bureaucrats

The costumes are vaguely Elizabethan—bedecked, bedizened and bejeweled until the characters seem nearly immobilized by their clothing. The idea is that pride and pretense, vanity and self-importance are assumed in layers of decoration.

"I love costume," says Christensen. "I love the idea of clothing, layers, gold thread and glitz. But not contemporary glitz. I lean upon the Elizabethan period, where characters are dressed to symbolize their importance. The more aristocratic or bureaucratic a person is, the more stuff he has on."

The glitz and glitter are visual cues to the characters. Like actors' costumes, their clothing reveals their place, their role in the play.

"I have a great affinity for actors because they're doing what I'm doing: creating a world of illusion. My little characters are living a part; they're on a stage with their own reality, and they're trying to communicate things with us."

Three Scientists Debating the Aerodynamic Capabilities of the Dynastes Beetle

The beetle flies for two miles at a stretch, but these self-important egos are debating it "scientifically." You may notice that their feet don't match up and it's very hard to tell where one leaves off and another begins. They have, in effect, lost their personal identities in their quest for self-importance.

A Small Plaice

There are a lot of galleries around the country that do miniature shows, offering original art for small places. I couldn't resist the fun of painting a small plaice. Since I love shadow boxes, which are typically rather small places, I put my small plaice in a *trompe l'oeil* shadow box.

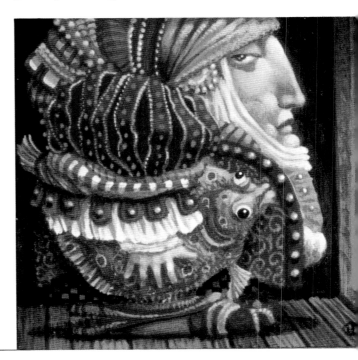

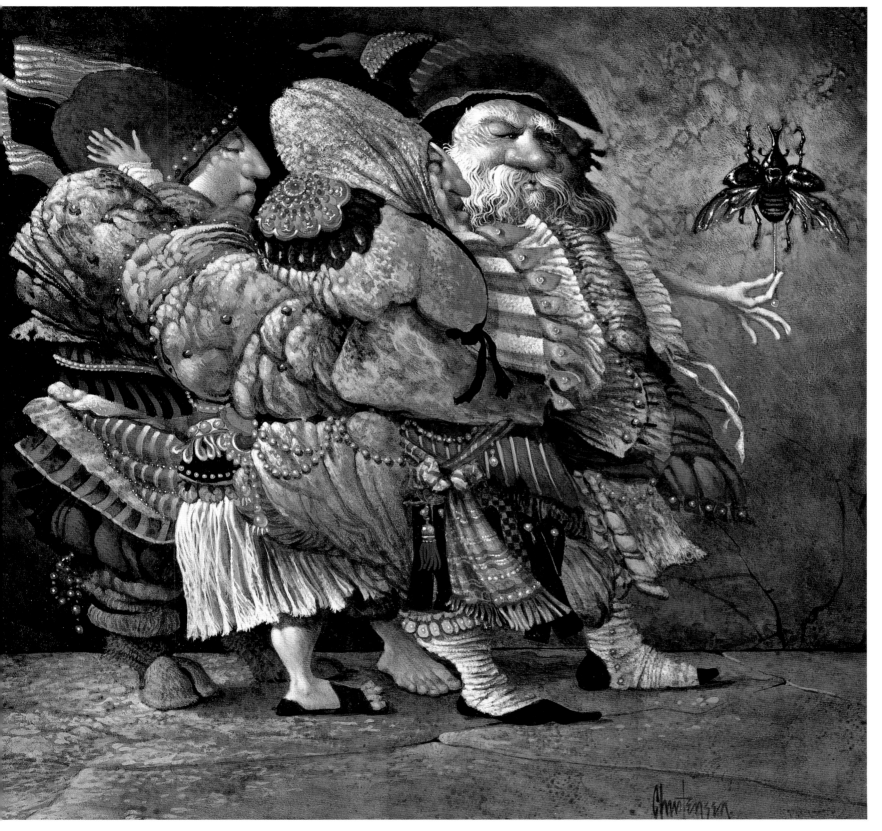

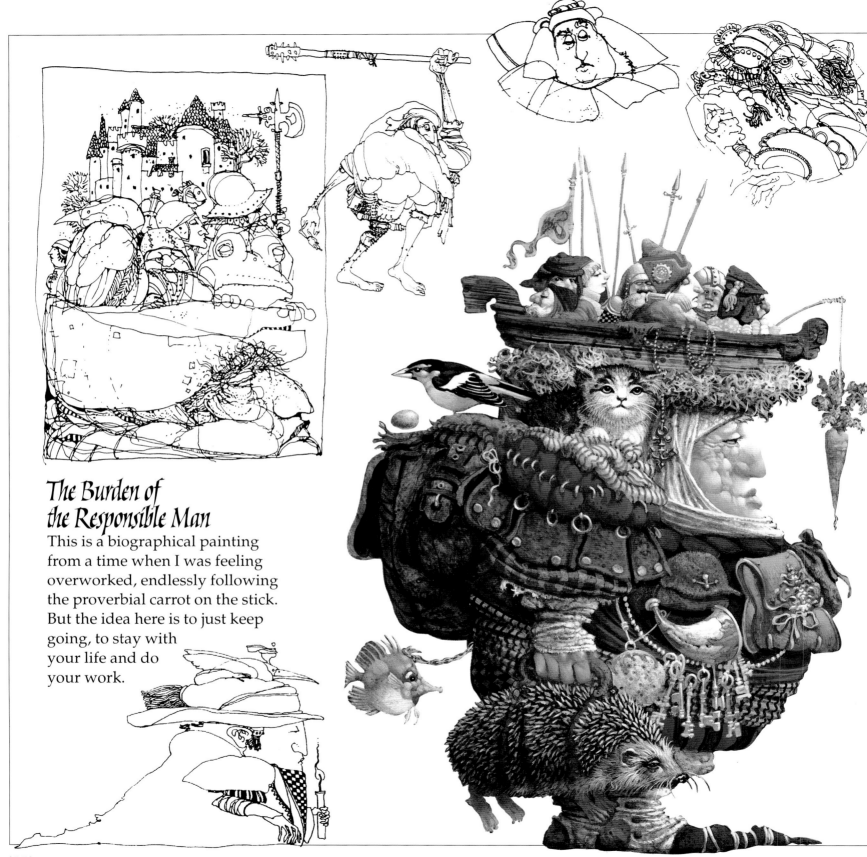

The Burden of the Responsible Man

This is a biographical painting from a time when I was feeling overworked, endlessly following the proverbial carrot on the stick. But the idea here is to just keep going, to stay with your life and do your work.

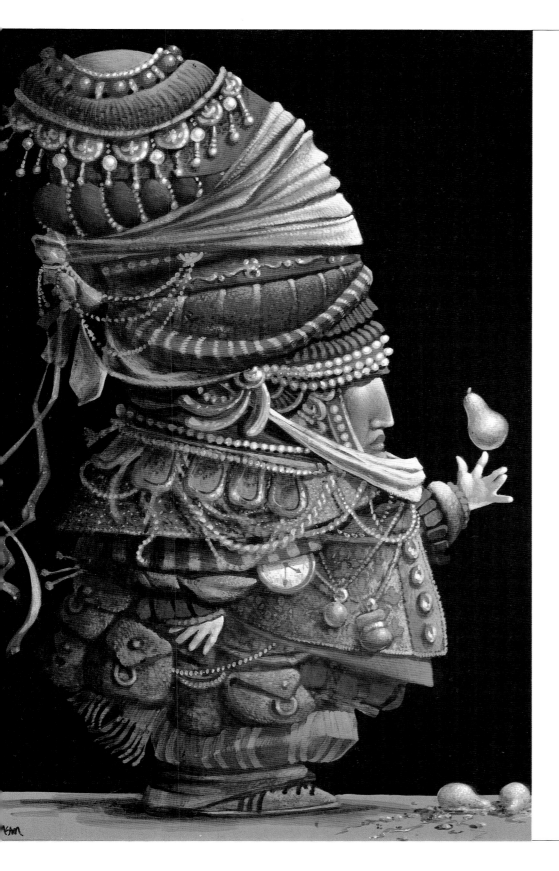

The Pear Balancer

This is one of my early experiments with little, over-dressed characters. The layered outfits symbolize the personas we build to protect our egos. This painting came out of the rigamarole I went through to get a parking permit while teaching art on a military base. Nearly immobilized by his clothing, this character can never be very good at his job, so he uses correctness and strict adherence to rules to give him a feeling of purpose. This guy is a bit of a rebel, though: the Adidas aren't regulation footgear for pear balancers.

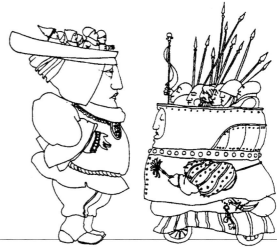

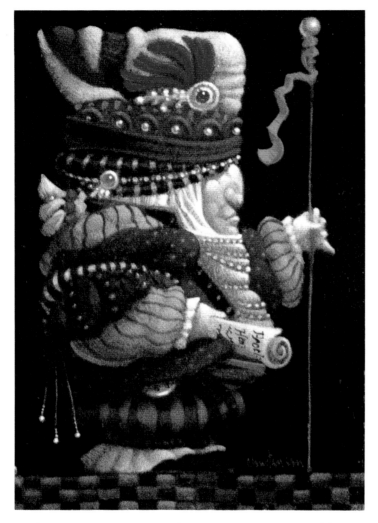

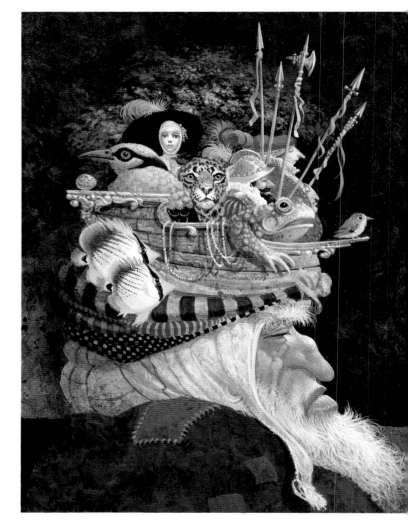

Life-Size Portrait of a Very Minor Official

I have an ongoing battle with the rigidity of bureaucracy. This is an officious little minor dignitary. If we use hieratic scaling—that is, the most important person in an image is the largest—then this tiny little portrait is life-sized.

Old Man With a Lot on His Mind

This was not inspired by workaholics. After listening to the life stories related by old people in my church, I realized that they were each a universe of tales and adventures, amazing stories that don't show from the outside.

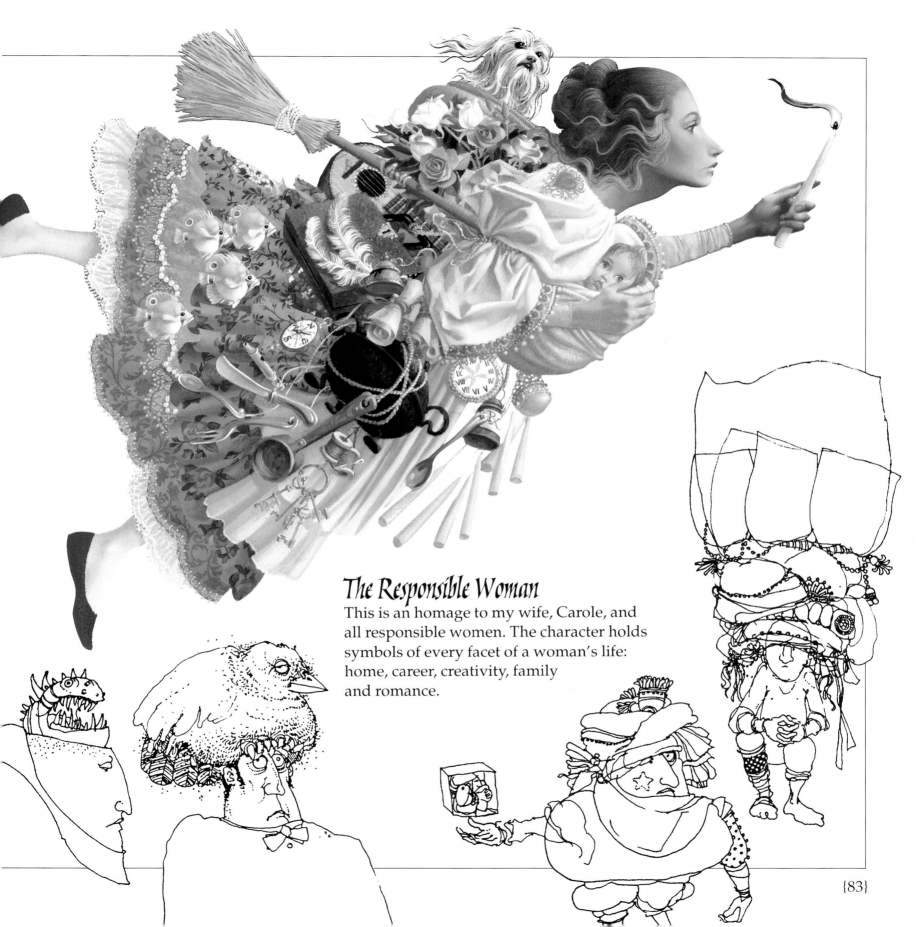

The Responsible Woman

This is an homage to my wife, Carole, and all responsible women. The character holds symbols of every facet of a woman's life: home, career, creativity, family and romance.

KING

NOBLE

KNIGHT

FREMAN

VILLEIN

SERF

Tweedledum and Tweedledee

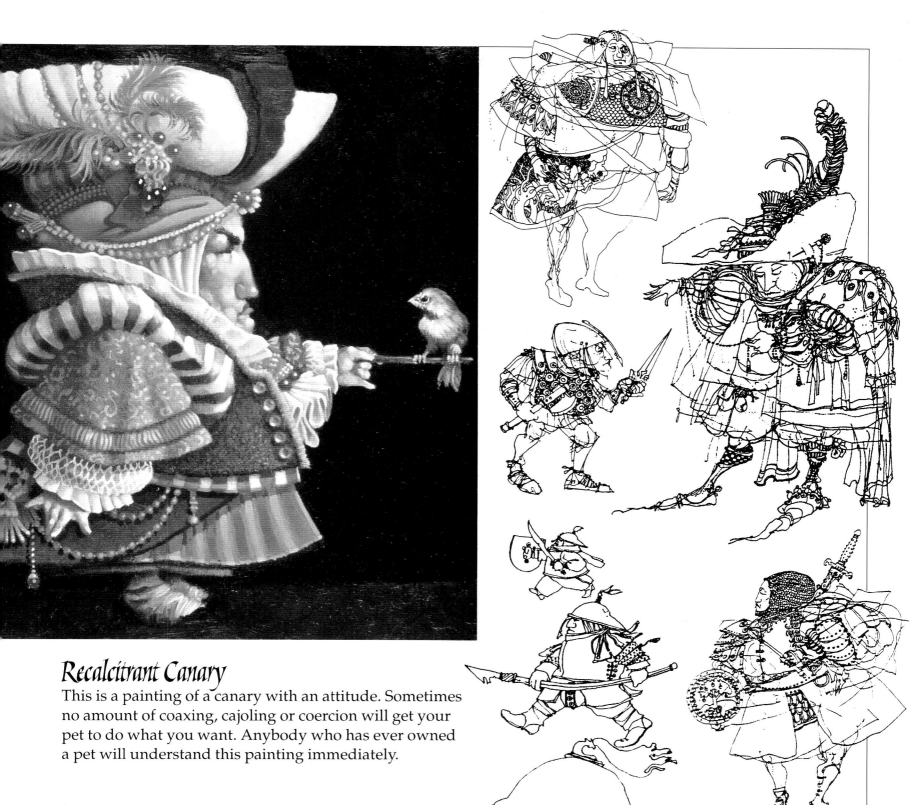

Recalcitrant Canary

This is a painting of a canary with an attitude. Sometimes no amount of coaxing, cajoling or coercion will get your pet to do what you want. Anybody who has ever owned a pet will understand this painting immediately.

Sometimes the Spirit Touches Us Through Our Weaknesses

The Latin *post nubila phoebus*, translates as "after clouds, sun." It's something like our saying that every cloud has a silver lining. I think that we often grow through adversity. No one wants trials and ordeals, and yet, having passed through the darkness, we often experience great spiritual illumination and feel the most connected with our maker.

Yet Another Fish Act

I do a lot of little drawings and watercolor sketches around the idea of striking a pose. It's also an excuse to put some fun shapes together.

The Mirror, the Spirit & the Everyman

Sages and philosophers from Socrates on have recognized the value of introspection. Often the most personal is also the most universal. And just as a reflection looks back from the mirror, there is in each of these images a character who looks back at anyone looking in.

That character is usually a hunchback. He is an Everyman. But he is also the wise fool, self-aware, recognizing himself amid countless scenes in the drama of life.

The hunchback has a timeless, cross-cultural history. From the flute-playing Anasazi god Kokopelli in North America, to the tragic French bellringer in Victor Hugo's tale, to the old superstition that it was good luck to touch his hump, the hunchback carries many themes and meanings.

In these images the hunchback's hump is not a medical deformity; it's stylized, a physical symbol of the burden all humans bear. It's a reminder that while every person has a weakness, it can be through those flaws that the spirit both touches and teaches.

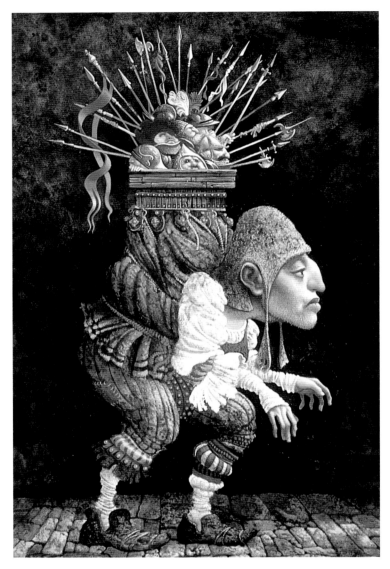

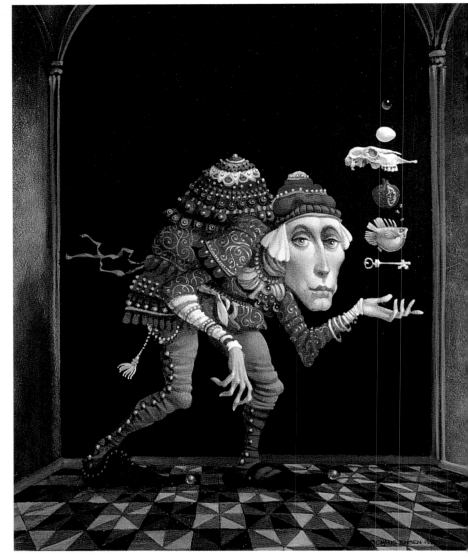

The Burden of the Common Man

A venture into the realm of politics. The soldiers and their weapons symbolize the weight of the defense budget weighing down the common man. And if you look at the path he's following, you'll see he's actually on a yellow brick road.

Seven Symbols

Though called "Seven Symbols," only six are stacked over the hunchback's outstretched hand. The seventh symbol is, in my own personal lexicon, the hunchback himself.

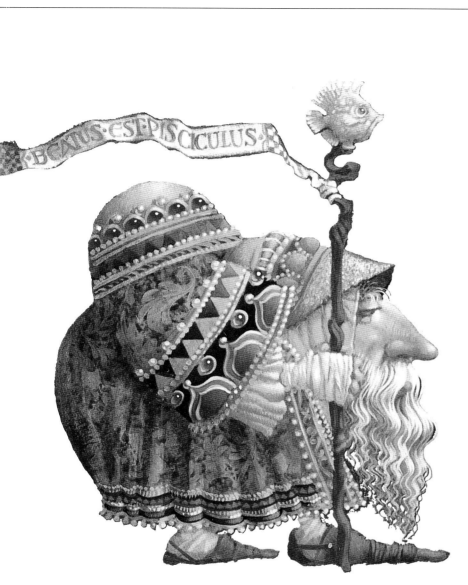

Old Fish Wizard

(Detail) Beatus est pisciculus is the
Latin for "Blessed is the little fish."
It serves both as a benediction to the
little magical fish and as my prayer
of thanksgiving for the privilege
of being an artist.

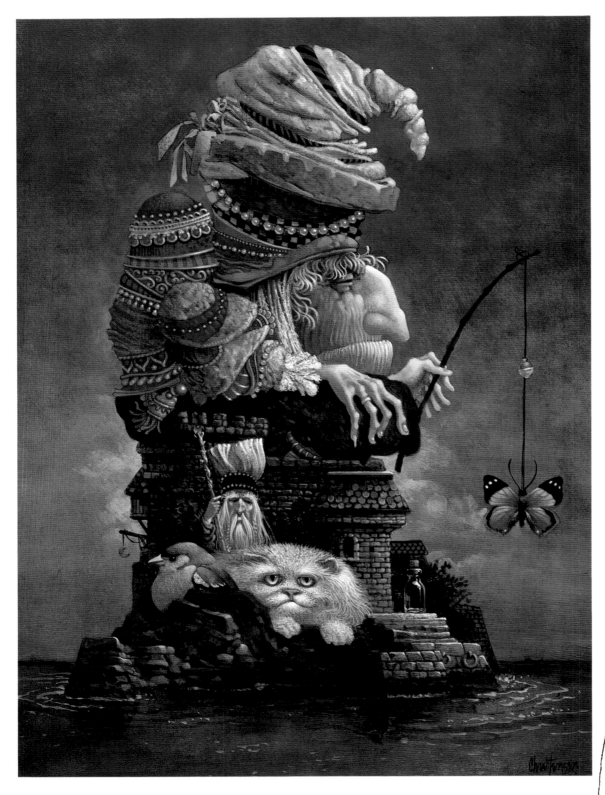

Butterfly Fisherman

When I was growing up in California, my grandfather and I would go down to Santa Monica, where we'd see these wonderful old men sitting on the pier, fishing. They hardly moved and seemed content just to sit in the sun. Obviously the activity was more important than the product, because if you looked, sometimes there wasn't even any bait on their hooks.

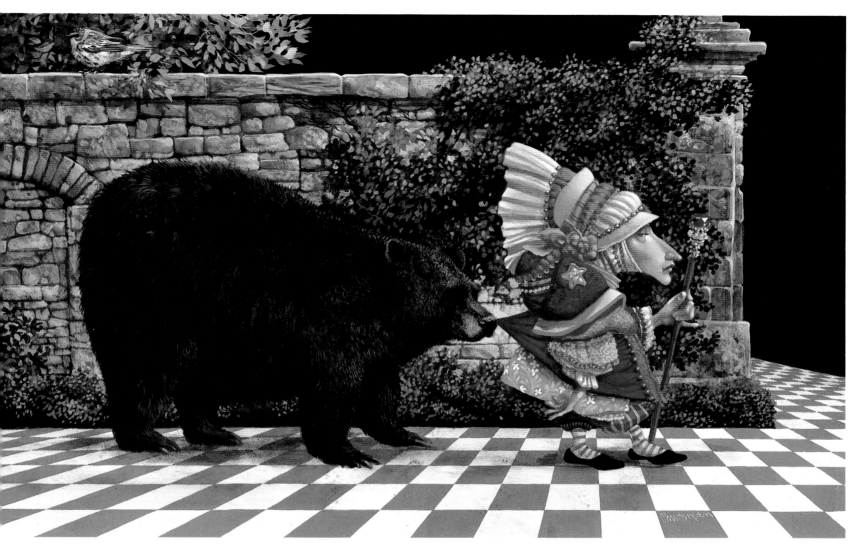

Lawrence Pretended Not to Notice That a Bear Had Become Attached to His Coattail

I think everyone occasionally procrastinates about dealing with problems in hope that they'll fade away. But that's not the only interpretation for this image. I gave a short talk about trusting your own ideas to a group of third-graders. When I asked them what "Lawrence…" meant, a little girl said, "You shouldn't take pets home without asking your mother."

Winged Words

Winged words, said Homer, are successful communications, thoughts that reach their mark.

Certain paintings found throughout the book (some with a gray background and checkerboard) are known as the Winged Words group. These arose out of a visit the artist made to the monastery of San Marco in Florence, Italy. There, the 15th-century artist Fra Angelico painted murals on the walls of the monks' cells. Fra Angelico painted ribbon-like banners of speech issuing from the characters' mouths so that the images of saints, martyrs and holy people are combined with explanatory dialogue.

The backgrounds in the Winged Words paintings are reminiscent of the stone monastery walls and most also have dialogue banners in Latin (translations appear in the captions). The aim is to emphasize that there is more to a painting than design, the portrayal of subjects and visual pleasure. Art is a method of communication, and a painting's inner meaning is the way the mind of the artist may connect with the imagination of the viewer.

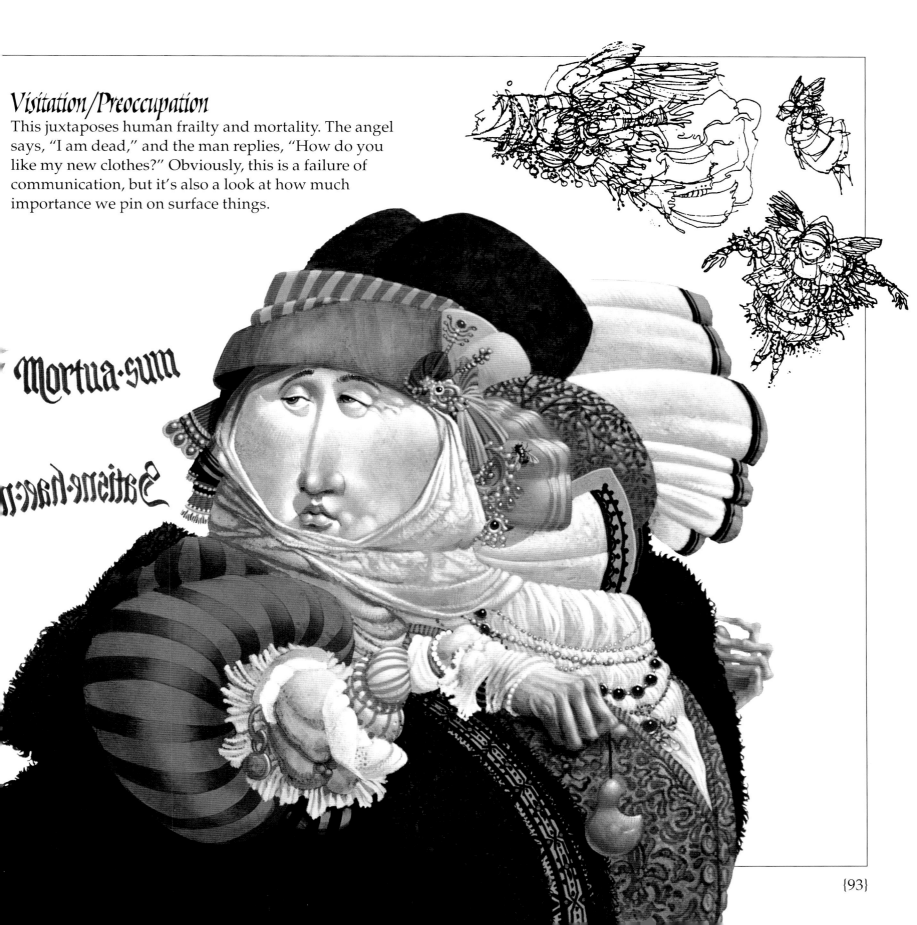

Visitation/Preoccupation

This juxtaposes human frailty and mortality. The angel says, "I am dead," and the man replies, "How do you like my new clothes?" Obviously, this is a failure of communication, but it's also a look at how much importance we pin on surface things.

Mortua·sum

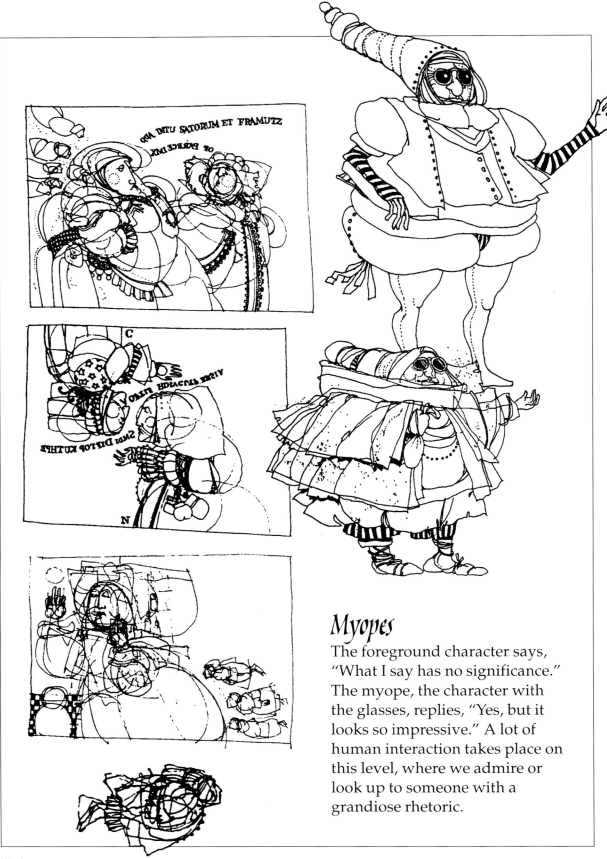

Myopes

The foreground character says, "What I say has no significance." The myope, the character with the glasses, replies, "Yes, but it looks so impressive." A lot of human interaction takes place on this level, where we admire or look up to someone with a grandiose rhetoric.

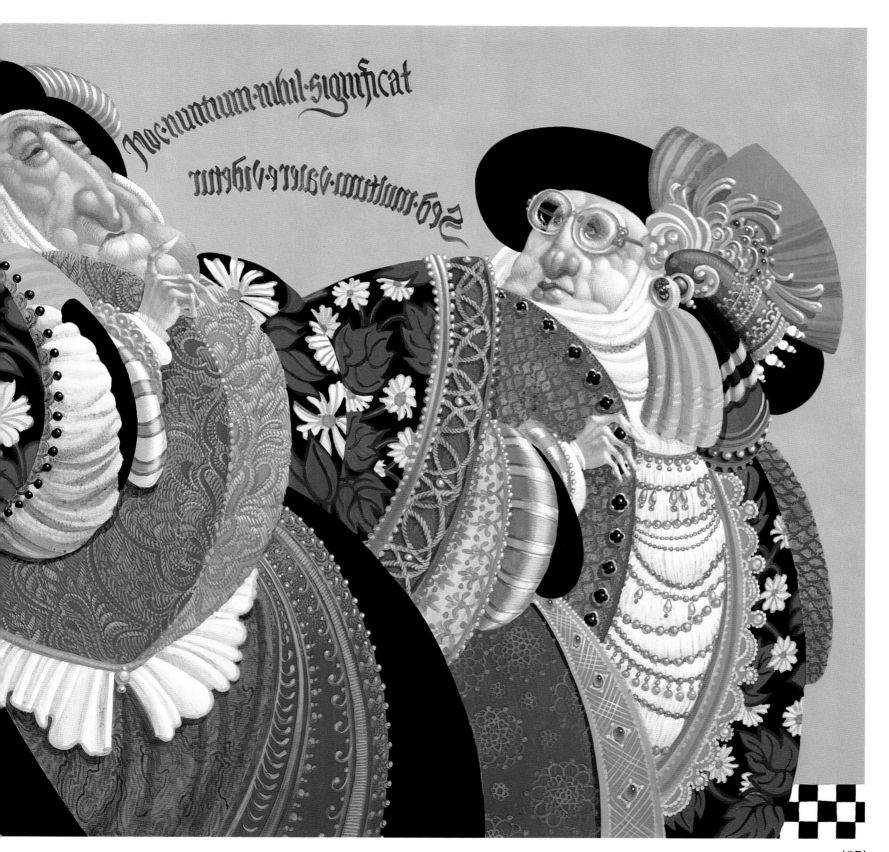

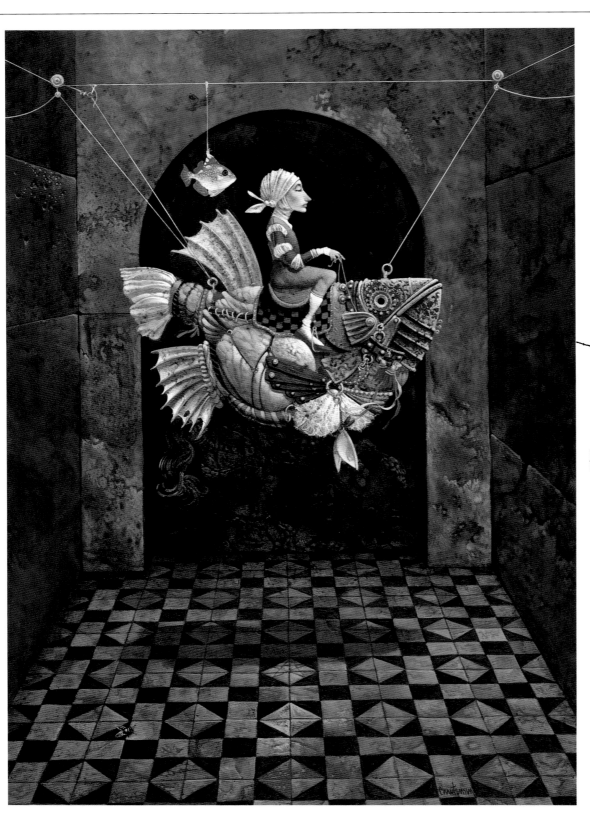

False Magic

A phony tries to pretend he can do magic, but the wires are obvious. The fly on the floor is a *trompe l'oeil* image; in other words, the fly, too, is a fake.

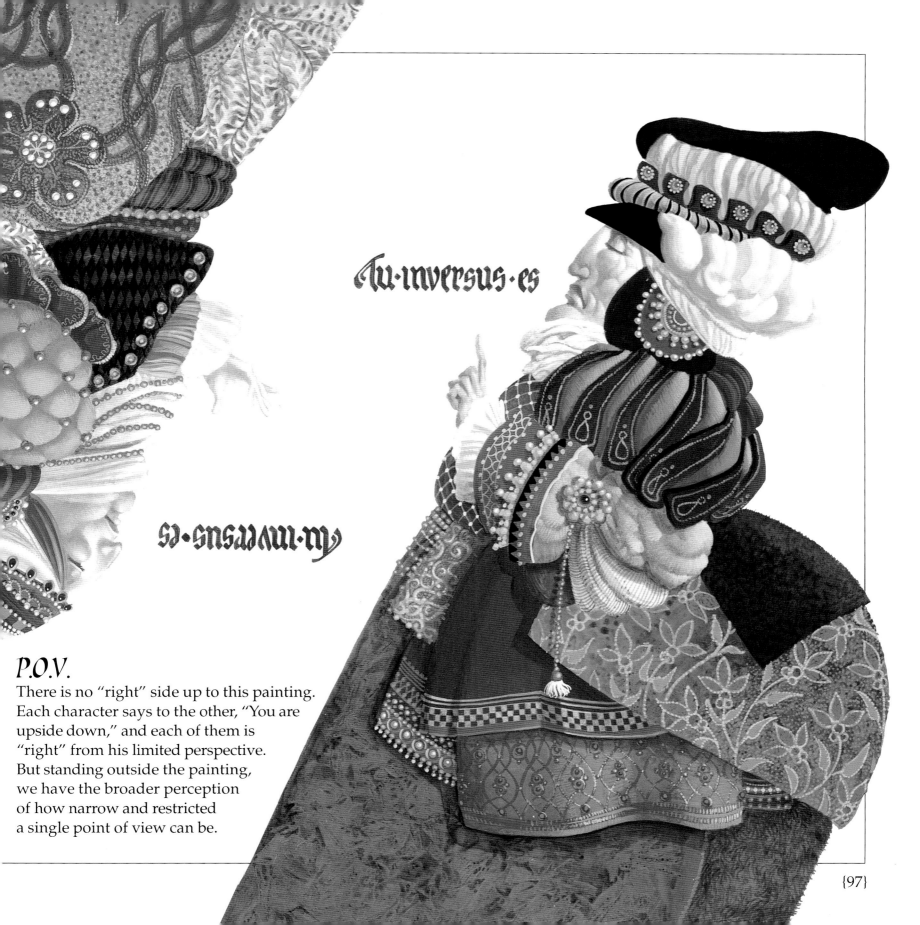

Tu·inversus·es

Tu·inversus·es

P.O.V.

There is no "right" side up to this painting.
Each character says to the other, "You are
upside down," and each of them is
"right" from his limited perspective.
But standing outside the painting,
we have the broader perception
of how narrow and restricted
a single point of view can be.

Artist's Island

This is a self-portrait, but in attitude rather than features. The objects around the character are things I like or have in my studio. The island represents the isolation necessary for an artist to focus on his art.

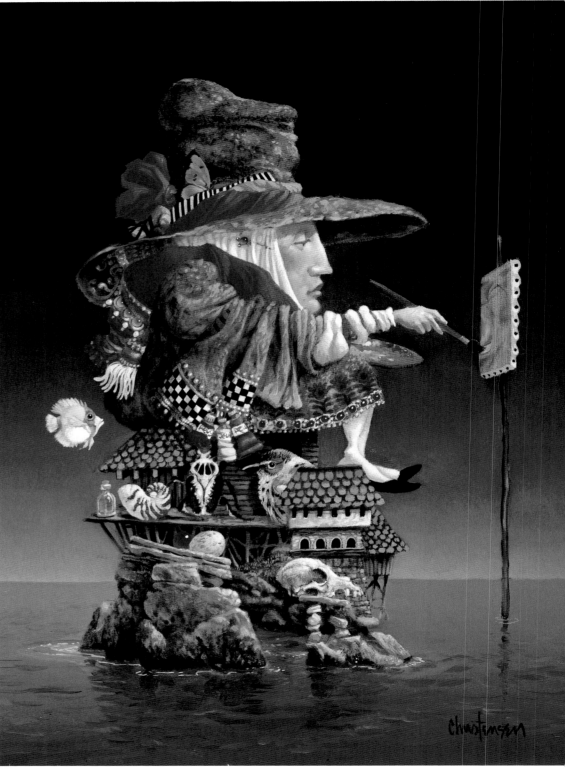

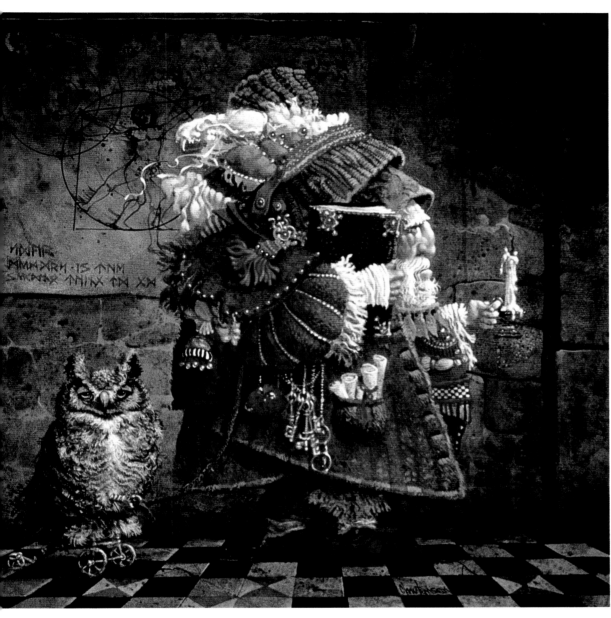

The Old Scholar

Every university has an old scholar or two, professors whose learning stopped years ago, here symbolized by the wormy apple and the snuffed-out candle. The tatty, stuffed owl on wheels, the Ptolemaic (earth-centered) solar system, and the Leonardian sketch that's all out of kilter symbolize wisdom that has become outdated or obsolete.

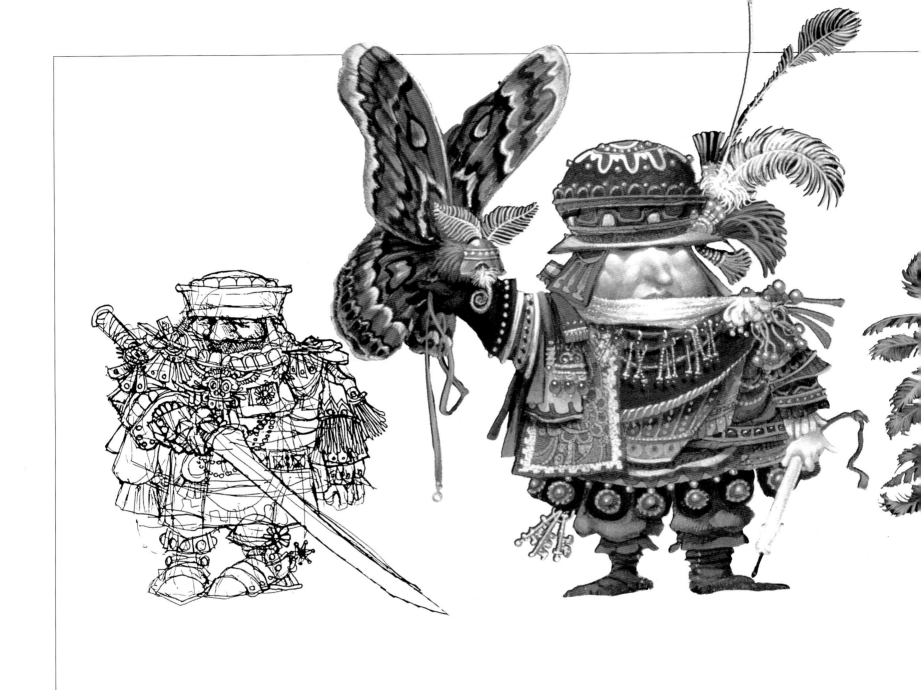

·4·
Lighter Fare:
Puns, Parodies & Alliterations

-4- Lighter Fare: Puns, Parodies & Alliterations

There are times when I paint an image for no reason other than the delight of a silly or absurd idea. I have been keeping sketchbooks for the past twenty years or so, a kind of visual diary, and this is often where I record some small quip or quote that makes me laugh. Often enough, these little sketchbook drawings are the impetus behind a painting. Other times, some little character will just seem to belong in a painting, not as the main focus, but almost as a theatrical aside, a pictorial one-liner.

Sometimes, after the work is done, I discover that there is a serious element inside all the fun, but that's not the driving force. I love the whimsical and nonsensical things in life, whether they appear to have any serious value or not.

Humor is a bright spark of illumination that connects the sender's mind with that of the receiver. It travels, perhaps not quite at the speed of light, but with an exuberant rapidity. Anyone who has ever watched a good comic perform for an audience understands the split-second reaction time between when the humorous message is sent and when the listeners catch the witticism. Humor connects us to each other, so the sudden, pleasurable understanding of something witty or whimsical seems to me an excellent vehicle for communication.

Several years ago, I did a painting called "The Bird Hunters" (p. 106). In the years since then, I've watched a wide variety of people look at the painting, read the title, look back at the painting, figure it out by mentally creating the scenario, and then smile or chuckle. Having to figure it out and being able to share it was part of the fun.

The neat thing is how fast everyone puts it together. I can usually count to about three between when the viewer reads the title and the chuckling starts. Generally, he or she then wants to watch someone else share the surprise, so a friend or family member will be called over. "Just take a look at this," the person will say to a companion, smiling (but not explaining), waiting to laugh again when the other person notices the hammers and makes the connection.

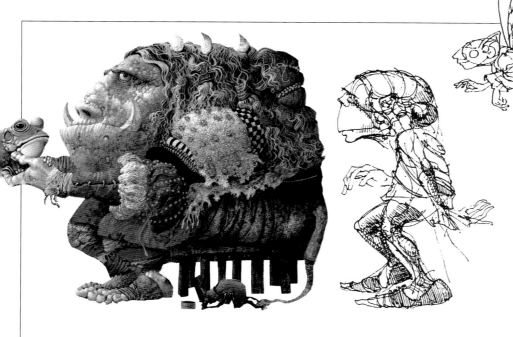

"If it is with outer seriousness, it must be with inner humor. If it is with outer humor, it must be with inner seriousness. Neither one alone without the other under it will do."
—Robert Frost

The nice thing about humor is not that something stays funny for you—humor itself is hard to sustain—but that it continues to be fun to share it with other people. The connection goes on and on. The idea becomes amusing again when you share it with someone else and see his or her reaction. I think humor loves company at least as much as misery does.

But merriment in artwork is suspect. There's an attitude that if there is humor in art, it robs the work of its substance. The easy solution for contemporary art is to create a facade of profundity by focusing on the negative, like the rape of the natural world, urban decay, and racial separation. It isn't that these are not serious problems, but that if they are not balanced within the art by humor, wit and the survival of goodness and beauty, the view cannot be other than one-sided. Such a Cyclopean view invites satire and mockery of the art. The more contemporary art strives to prove itself serious and valuable for its strident messages, the more people are inclined not to take it seriously or even to laugh or scoff.

I think that's because humans seem to know innately that life is a tragicomedy. Unrelenting pathos finally becomes blunted, and tragedy often comes in an absurd package. Suppose you hear that someone has been killed when a thirty-foot statue of a dancing pig falls over because a gopher has dug up one of its support wires. It's tragic, but it's also absurd, a kind of cosmic pratfall.

Despite humor's universal presence, I suspect some of us feel that dedication and a light heart are mutually exclusive. But I think we can take the study and the craft of art seriously, while understanding that humor in art has its place. It isn't just that it makes us feel better to laugh and that it lets us explore funny, unexpected juxtapositions, but that seeing only the sober stuff is a kind of blindness.

Humor communicates, and it does so with leaps and bounds that are pleasant and mentally invigorating. It also works because it allows us to play with the unexpected. Sometimes in my paintings

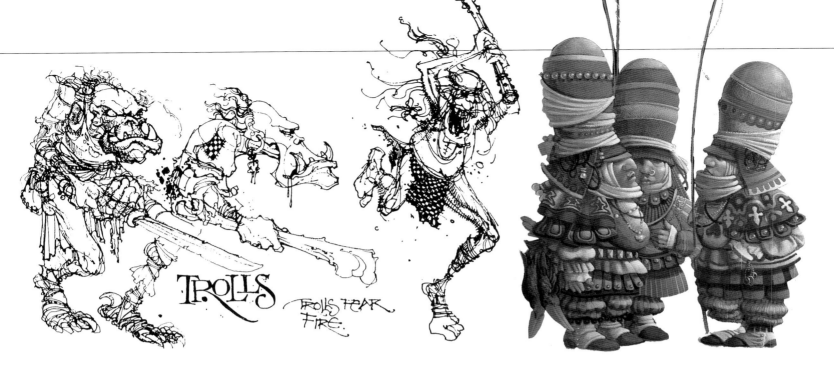

the surprise is obvious visual fun, like "Two Dowager Ogresses Having Tea" (p. 113), where two well-dressed dowagers sit drinking tea. That these "ladies" have large tusks in addition to neatly painted toe-talons and fingernails is an unexpected juxtaposition of physical traits. And, generally speaking, one does not take tea with a rat.

Sometimes the humor or surprise is more subtle. As in "The Bird Hunters," I've used the title to help create the humor in "Steward of the Hunt" (p. 107), but I think it takes a little longer to get the idea. You have to know something not just about falconers, but about moths as well.

In "Returning the Princess' Porcupine" (p. 112), however, the title prompts all sorts of questions. "What's going on? Why did the princess own a porcupine in the first place, how did she lose it, and how did it get so far from home? Why is the boat floating above a checkerboard?" It's as if you've been given one scene from a story and no one can tell you what the story is. You have to look at the painting and decide for yourself what meanings there are.

There's also a little bit of extra fun for people who know their Latin. The little banner off the stern of the boat says, "You lose it, we find it."

I've used both puns and plays on words as points of departure for paintings because I also have an interest in language itself, for its beauty and rhythm, as well as for the ambiguity that makes it so useful and flexible.

Several years ago, Carole and I and another couple, Sue Ann and Steve, were dining at a restaurant in Stratford-on-Avon. Sue Ann and I each ordered plaice, a type of flounder. When the orders came, the waiter put an order of plaice on the table between us, and Sue Ann asked politely, "Is this your plaice or mine?" Immediately, the wheels began to turn, and I drew the very first sketch right there on a napkin. When I painted "Your Plaice or Mine" (p. 111), what started as a play on the word "plaice" became an observation on the rigors of the dating game.

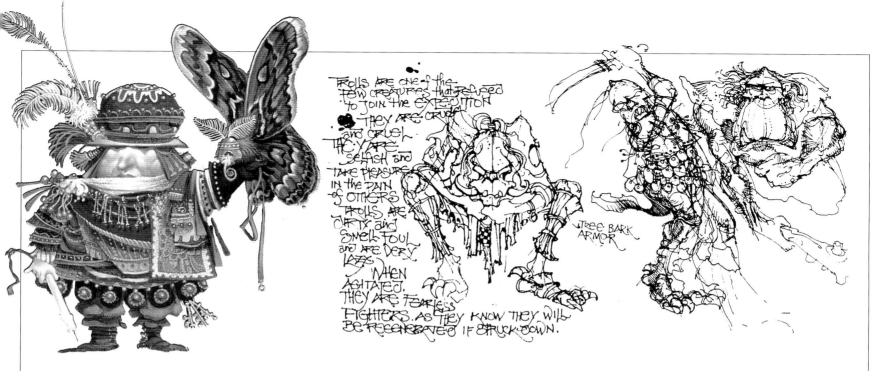

TROLLS ARE ONE OF THE FEW CREATURES THAT REFUSED TO JOIN THE EXECUTION. THEY ARE CRUEL AND CRUEL. THEY ARE SELFISH AND TAKE PLEASURE IN THE PAIN OF OTHERS. TROLLS ARE DIRTY AND SMELL FOUL AND ARE VERY LAZY. WHEN AGITATED, THEY ARE FEARLESS FIGHTERS, AS THEY KNOW THEY WILL BE REGENERATED IF STRUCK DOWN.

TREE BARK ARMOR

The addendum to this tale is that when a gallery advertised the painting in a magazine, one of the editors from the publication called us and said, "Hey, there was a typo in your ad—there was an 'i' in place—but don't worry, we fixed it."

Sometimes, the play on words grows out of a painting. While we were living in Madrid, I began working on an image of a man taking his pet shallot for a walk. When we returned to the States, I asked Carole to buy a shallot so I could finish the painting. "Can't you use a green onion?" she asked.

"No," I said, "That's a stupid pet. Nobody would have a green onion for a pet." Carole shopped for weeks. I think she even had regiments of her friends scouring surrounding counties for shallots. There were no shallots anywhere in Utah. I think they even checked parts of Nevada.

Finally one day, Carole came home triumphant and excited. "I've found what you wanted," she said and handed me a paper sack from the new grocery store. It was just a bunch of leeks.

"No, that's not right," I said, returning the sack. "Those are leeks, not shallots." Carole looked me in the eye, handed the leeks back and said, "James, finish the painting." So I painted "Man Taking a Leek on a Tiled Wall for a Walk" (p. 118). The play on words came after the fact.

When I incorporate humor into a painting, I have the pleasure of anticipating an audience who sees and understands the humor. Since I want to make that connection, I am as conscious of my drive for careful craftsmanship when the subject is humorous as when it's serious.

There seems to be an unspoken rule saying that if you're having fun, what you're doing is frivolous. It's that Protestant work ethic—if you're enjoying yourself, it's not work and it's not worth doing. I disagree. Humor balances out the gravity in life. It's an aid to healing in adversity and a tool for survival. I also think humor works a kind of medicine for the soul. Or maybe it's the lubricant that keeps life from chafing at our tender places.

The Bird Hunters

The thing that I think is the most fun is just to give the title of this painting and then count: one, two, three. That's when you get the laugh. It takes people a few seconds to put the title and those weird little hammer weapons together.

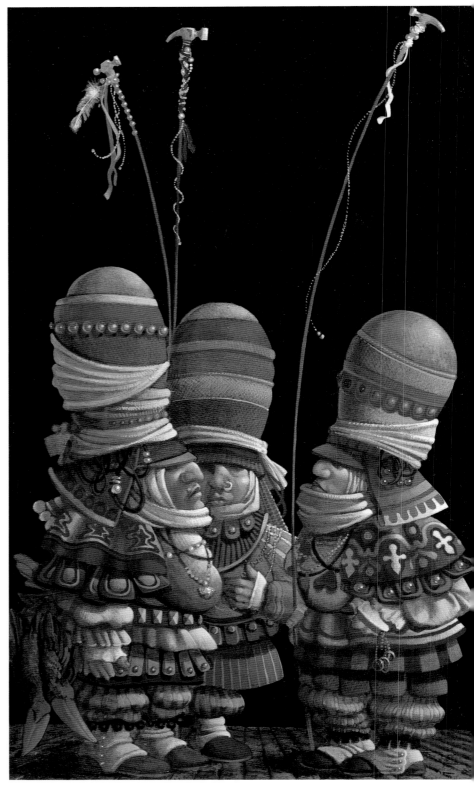

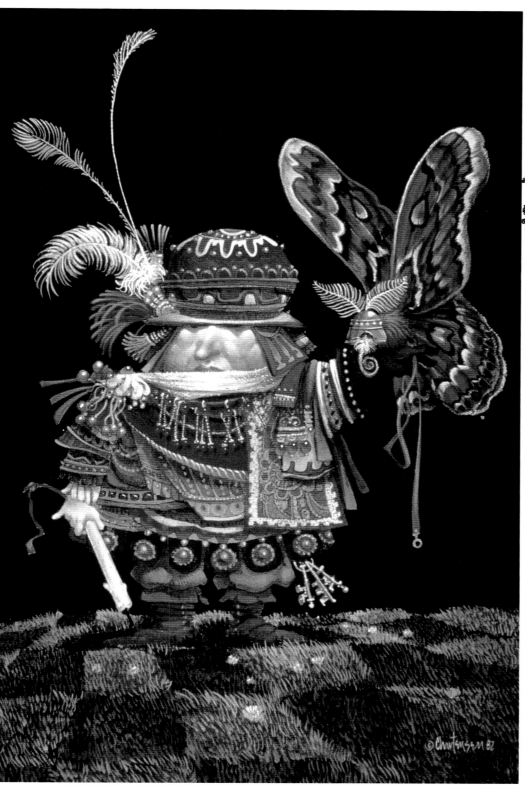

Steward of the Hunt

A bit of meat will coax a peregrine falcon home, but what would you use to tempt your moth?

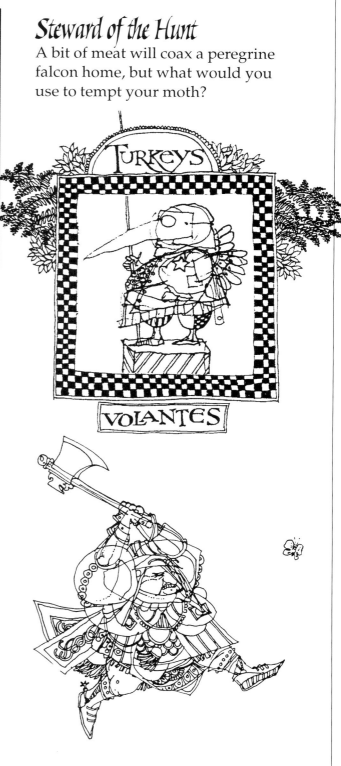

TURKEYS

VOLANTES

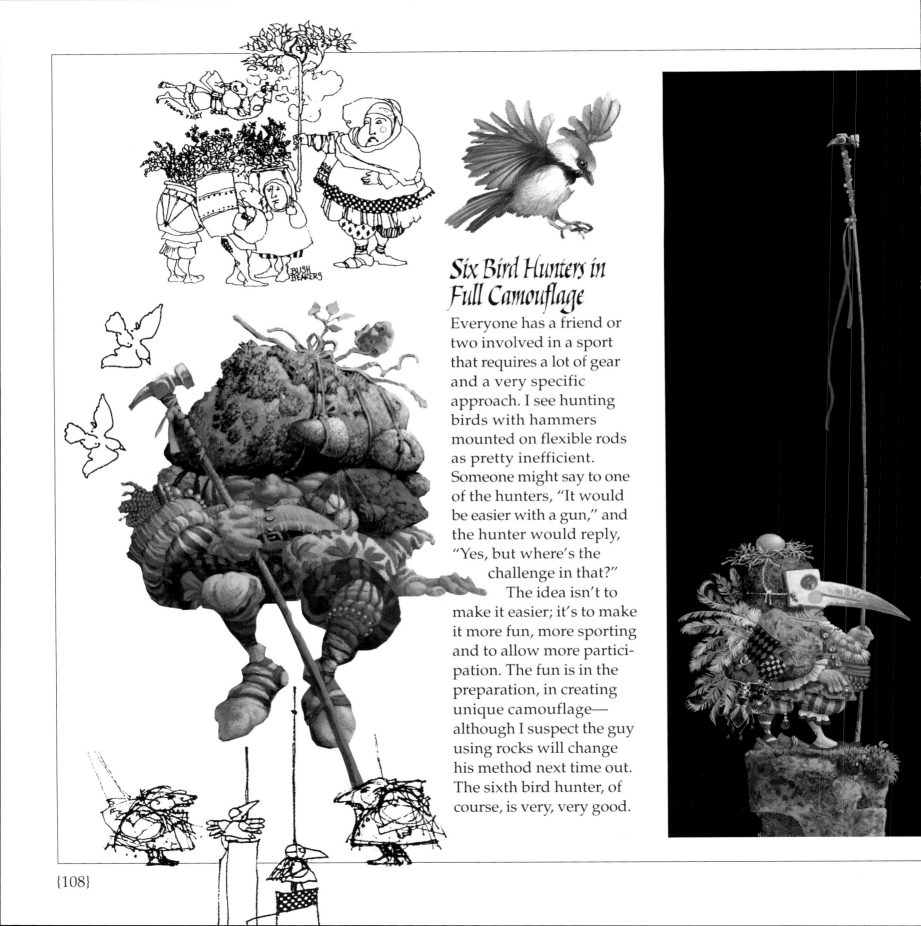

Six Bird Hunters in Full Camouflage

Everyone has a friend or two involved in a sport that requires a lot of gear and a very specific approach. I see hunting birds with hammers mounted on flexible rods as pretty inefficient. Someone might say to one of the hunters, "It would be easier with a gun," and the hunter would reply, "Yes, but where's the challenge in that?"

The idea isn't to make it easier; it's to make it more fun, more sporting and to allow more participation. The fun is in the preparation, in creating unique camouflage—although I suspect the guy using rocks will change his method next time out. The sixth bird hunter, of course, is very, very good.

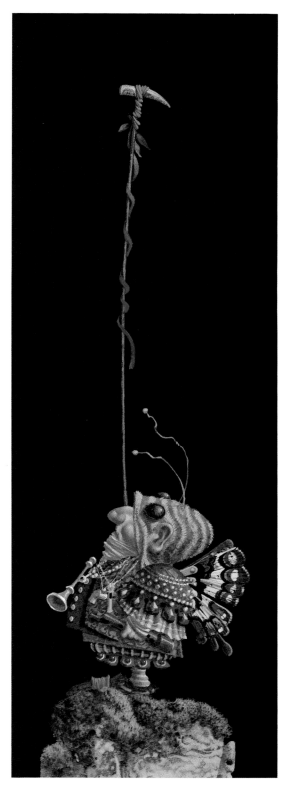

Your Plaice or Mine

(Right) This little would-be Casanova is waiting outside a fish store to use his carefully contrived pickup line. If you look at his watch, you can see it's the eleventh hour. The fun for me is wondering what her reply will be. Interestingly, a lot of people see her asking the question and being the aggressor.

Frog and Ogre

Sometimes you see a couple and you can't help but think, "It's great that they found each other."

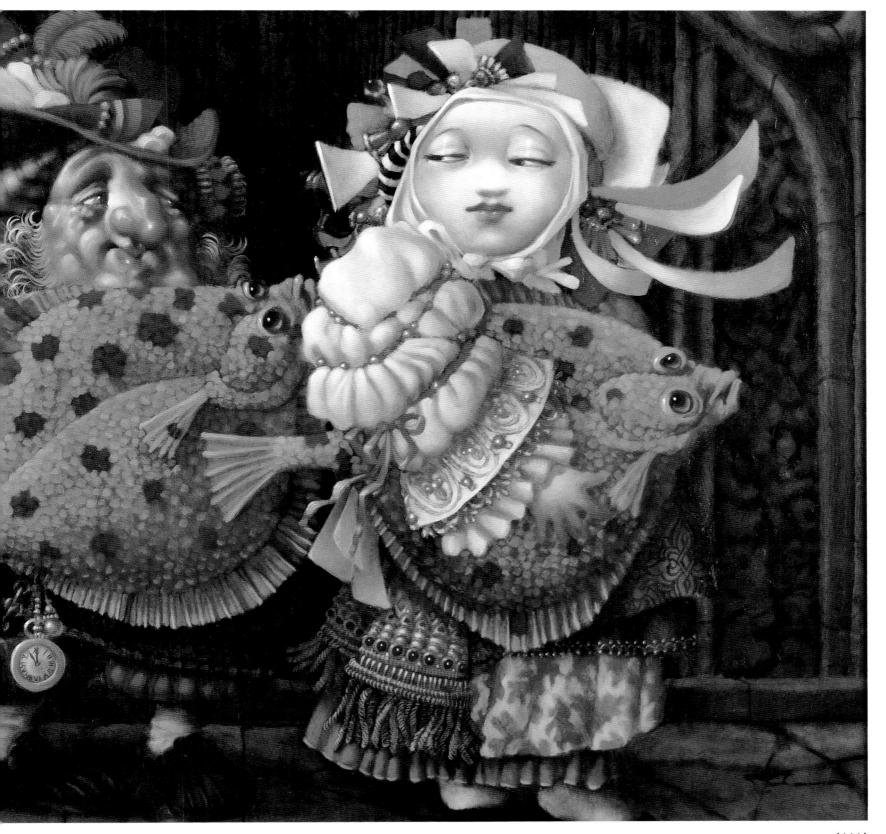

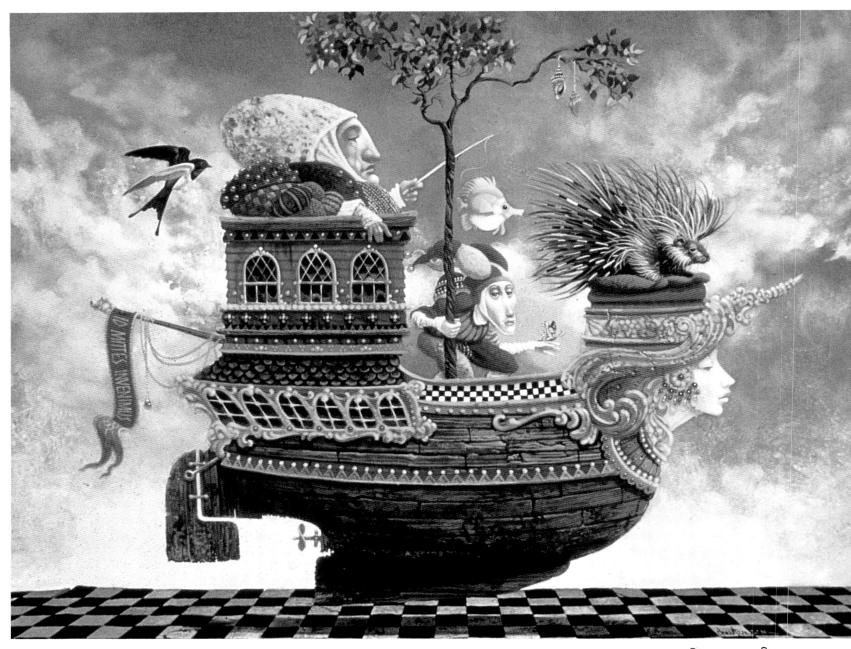

Returning the Princess' Porcupine

One day, I saw a porcupine in the wild chewing on something. When he heard me, he calmly looked around and sized me up. He knew he was more than a match for me—or pretty much anything but a tortoise with a hand grenade. He just went nonchalantly back to eating. So this painting is mostly for fun, and it's one of the first with a Latin inscription. It says, "You lose it, we find it."

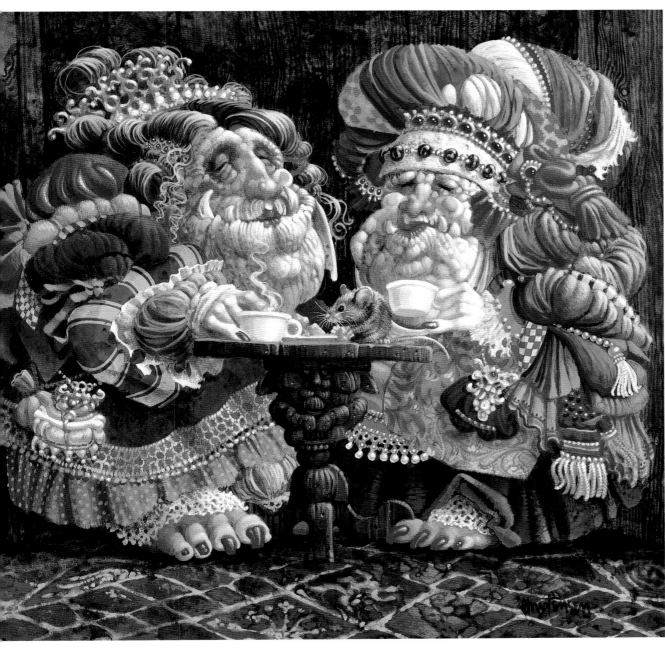

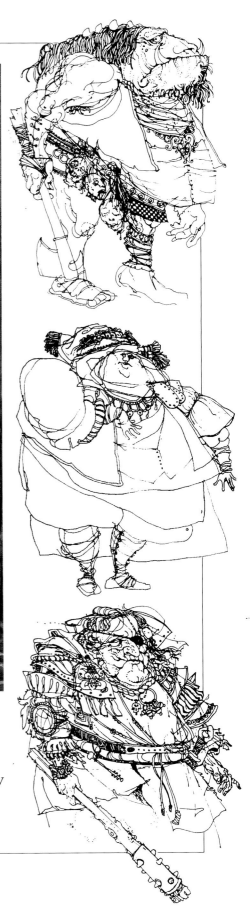

Two Dowager Ogresses Having Tea

One of the places where we stopped when we were in England was a tea shop, and there were two elderly ladies having tea together. I couldn't help but see them as benevolent ogresses. The floor is actually copied from a section of floor in Glastonbury Abbey. What you might not have noticed is that the ogress on the left is offhandedly stirring her tea with her finger, which has turned red from the heat.

The Candleman

(*Right*) The candleman's job is to help people get from here to there in the dark. He's a kindly soul who tries to do a good job. Still, I think it's a government position, because you can never find a candleman when you need one.

Dwarf With One Red Shoe

I was inspired by a Tom Hanks spy spoof called "The Man With One Red Shoe." I think this dwarf looks kind of like a spy, and I love the wonderful red of his shoe.

CORPORAL FORBISHER, S.N. WAS FULLY EQUIPPED IN HIS GW7R COMBAT ATTACK. RECON ORIENTED ION POSITRONIC. ANTI-RAD GRAV ASSIST. INFRARED CLOAKED 297 DL ACTIVE BOOST RADIAL AXELATED 7 MEG TERMINATOR ARMORED ASSAULT SUIT. HE COULDN'T MOVE, BUT HE LOOKED COOL!

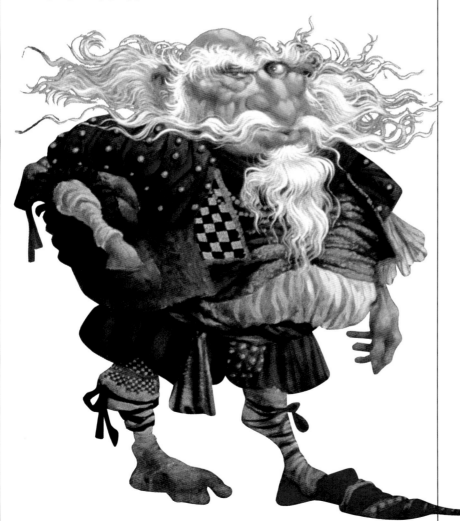

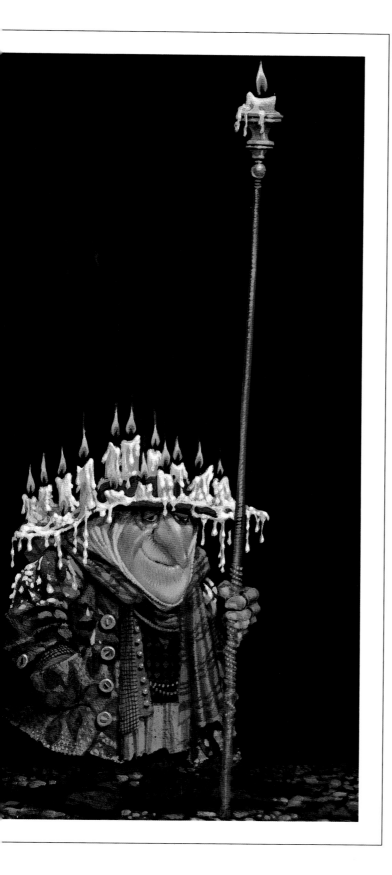

Why So Solemn, Art?

 Isn't it interesting that humor is accepted in theater but not in the visual arts? Where in painting and sculpture are the wonderful wit and merriment that have so enriched our literary and theatrical traditions?

An author can create a tale filled with wit and waggishness and yet still have a serious story. Shakespeare's *Henry the Fourth*, Part One, is no less serious for Falstaff's buffoonery, nor does Pat Conroy's *Prince of Tides* sacrifice its gravity for all its comic episodes.

The legitimacy of humor in plays and books is accepted, but very seldom does a comedy win the Picture of the Year Award. The perception may be that humor is neither serious nor significant. Small wonder that so few artists are willing to risk having a work of art be thought lacking in depth.

Yet humor belongs in art, however much daring it takes to put it there. Life may be a tragedy, but funny things still happen on the way to the mausoleum. Without humor, art is like a one-winged bird: beautiful perhaps, but asymmetrical, and reduced to ragged hops instead of a sure and rhythmic flight.

Gerome Spent His Free Time Daydreaming of Being Reincarnated as a Snake

For the longest time, I had a piece of masonite in the studio that was a long, skinny, goofy shape. Eventually, Gerome kind of slithered onto it.

① THE TROLL'S TAIL IS HIS PRIDE & GLORY. HIS MACHISMO IS INEXTRICABLY TIED TO HIS POSTERIOR PLUMAGE

SAVE THE TROLLS

② IN RECENT YEARS, KEY FOBS FOR BMW YUPPY CARS WOVEN FROM THE TAIL HAIRS OF THE MALE TROLL HAVE BECOME A FAD WITH WEST COAST YUPPIES. IN SPITE OF EFFORTS TO STOP THE HARVEST OF TROLL TAILS THE UNSCRUPULOUS TROLL POACHERS CONTINUE TO SEEK OUT THE VANISHING TROLL, BOP HIM ON THE HEAD, AND CUT OFF HIS TAIL!

③ DEPRIVED OF THE SYMBOL OF HIS MANHOOD, THE TROLL GOES INTO A DEEP DEPRESSION AND BECOMES IMPOTENT. AS THE MALES CEASE TO BREED, WE ARE FACED WITH THE EVENTUAL EXTINCTION OF THIS LARGELY WORTHLESS & VERY SMELLY SPECIES.

Playing a Hunch

I can't resist a good play on words. Here, there are two hunchbacks with their ornamented burdens. The bird, of course, does the vocals, and they play small clubs and lounges.

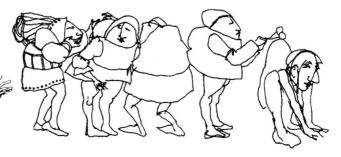

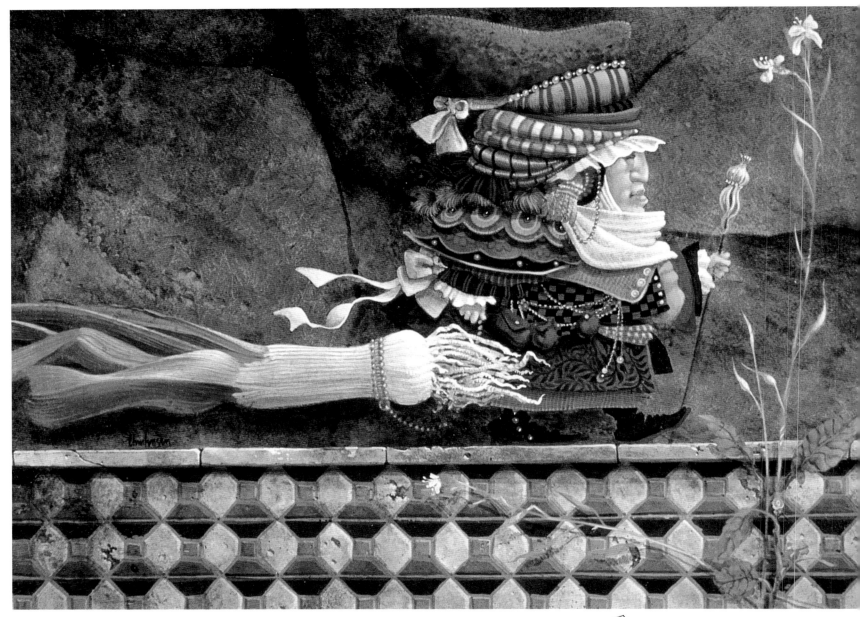

Man Taking a Leek on a Tiled Wall for a Walk

While in Spain, I began painting a man walking his pet
shallot. Once back home, I discovered that shallots
aren't easy to find in Utah, so I had to substitute a leek.
The pun was an afterthought.

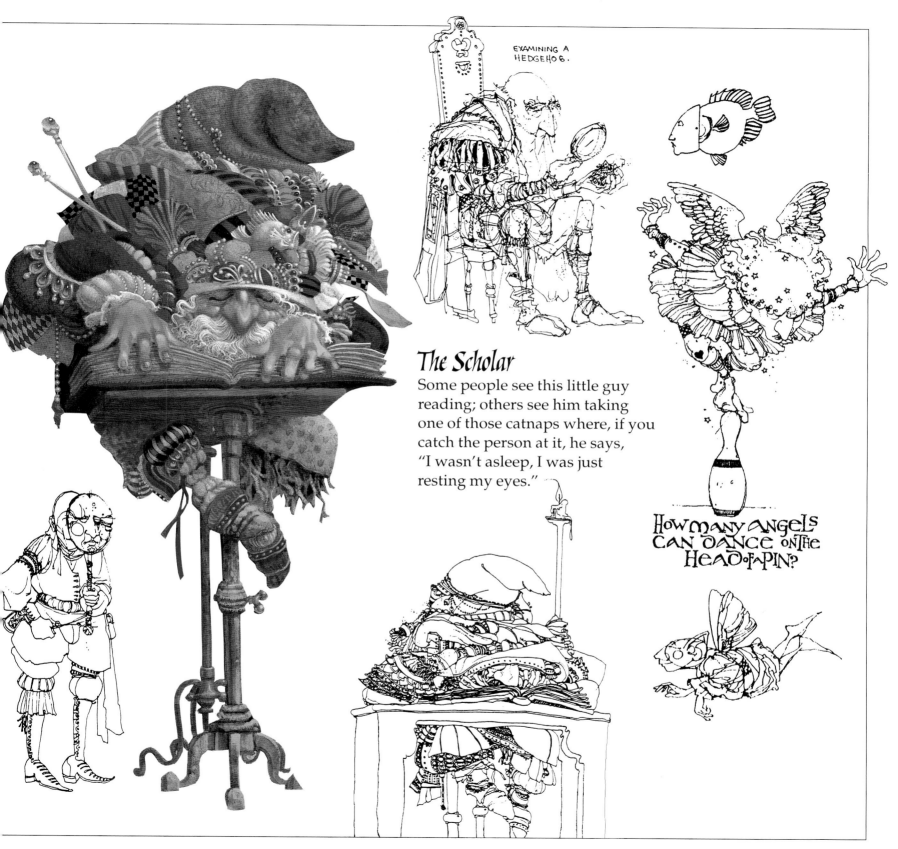

EXAMINING A HEDGEHOG.

The Scholar

Some people see this little guy reading; others see him taking one of those catnaps where, if you catch the person at it, he says, "I wasn't asleep, I was just resting my eyes."

HOW MANY ANGELS CAN DANCE ON THE HEAD OF A PIN?

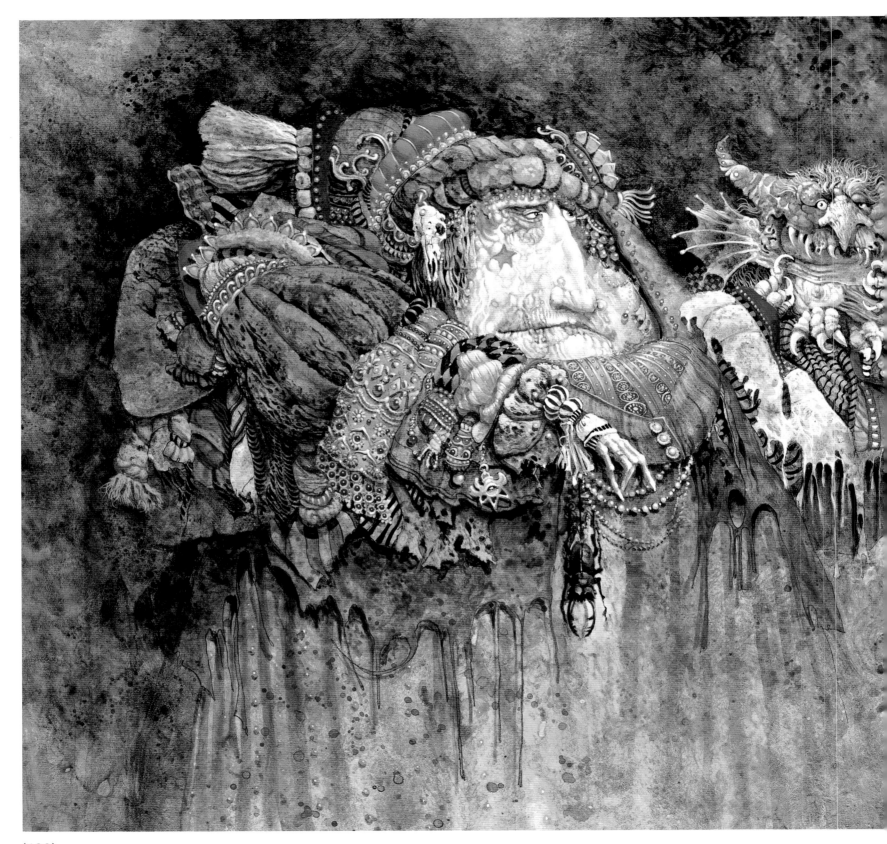

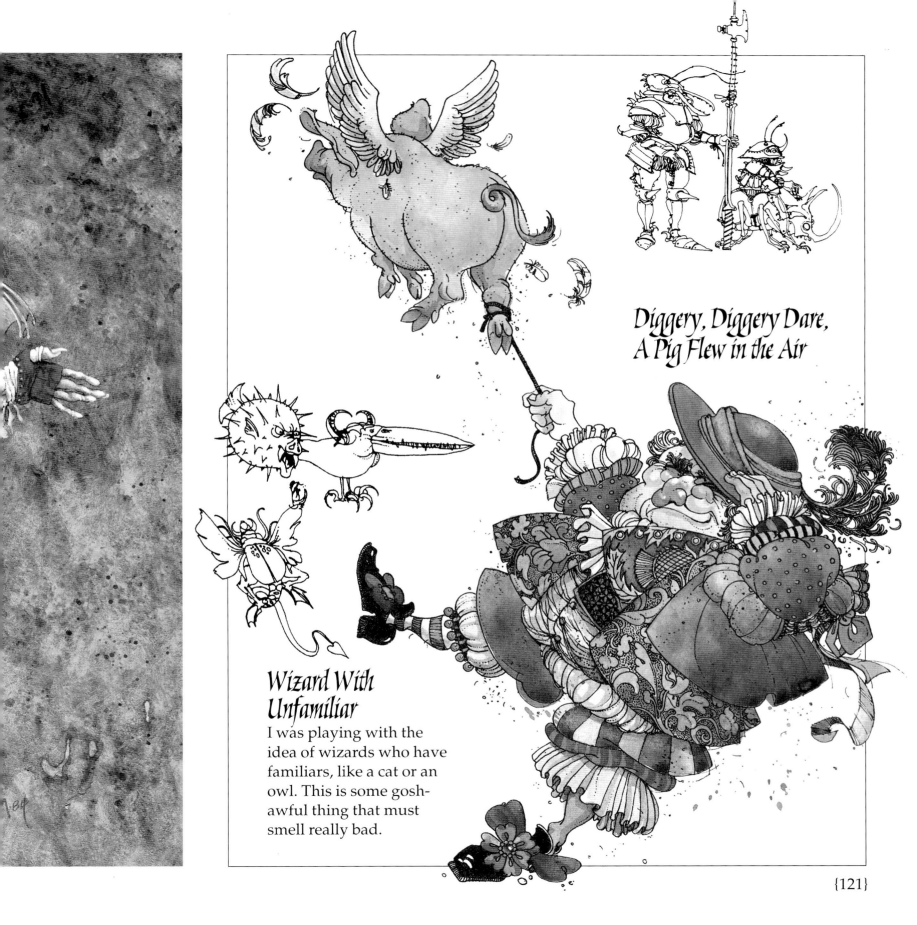

Diggery, Diggery Dare,
A Pig Flew in the Air

Wizard With Unfamiliar

I was playing with the idea of wizards who have familiars, like a cat or an owl. This is some gosh-awful thing that must smell really bad.

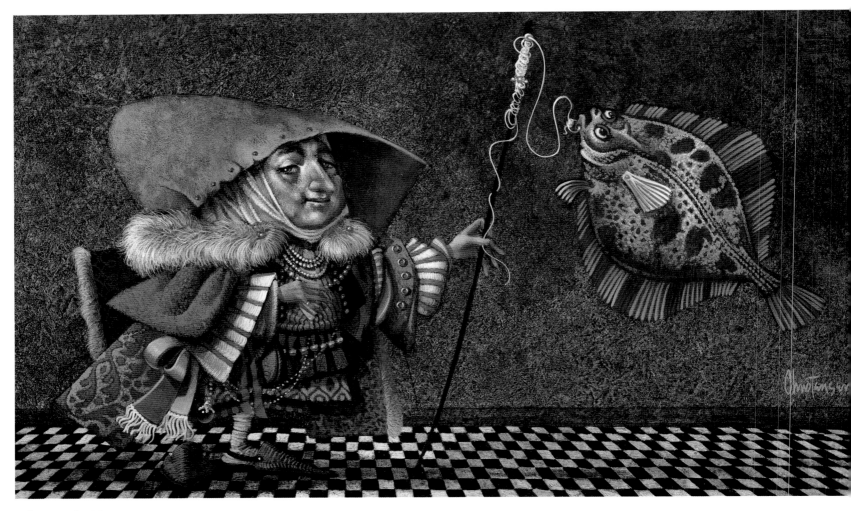

The Fish Kite

I got the idea for this while looking at Japanese fish kites, but it's actually about relationships and the small deceptions we allow each other. The man has a real fish on a string, but the fish doesn't want to be eaten so he's doing the graceful moves of a kite. The fish thinks he's got the guy fooled. The guy looks out at us, knowing that the fish is a real fish, but its kite dance is so beautiful that he pretends to be fooled. It's like marriage: My wife knows I'm a fish, but I've got such great moves that she doesn't blow my cover.

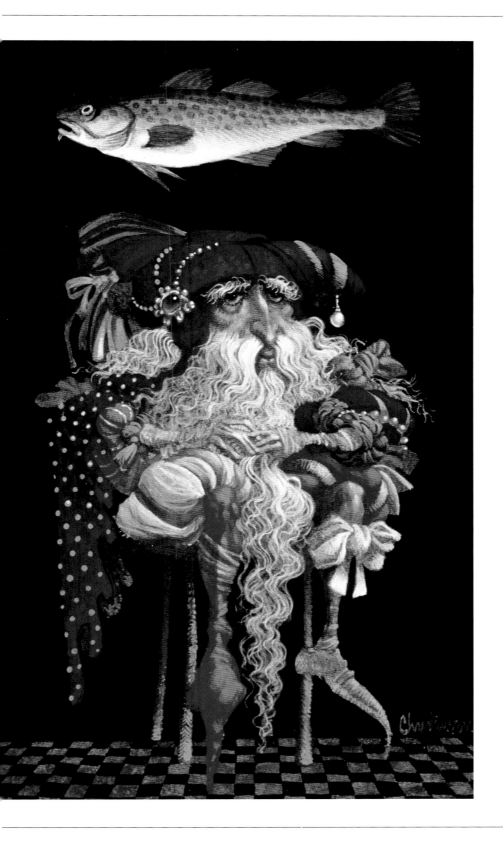

Cod and Codger

This was a very tiny painting done for a miniature show. It was just a fun painting with a playful use of repeating sounds in the title.

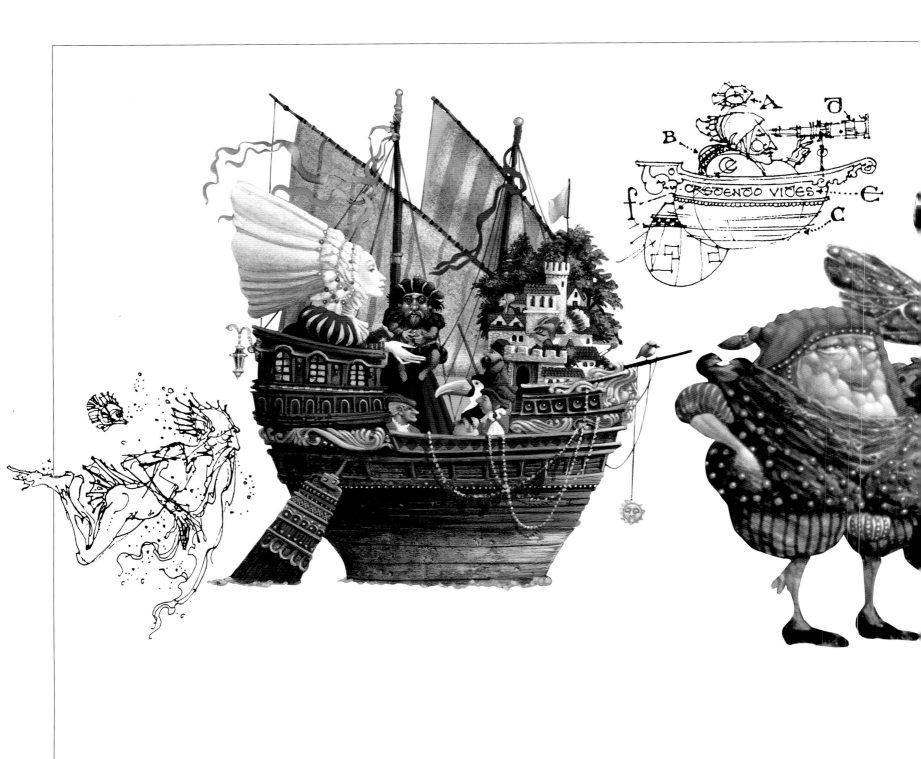

CRESCENDO VIDES

·5·
Fellow Travellers:
Passengers, Pilgrims & Poopdecks

·5· Fellow Travellers: Passengers, Pilgrims & Poopdecks

We breathe in the histories, tales, adventures, experiences, ideas, sorrows and joys of our fellow travelers. This is in its truest sense "inspiration," breathing in whatever is around us. I am aware of how indebted an artist is to all of his companions on the journey, whether they're living friends and family, or the writers, artists and thinkers who have gone before.

It seems to me that our travel through life resembles the winding progress of a river, and a boat is an excellent metaphor for the journey we make. On a boat, space is limited and many disparate elements or people come together, maybe even are forced together. Sometimes we travel with chosen companions; sometimes our companions are chance encounters. We don't always know them well; sometimes we don't enjoy them very much. All of us have times in our lives when we feel as if we're trying to navigate upstream, or that someone else is steering.

Boats can also symbolize the things we do that define our lives. Someone has to build a boat; it doesn't just happen—not in this universe, anyway. I believe each of us has a purpose in this life and that we best succeed in finding it when we take care of our boats and give some thought to our journey.

In "Side-Wheeler, Full Steam" (p. 130), I was interested in exploring a whimsical combination of passengers. I like the way this group of traveling companions seems happy and civilized. I don't know whether any of this group knows any of the others. Does it look as if the dragon is an old friend of the man who's powering the boat, or might the pig be acquainted with the geese from some other journey? Is the rat convivial, or does he look as though he probably keeps to himself? I don't always work these things out, preferring to leave that open for many interpretations.

"Maiden Voyage" (p. 132), on the other hand, is full of relationships. Aboard this ship are travelers who have gathered together with the idea of a shared goal in mind. Since they are entering some totally new enterprise, I loaded the image with symbols of new beginnings and—because no one can actually see what the future holds—timelessness. In one

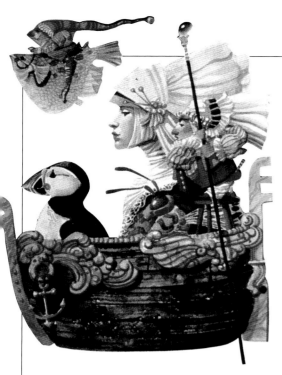

sense, all the people on this expedition are wise fools, people brave enough or foolish enough to band together, throw caution to the wind and try something wholly new.

In the prow, one of the figures, a hunchback, looks out at us. Quite often, someone will say to me, "That guy with the hump looks sort of like you. Is he you? Is it a self-portrait?"

Although I have to admit that there's usually something of me in those images, it's not the entire story. The hunchback is an Everyman. Since I'm part of Everybody, it's natural that someone could see me there. But I also hope that anyone who looks into the scenes depicting these little characters can see him- or herself, too.

Now if you want to see a character that's really me, take a look at Professor Algernon Aisling, the figure carrying a net and a book, in "The Voyage of the Basset" (p. 152). The professor is me. Except that I'm *much* younger and thinner than he is.

The "Basset" is a work I often give as an example of the "What If?" Principle, the conscious use of active imagination. After seeing a television program about Charles Darwin's five-year journey as naturalist aboard H.M.S. Beagle, I thought, "What if someone had sailed in the other direction, seeking all the creatures of myth and legend that Darwin had missed?"

The process of giving these imaginary beings "a local habitation," as Shakespeare called it, was full of discovery for me. In painting "The Voyage of the Basset," I found that the old myths came alive for me in a new way.

Fantasist Felix Marti-Ibanez called artists "the custodians of the gods." But I think there's more to it than just presentation and caretaking. The artist also interprets, a kind of continuous re-visioning of myth and legend. As I worked, the Basset came to symbolize the world for me. I knew and loved the ancient tales, but I also saw the myths with 20th-century eyes. All the different creatures aboard the Basset were brought into proximity, the way technology and population growth have brought the

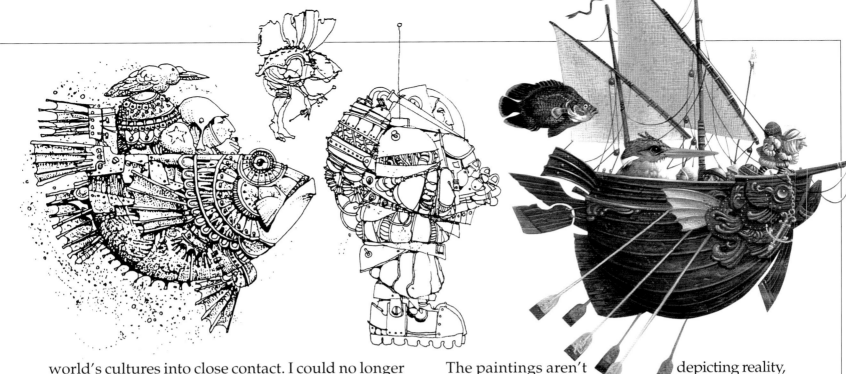

world's cultures into close contact. I could no longer view each mythical being as separate, a story unto itself. Fellowship, tolerance and acceptance became an integral part of the story.

This, to me, is how a myth stays "alive." It grows with the people who tell it, relating old truths to current realities. It also points out the value of the imaginary realm. Stepping outside the day-to-day world allows us to explore ideals and possibilities that we couldn't find using only the logical compass of reality.

 That's why I paint perspectives that wouldn't work in the real universe. An incorrect perspective hints at a place outside of the sensible, rational world. I want to keep reminding viewers that *there* is not here. It's an otherwhere (and otherwhen) that exists nowhere else but in the painting.

When Algernon Aisling sailed "the other direction" from Darwin's, he wasn't going in a cardinal direction. He was outside of reality.

The paintings aren't depicting reality, yet each image has to work in relationship to itself. I was working on a painting one day while an artist friend was in the studio. I sat back and looked at the painting and said, "You know, there's something wrong, something in here that just doesn't work." My friend laughed and said, "What are you talking about? None of your paintings are 'right.' The perspective isn't right; the characters are all wrong in proportion to each other. That's what the magic of your work is. You break all the rules. You can do anything you want."

But I really can't. The image has to work in its own context. There has to be cohesion in the way the elements come together. I worked on that particular painting after my friend left, finally reducing the size of one of the characters and shifting its position in relation to the others. Later, when he came back, he looked at the image and said, "Well, you were right. The painting does work now."

I have to have an intuitive sense of rightness within whimsy. The design (how the painting is laid out), subject (what it's a picture of) and content

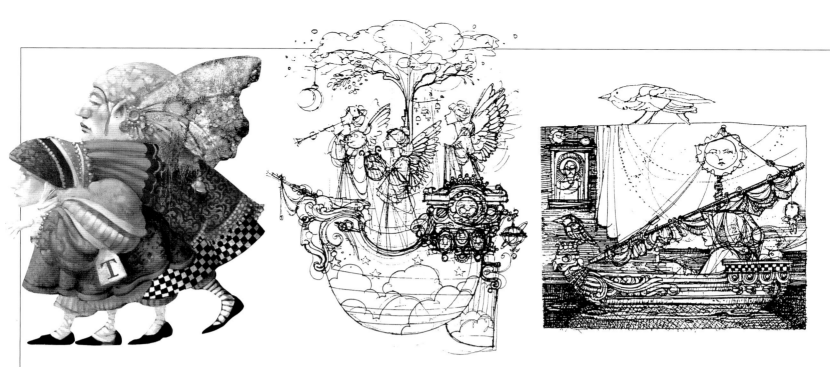

(what it means) need to agree in some way so that they become integral parts of each other. I generally put much of my focus on the painting's content, with the subject in support, creating a way to express the meaning and design and thereby making the image function as a whole.

For instance, when I use a checkerboard in my paintings, I allude to several different meanings: the game of life, the balance of opposites like light and dark, or good and evil. It's also a reference to the Flemish painters I admire, like Vermeer, many of whose paintings included images of checkerboard floors. But aside from its indications of content, the checkerboard has uses as part of the design. With it I can create depth or destroy pictoral space. It's a device to control how far into the image you can look. I can use it to manipulate space, keeping viewers visually off balance, a reminder that we are not in real space where you can expect normal things to happen.

I want to evoke questions like, "What does this mean?" rather than offering a single, pat answer. I want to stimulate our natural human curiosity and encourage viewers to do some of the imaginative work. I do often start with an idea, building the design around a central meaning. But one of the reasons I create little places that won't work in the real universe is to keep the possible meanings open-ended. When I manipulate the depth and perspective of an image, especially one filled with odd, not-quite-real characters, I can urge viewers to do more than just rational, linear thinking.

A lifetime may be linear, day after day, year after year, but the journey we make is not. Life meanders. Chance and the choices we make combine, sometimes creating a whirlpool of confusion. We can't make useful sense of it with merely straightforward thinking. So we tell each other stories, as the traveling companions in *The Canterbury Tales* did, to make the journey more interesting and to bring some order out of the tangle. We each add our own chapter to the larger narrative as the river winds along. Paintings are my part of the story.

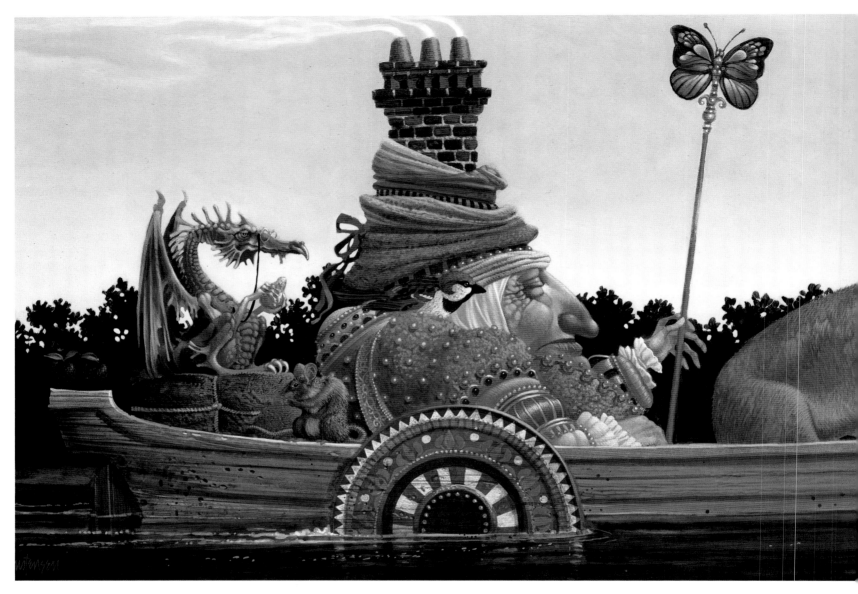

Side-Wheeler, Full Steam

This all springs out of an idea where a man becomes an engine, thus the smokestack that comes out of the largest character's hat. There are lots of interesting juxtapositions: the pig and geese and a civilized-looking dragon. They all seem as if they're peaceful and quite content to be heading down the river.

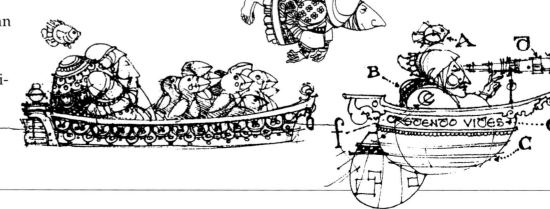

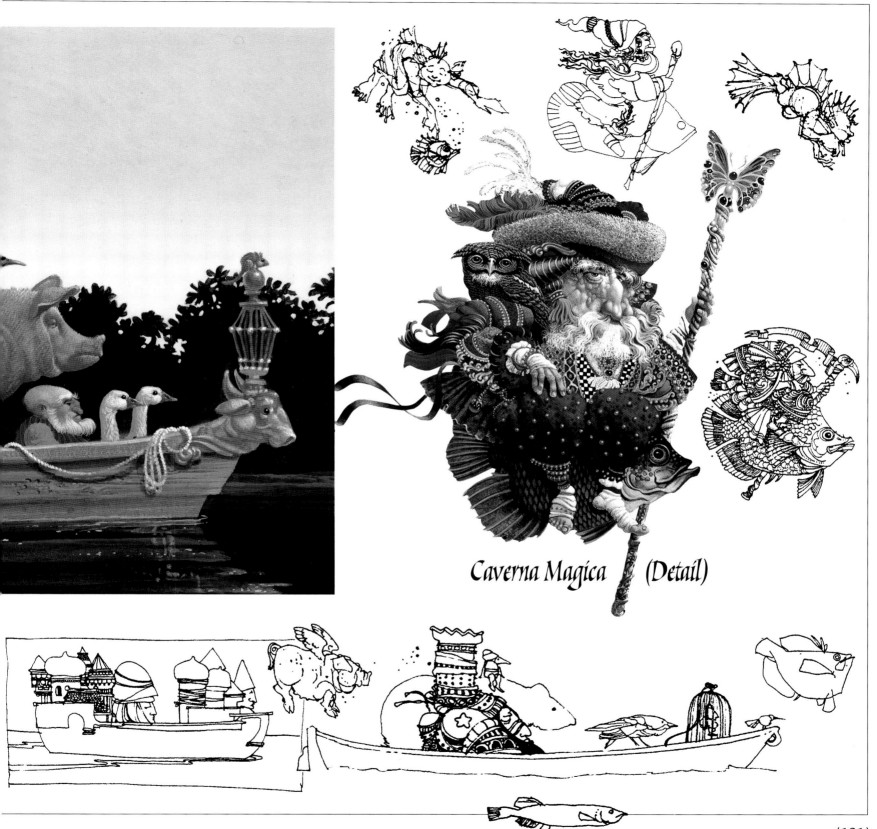

Caverna Magica (Detail)

Maiden Voyage

This was created as artwork for the Academy of Science-Fiction and Fantasy. The images have to do with beginnings, voyages and timelessness. Several fantasy artists are in the crew: Hap Hendrikson in the prow with myself as the hunchback, Michael Whelan in the crow's nest and Real Musgrave in the cabin smoking a pipe.

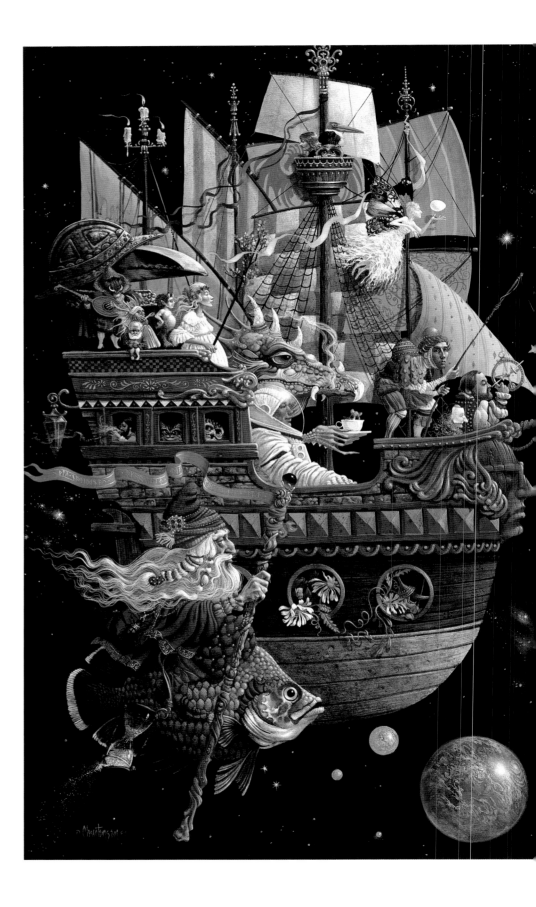

Petite Voyage

Traveling the River of Time

 The great river has been a metaphor for life's journey since civilization first discovered the otherworldliness of traveling on water. In any number of myths and religions, mortality is bounded by a river that must be crossed to reach the afterlife: Lethe, Styx, Jordan.

For that little journey, the human lifetime, a boat is the perfect symbol. It passes from port to port, never compassing the entirety of the river, yet it allows a great measure of truth and learning for those who seek.

The boats appearing in this book carry with them the age-old meanings about the journey of life, but with a modern ethic. Many of the boats are as delicate and beautiful as Fabergé eggs, not unlike the fragile natural world. There is in these boats a reverence for the small lives of fish and butterflies as well as the quest for truth.

And if there's an added sense of life's comic side, well, it's a reminder that when searching for the path to wisdom, a good fish story can make the journey a lot more fun.

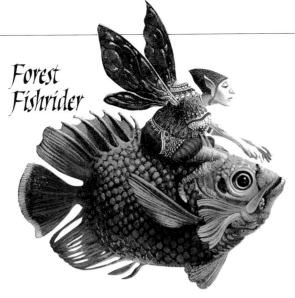

Forest Fishrider

The Residents of a Very Small Town on a Pleasure Cruise Being Entertained by a Lady of Station With Her Vasco da Gama Ventriloquist Act

Once, I saw a not-very-well-executed painting of Vasco da Gama, and I realized he looked like a ventriloquist's dummy. One thing just led to another.

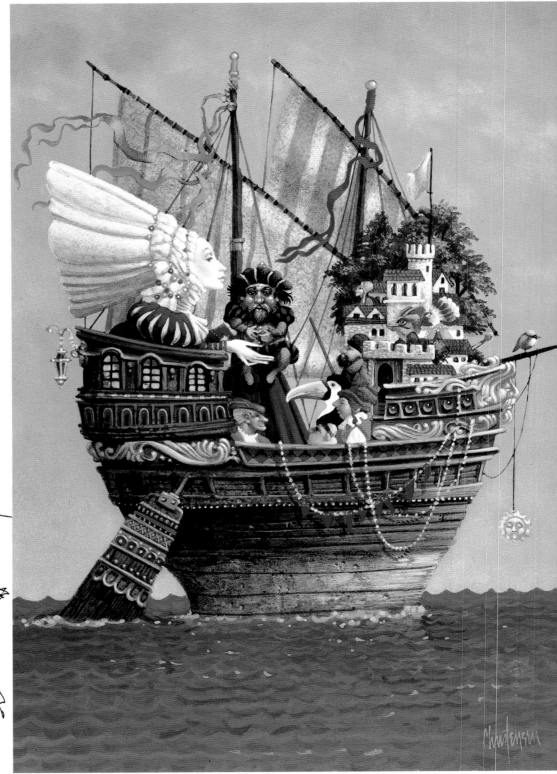

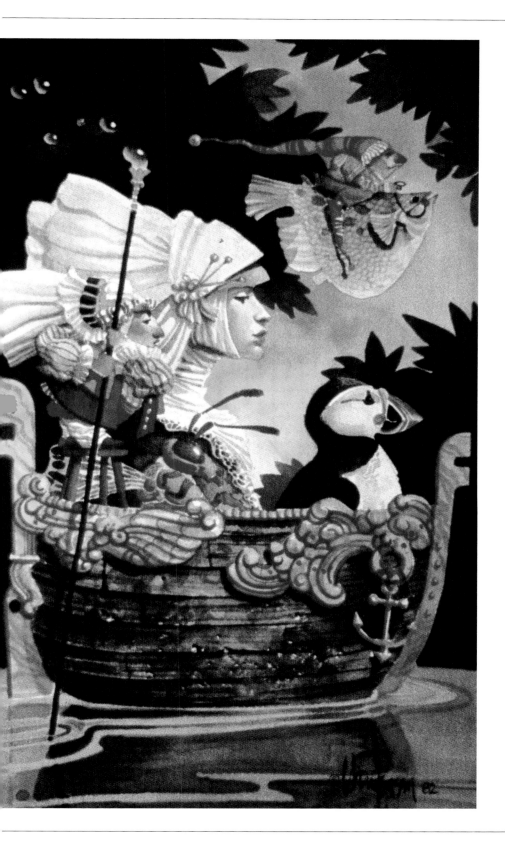

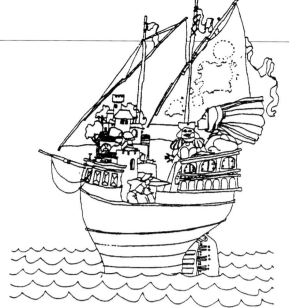

Voyage With a Puffin

The thing I like about puffins is that if you'd never seen one, you might think they were made up. They just don't look real. Their eyes are like art. I was surprised the first time I saw puffins; they're smaller than I thought they'd be, and they have these silly, stubby little wings. Maybe that influenced me to place the puffin in the boat. They put such an effort into flying, make so much noise and create such a to-do that you wonder if that's really the way they should be traveling.

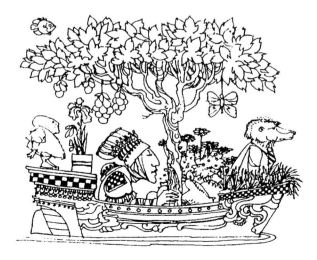

Low Tech

I was asked to paint something for NASA's "Visions of Other Worlds" show. A lot of the things from which this intrepid space explorer's ship is constructed were things I found in my dad's basement: an old flashlight, an eggbeater, and a transistor radio's innards.

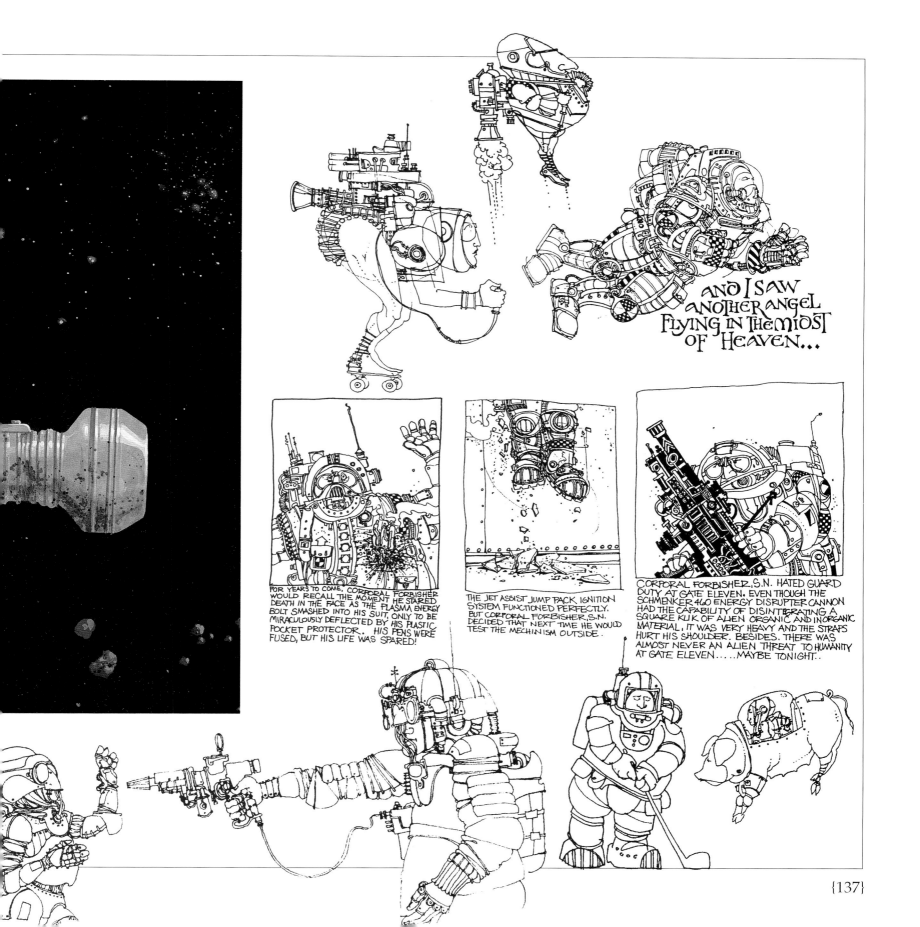

AND I SAW ANOTHER ANGEL FLYING IN THE MIDST OF HEAVEN...

FOR YEARS TO COME, CORPORAL FORBISHER WOULD RECALL THE MOMENT HE STARED DEATH IN THE FACE AS THE PLASMA ENERGY BOLT SMASHED INTO HIS SUIT, ONLY TO BE MIRACULOUSLY DEFLECTED BY HIS PLASTIC POCKET PROTECTOR. HIS PENS WERE FUSED, BUT HIS LIFE WAS SPARED!

THE JET ASSIST JUMP PACK IGNITION SYSTEM FUNCTIONED PERFECTLY. BUT CORPORAL FORBISHER, S.N. DECIDED THAT NEXT TIME HE WOULD TEST THE MECHINISM OUTSIDE.

CORPORAL FORBISHER, S.N. HATED GUARD DUTY AT GATE ELEVEN. EVEN THOUGH THE SCHMENKER 460 ENERGY DISRUPTER CANNON HAD THE CAPABILITY OF DISINTEGRATING A SQUARE KLIK OF ALIEN ORGANIC AND INORGANIC MATERIAL, IT WAS VERY HEAVY AND THE STRAPS HURT HIS SHOULDER. BESIDES, THERE WAS ALMOST NEVER AN ALIEN THREAT TO HUMANITY AT GATE ELEVEN......MAYBE TONIGHT..

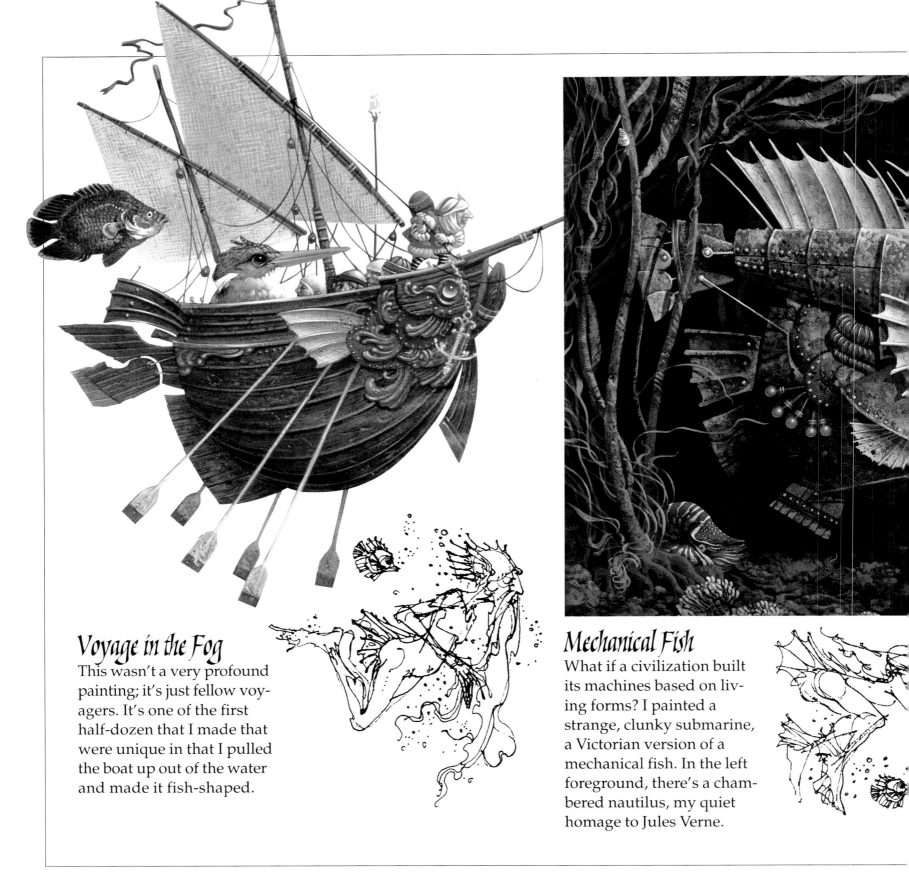

Voyage in the Fog

This wasn't a very profound painting; it's just fellow voyagers. It's one of the first half-dozen that I made that were unique in that I pulled the boat up out of the water and made it fish-shaped.

Mechanical Fish

What if a civilization built its machines based on living forms? I painted a strange, clunky submarine, a Victorian version of a mechanical fish. In the left foreground, there's a chambered nautilus, my quiet homage to Jules Verne.

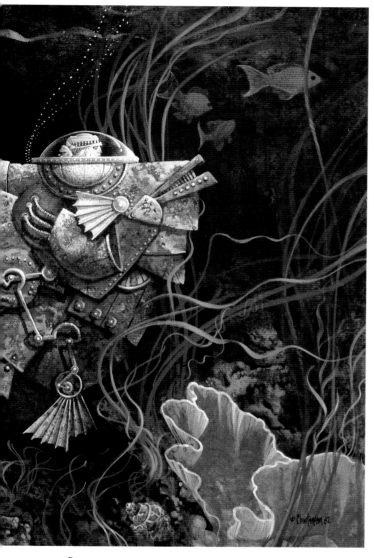

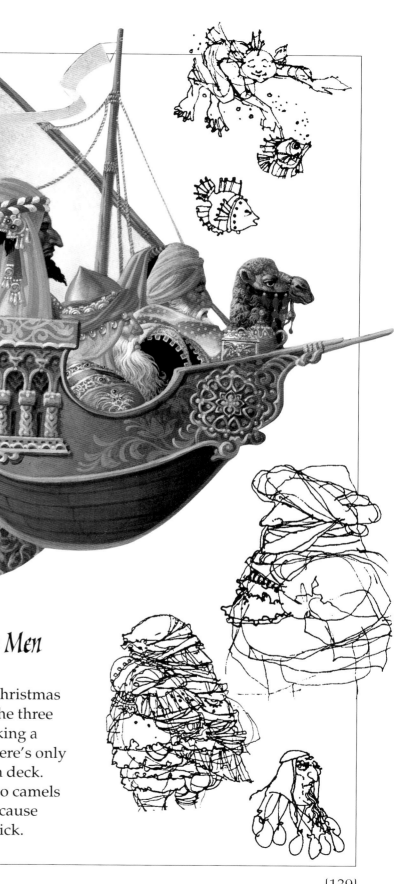

CORAL FAERIES

Three Wise Men in a Boat

This was a Christmas painting of the three wise men taking a short cut. There's only one camel on deck. The other two camels are below because they get seasick.

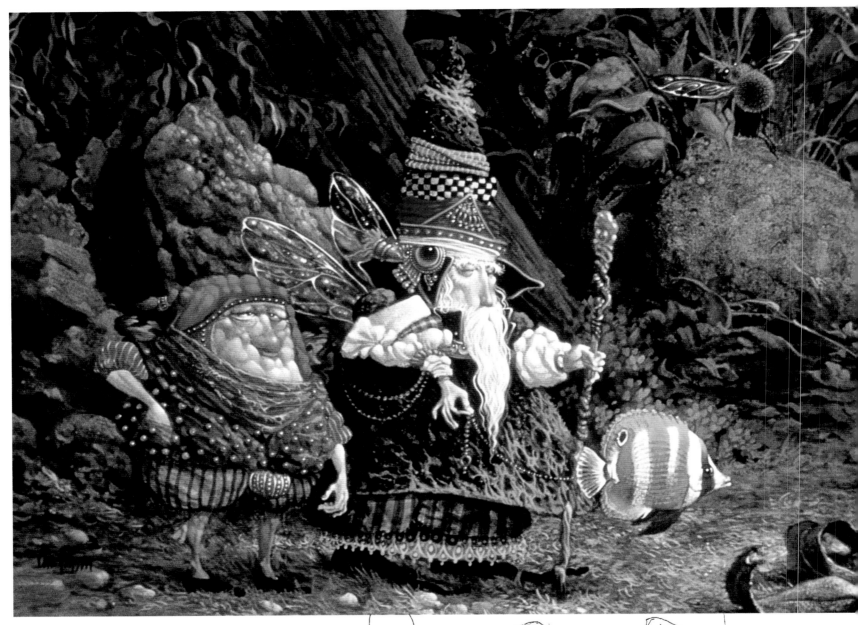

Two Old Faeries Just Getting From Here to There

These started as two separate sketchbook drawings and they seemed to belong with each other, so I put them together in a realistic landscape.

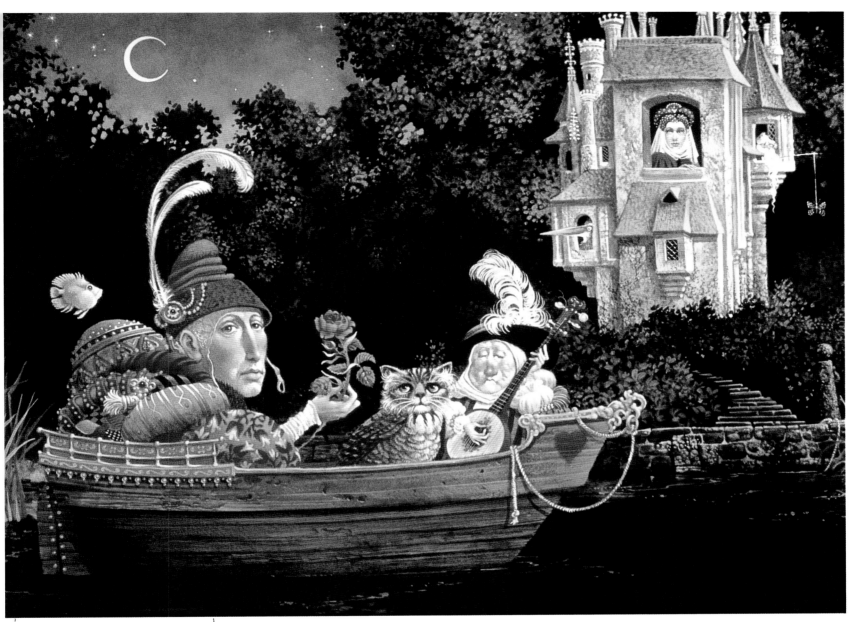

Courtship

Anyone who has stood on the precipice of revealing their true emotions toward another will find this scene familiar. I'm not certain whether the little hunchback is holding up the rose because he wonders if it's enough to capture the lady's affections, or if he's merely declaring his love and saying, "Here I go, come what may."

Through the Magnifying Glass

Things aren't quite in step with reality in these images. Birds that are five inches long in the real world grow to be the size of a man; tropical fish leave the water and become huge. Do the people get smaller, or the animals, bigger?

Sometimes the strange use of size harks back to medieval times, when hieratic scaling was used to tell the viewer which character in the painting was the most important, rather than to give clues to distance and perspective. At other times, scale and juxtaposition serve to unsettle the viewer—just as crossing one's arms is easy until it's attempted the opposite way. That slightly off-balance feeling is an attention-getter, a full stop in the white noise of habit. The playful use of curious juxtaposition and unlikely scale provides surprise, delight, and a pathway to the imaginative journey.

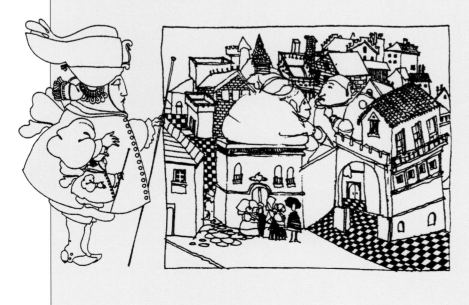

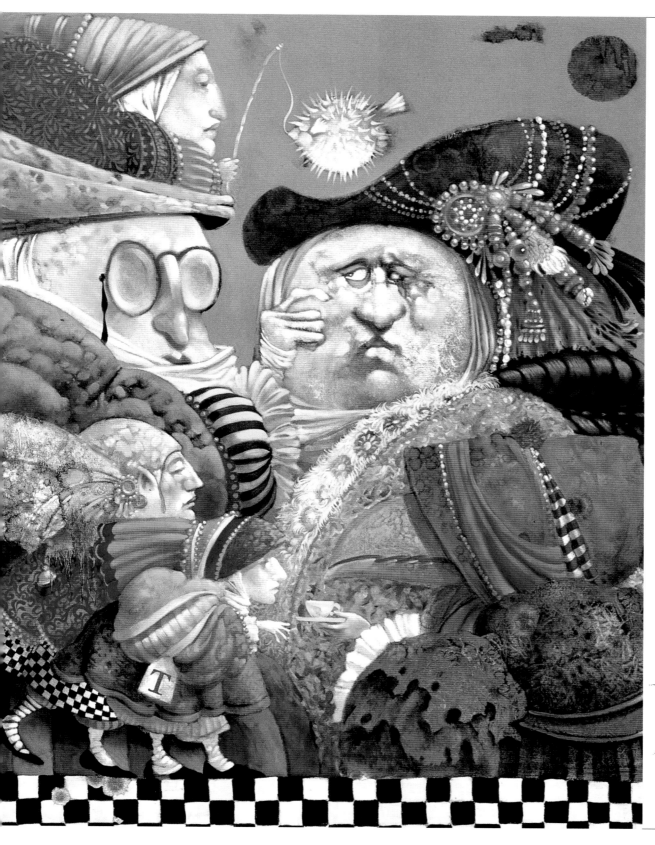

Tea for Toucan

This painting is a little like a cocktail party where there's a group interacting, and then you've got the little guy in the boat that stands on the outskirts of the group, desperate to be part of something. Something else I find interesting and puzzling is the fisherman. If you think of this as fishing for truth or wisdom, what does it mean to catch a puffer fish? Maybe truth isn't always the easiest thing to find.

The Candleman With Children

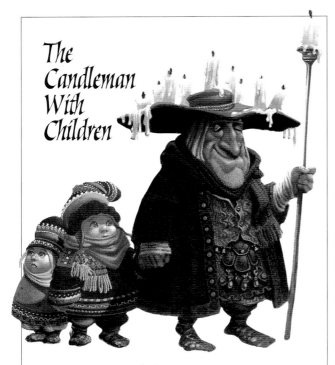

Fantasies of the Sea

One part oxygen, two parts hydrogen, three parts magic. Many of the creatures are real, such as the anatomically correct fish, lobsters and jellyfish, side by side with fantasy characters like the water-dwelling hunchback and mermaid.

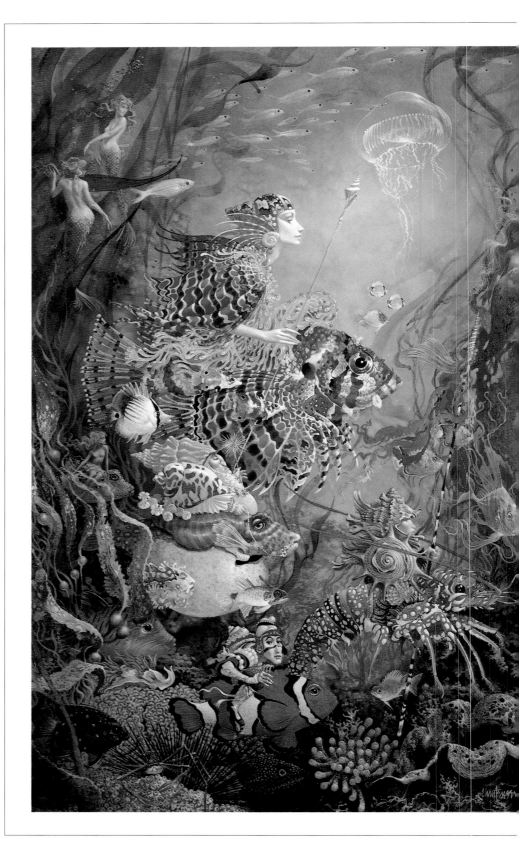

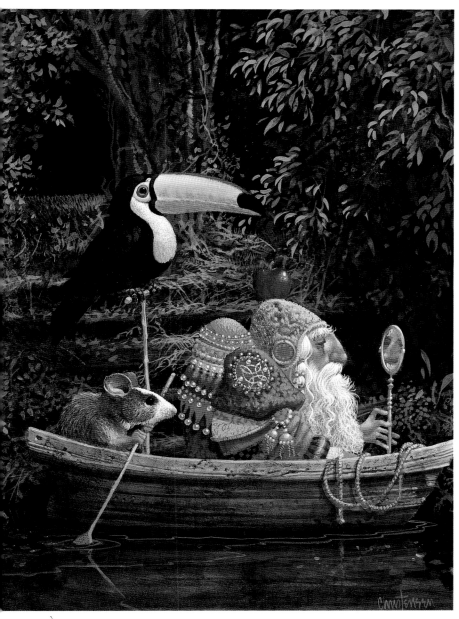

Looking in the Mirror

The tricky thing about mirrors is that they *seem* to reflect reality, but what we see is often colored by our own illusions. Of course, if this guy is married, he'll get a much more honest reflection of himself once his wife shows up.

Santa on a Pig

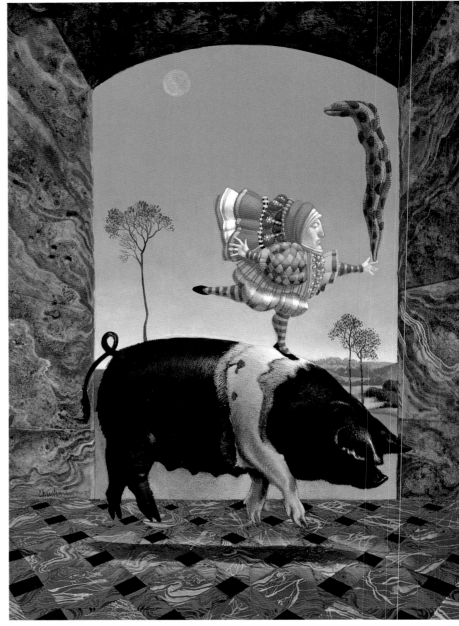

Gulag Archipiglio and His Practically World-Famous Balancing Moray Eel Act

Sometimes, you simply meet the most interesting people.

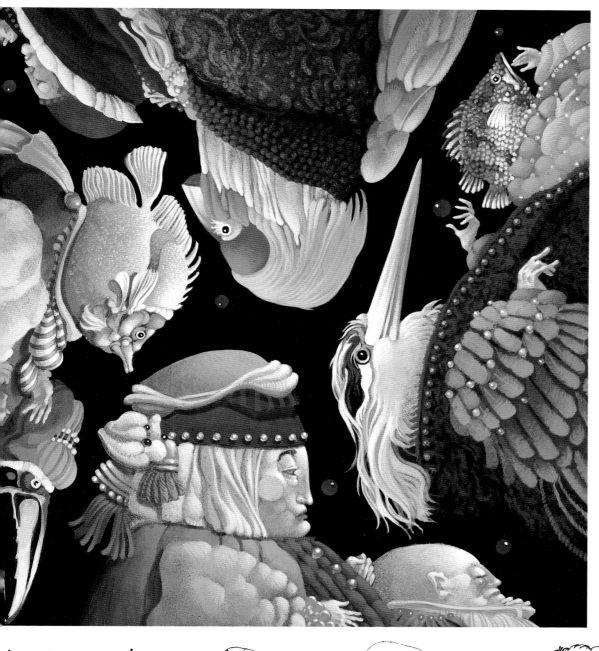

Seven Red Marbles

I was experimenting with other ways to look at art. This painting actually had four hangers, since there's no particular right side up. It could even be hung on a ceiling, perhaps in a dentist's office. That way the patients would have something to look at other than the drill and the dentist's nostrils.

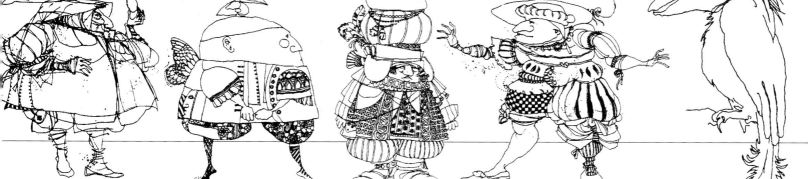

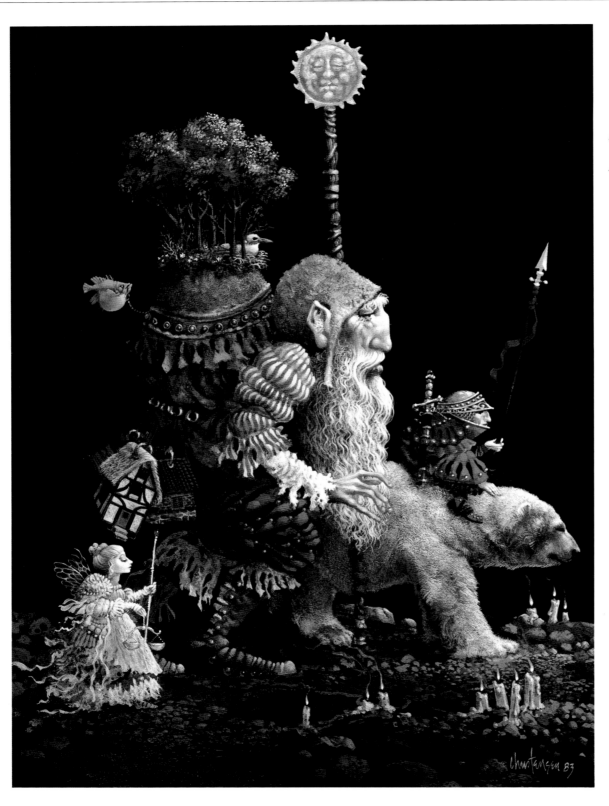

Pilgrimage

This painting is loaded with meaning. It's about the journey of life, in all its variation and color. I see the old man as a metaphor for the world, and the little guy on the polar bear as a military presence. Perhaps the little faerie with the scales adds the idea of justice, symmetry and balance.

The Oldest Angel

I think of this angel in much the same way that I think of people who stay in off-the-beaten-path, Mom-and-Pop stores. You ask them why they stay and they look surprised and say, "It's our little spot and we like it here." I see this angel at about the farthest reaches of eternity, climbing each night to hold up his candle, kind of as if it were a star.

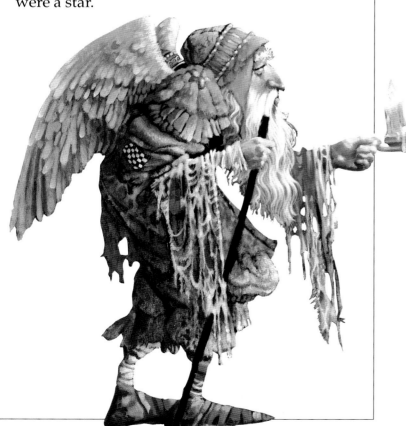

Hopeful Dreaming

 To be human is both to dream and to do. They work together like yeast and flour, seeds and earth. The junction of the dream and the endeavor is what author Lloyd Alexander calls the difference between wishful thinking and hopeful dreaming.

Hopeful dreaming is the beginning of active imagination. The groups of funny little characters sailing ships, piloting spacecraft or making pilgrimages are allegories. To bring the imaginative vision into the physical world requires the courage of wise fools, working either together or alone. The images of such attempts are not in praise of success or work for work's sake, but an homage to the endeavor and the leap of faith.

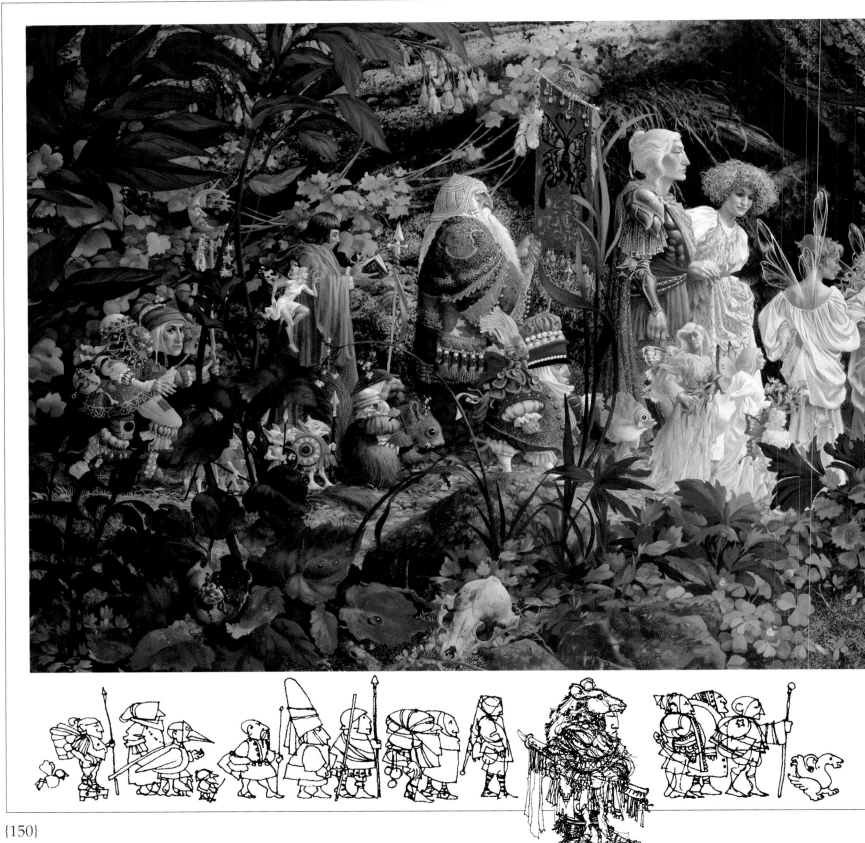

The Royal Processional

I wanted to provide just a glimpse of the faerie world. The story of what's happening has to come from whoever looks at the painting. The point of view is more or less at ground level, as if someone had fallen asleep in the forest and then awakened to see the king and queen of the faeries passing by. Also, in movies or books, you're told that the king is coming to visit, but it's really forty people who show up, because he has a whole retinue. This painting is also a good example of hieratic scaling. The king and queen are the most important personages here, so they're the largest. The king's steward or chamberlain, the character walking behind the king, is a little smaller than the royal couple, and so forth. When a medieval king went on a journey, he'd have trumpeters to announce his presence in the countryside. The faerie people wouldn't do that; there'd be too much risk of discovery. Perhaps they'd use a very subtle announcement.

The ladies bearing incense burners are letting the magical fold know that royalty is passing by.

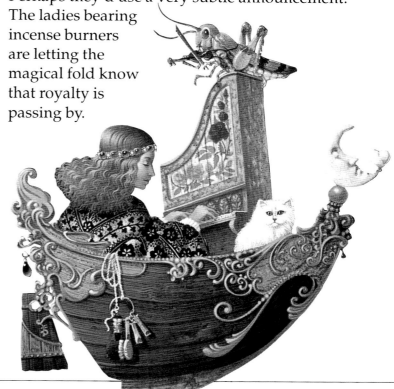

Music Makes
the Journey Sweeter
(Detail)

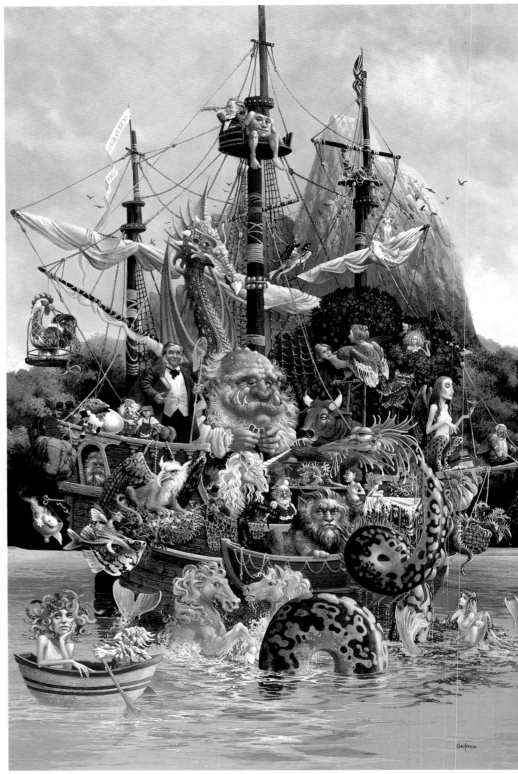

Voyage of the Basset

What if there had been a sister voyage to that of Darwin's travels on the Beagle, one that went the other direction in search of magic and mythological creatures? I realized as I worked that this wasn't just a voyage into a mythological unknown, but a symbol of all of our little planet's different creatures and cultures who must learn the art of fellowship.

Olde World Santa

When I started doing research for an Olde World Santa, I found that there wasn't one. Kris Kringle is from the German Kris Kindle, or Christ child. The red robes are from St. Nicholas. The Protestants didn't want to worship a Catholic saint, so they came up with Father Christmas. We've blended some of every country's traditions to create a unique American symbol of Christmas.

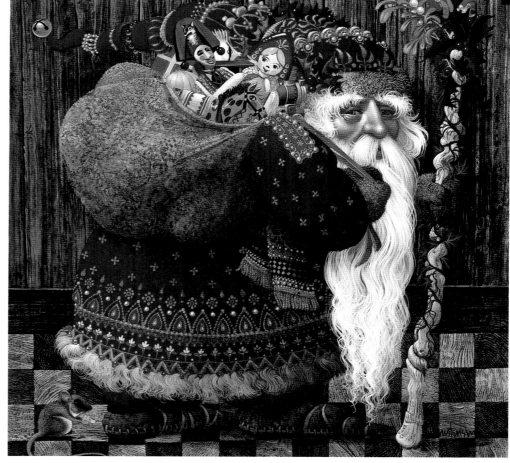

Professional Fish Walker

I was inspired by the entrepreneurial spirit. I had an image of this creative little guy who discovers that he can earn a living by walking people's fish while they're at conventions and meetings.

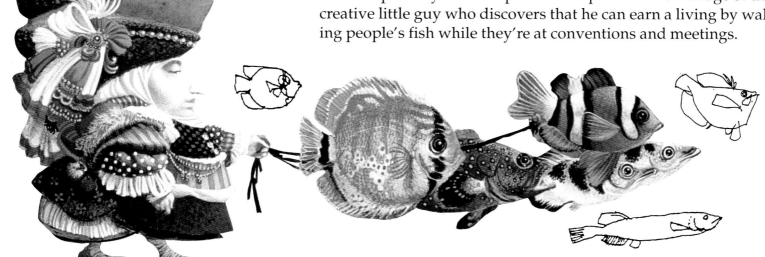

{153}

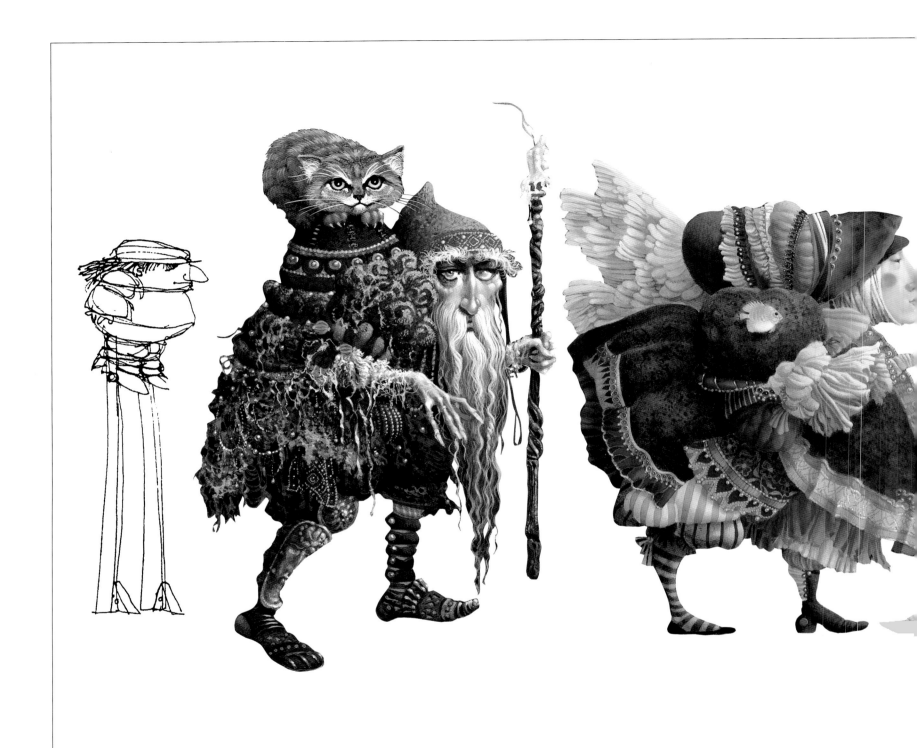

·6·
On Course:
Proven Paths & Different Tacks

On Course: Proven Paths & Different Tacks

When I say, "I'm a fantasy painter," a lot of people envision bosomy ladies in metal bras, and barbarians with bulging muscles and fur jock straps. Much as I love the images of artists like Frank Frazetta, that's not all there is to it. The truth is that fantastic art—which is the more official title—has a history as long as mankind's.

There's never been a period in art referred to as *la fantastique* or the fantastical movement, but the qualities of fantasy move through the whole *oeuvre* of art history. It wasn't until the 19th century that painters actually began creating new places from their imaginations. But when I look back over the course of art history, I can draw upon the creative visions of earlier artists, even though they weren't engaged in painting fantasy.

The cave painters of the Neolithic left behind enigmatic little puzzles about who they were and what they believed. We cannot know whether these images were meant to control the natural world, invoke some sort of magic or express the artists' dreams or pleasures. What we do know is that these painters, like us, were able to envision something beyond the objective world of the senses.

For much of history, the fantastical in art had purposes other than fantasy. The mythical creations of past centuries were most likely done for specific religious reasons, a way of symbolizing an unseen world of spirituality.

For many centuries, the Christian Church in Rome controlled what kinds of art subjects were acceptable. That's not all bad. Religious art is a good place for someone with an imagination, since it does deal with a spiritual world beyond what we can actually see. But most artists, whether they wished to or not, were careful to stay within the orthodoxy; being accused of heresy had some less-than-healthful consequences.

That may be why paintings of Adam and Eve or sinners in Hell were popular. It was the only way you could sneak a nude or two past the ecclesiastical eye. As long as you were painting monsters and miscreants in the context of "This is what will happen to you…," you were okay.

During the early years of the Renaissance in the north, religious beliefs fostered the creativity of artists like Bosch, the Bruegels (both elder and younger) and van Eyck. But the Renaissance nonetheless began to move toward more secular art.

In the north, this move away from religious art took the form of paintings of burghers and their wives as the merchant class grew richer and more powerful. Italy was a little more laid back; you might consider it to have been the Southern California of Europe. There, artists like Botticelli were involved in fantasy based on classical myths.

There are artists and works of art that don't fit well into any genre. After suffering a bad love affair, having a falling out with the king and going deaf, Goya retired to a little farm and did brooding, fantastical murals that make up his Dark Period. The poet and painter William Blake was a unique character who merely did his own thing, before anyone knew about doing your own thing.

The era I identify most closely with—and it's probably the closest thing we have to a fantastical period—is the English arts and crafts movement that was part of the romantic period in the 19th century. That's probably the first time artists purposefully created art based on wholly imaginary realms. These artists come as close to fantasy painting as any group did.

There are a lot of fun and interesting paintings from that time. I love William Waterhouse's "Lady of Shalott" so much that I had her get up out of her boat and come model for me for "Once Upon a Time" (p. 161), and then get back into her own painting. Another of my favorites is by Richard Dadd, "The Fairy Feller's Master Stroke." Dadd was a better painter than role model, though: He stabbed his own dad to death in a paranoiac rage and spent the rest of his life in Bethlehem (Bedlam) Hospital, an asylum in London.

World War I changed the world. Artists became cynical and disillusioned, and their work, however imaginative, became less romanticized. Freud's theories of the unconscious became popular. Salvador

Dali's strange images, which he said were pictures of his dreams, were compelling but disquieting.

The surrealists, like Dali and his contemporaries, influenced me because I love the imaginative quality of their work. But I find that their philosophy is often nihilistic, far too negative and bleak. Nor did the abstract, geometric art of this century call to me. I had to find my own direction.

A couple decades ago, my love for drawing, for the craft of painting, would have locked me forever into illustrating (a four-letter word in New York). In fact, plenty of artists have made careers doing book and magazine covers. Now, however, many are beginning to be recognized as fine artists.

I think that fantasy has become more popular because so many people want to look at art that has imagination and meaning. They want access to the heart of a painting. No coldly logical artistic theory, however impressive, can fill the need we have to connect with one another.

Some time ago, a person came up to me and said, "About a year ago I bought one of your paintings with a group of little guys in it. I hung it on the wall with a picture light over it, and that light is the last thing I turn off at night. Sometimes in the evening I sit in my chair and just look at the painting. Over the year, I've made up meanings for all the characters, named them, given them personalities and life histories." Now this was a businessman, not a writer, not an "artistic" person. And then this man said to me, "Is it okay that I've done that?" as if I might frown at him and say sternly, "No, it's not okay. I didn't put those meanings in there, so you shouldn't either."

I'm delighted that he let his own imagination take over and supplied meanings of his own. That is exactly what I want my art to do. Anytime that someone looks into one of my paintings and brings his or her own unique experience to its interpretation, I feel that I've succeeded in drawing that person into the process.

I paint for myself, but I also want to communicate the idea that people need to trust themselves

and their own ideas with my art. If I want you to get a specific message, then it's my job to give you enough universal, "readable" information to provide access to the image. We all have an imagination. We are all capable of looking at a work of art, bringing our own perspective to it and coming up with our own answers.

There are times when you have no access to what I meant with a painting. "The Fish Kite" (p. 122) is a good example of this. There's no way to know that this is my interpretation of how a relationship functions unless I tell you. Yet you have access to the imagery through your own imagination. Your feelings about what a painting means are no less valid than mine, even though I made the painting. You can only add to the art, not take away from it, by trusting your own active imagination.

I think part of my job as an artist is to urge adults to be willing to use their imaginations to explore with the same brave curiosity that children have. Kids don't worry about being "right" when their imaginations are engaged. They jump right in. The journey is open-ended; anything can happen.

Growing up doesn't steal that ability from us, but our work, our learned solutions, our self-consciousness can imprison imagination or keep it dormant. I think that, in most of us, imagination longs to be awakened and to be of use. In the process of being used, our imaginations grow and stretch. We expand our horizons. We create new possibilities in the practical world. And when art and imagination work together, we get true insights into ourselves.

 The thing is to trust yourself. In an age when the individual experience is often undervalued, it's important to remember that no one but you can be you, think your thoughts, have your unique perspective. What I hope is that in looking at my paintings and reading what I was thinking about while I made them, you begin to say to yourself, "OK. Now, what does this mean *to me?*"

When you can look into a painting and ponder its meaning, without being told what it's about, then you have truly begun a voyage of the imagination.

Once Upon a Time

The fun here is that the storyteller is telling stories to the characters that appear in faerie tales and legends. Timpanogos, the Utah mountain I can see from my house, is in the background. I've appropriated an Edward Burne-Jones knight, and the woman in white is the Lady of Shalott from the Waterhouse painting.

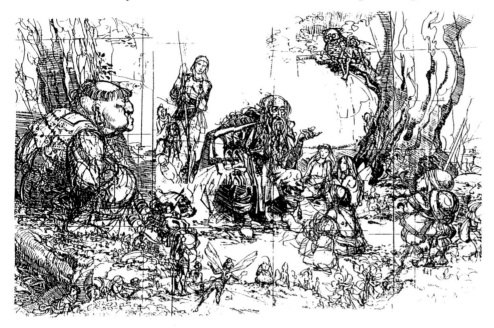

One, Two, Three, Four, Five, Catch a Fishy Alive

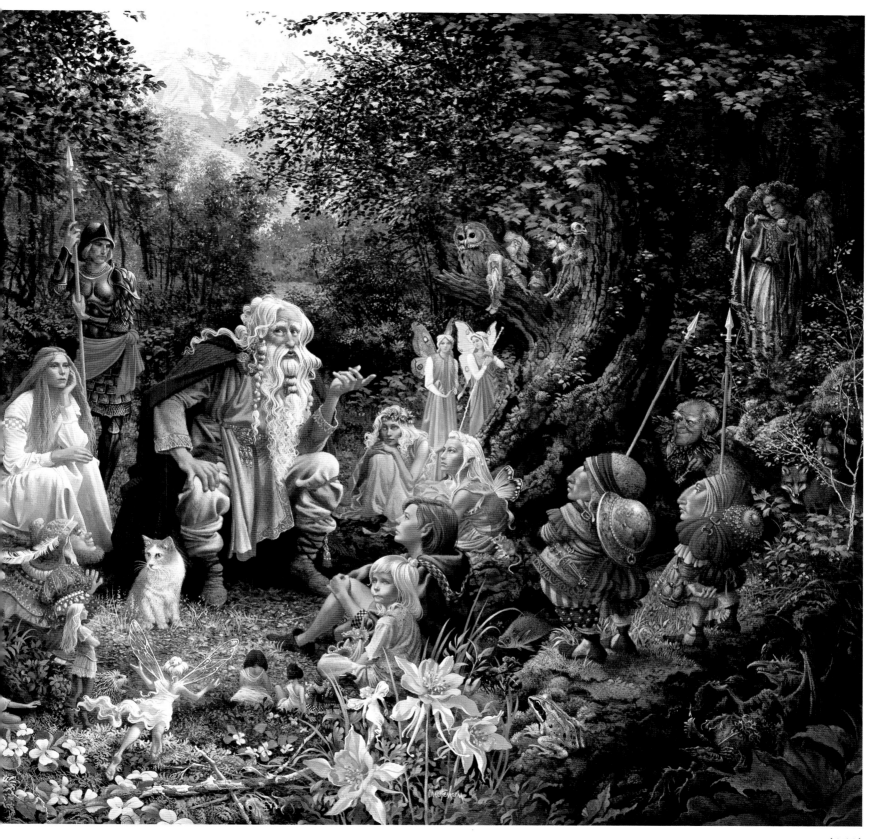

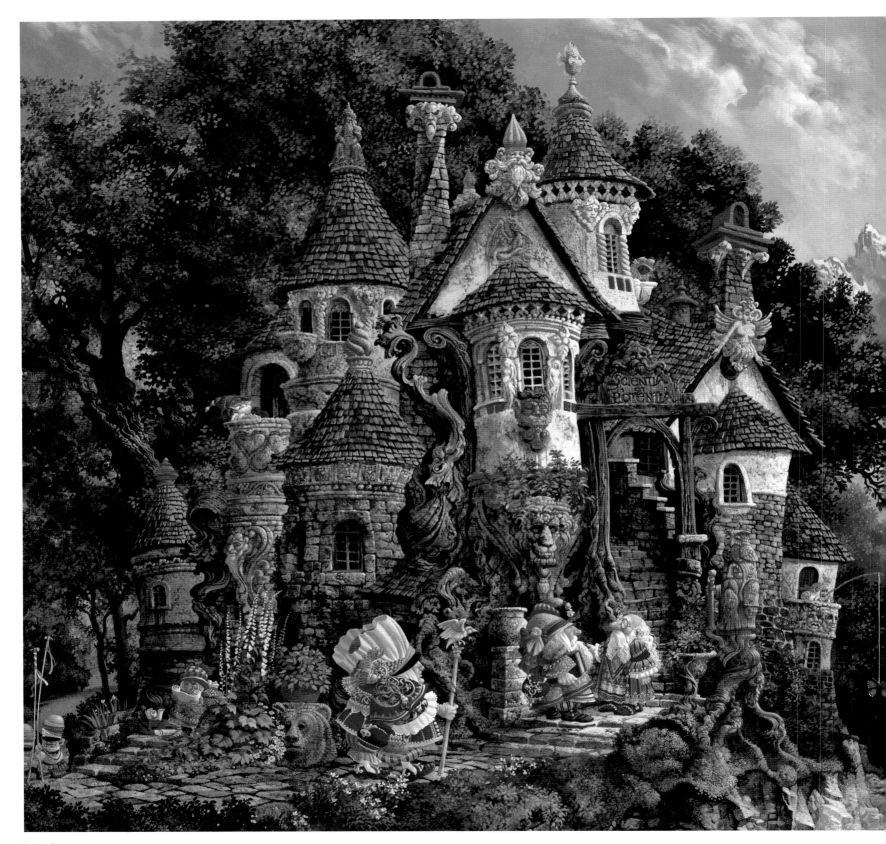

College of Magical Knowledge

The Latin inscription *Scientia est potentia* means "knowledge is power." But you don't learn ordinary stuff here, like how to succeed in business or get elected governor. This knowledge gives access to magic, to living a life that isn't ruled by ordinary reality. The college's library is full of texts and tomes we can only guess at. This is a great place for contemplation and for learning what you need to know to enter the land a little left of reality.

Opening the Enchanted Onion

Entering the fantastical realm begins with a surprising glimpse through the magical window. The unexpected feast of ornate detail, intricate patterns, sumptuous color and visual fun must first capture and delight the eyes.

But color and design are just the outer sheath of the enchanted onion. Looking deeper, one may discover the multiple layers of meaning that the artist wishes to share. And still the journey continues. Each viewer brings to the art the unique sum of his or her own thoughts, memories, life experiences and beliefs. The imaginative pathways that are discovered by the individual viewer are also exactly where the art is supposed to lead, no matter that the artist never walked these paths or knew the other meanings that lay hidden in the work.

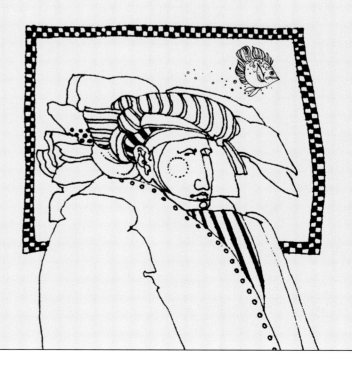

Pelican King

This image seems to have under-
tones of both comedy and pathos.
I don't know if I've figured it all out.
The stick becomes a scepter, and
the bent keys, symbols of obsolete
power. The onion becomes an orb,
an ancient symbol of sovereignty. Its
sprout may mean rebirth. Mytho-
logically, a single wing means
someone lost in a dream. Yet a peli-
can has chosen to build a nest on
him, which seems symbolic of his
purposefulness. He has a perma-
nence about him, but this painting
remains enigmatic for me.

'SORRY WE HAD
TO SMASH AND
GRAB...'

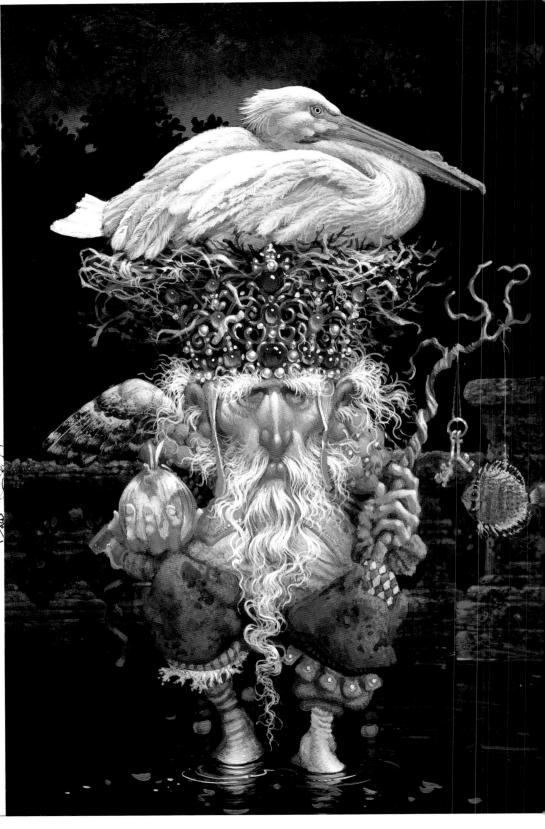

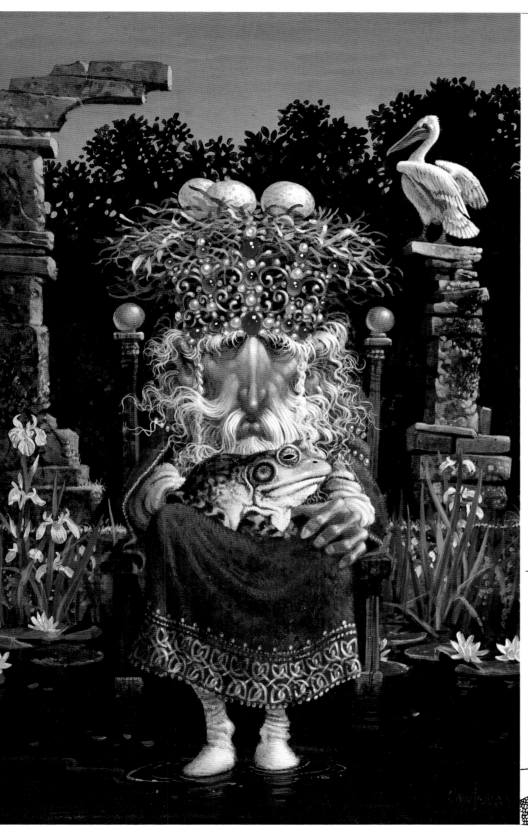

The Pelican King and the Prince

The Pelican King sits very still because he's the vehicle for the entry of the next generation of pelicans. I put the big green frog in his lap and decided to call it "The Pelican King and the Prince." The prince, obviously, is still in a state of becoming.

Boat in the Forest

The Latin graffiti scrawled on the side of the boat says, "Let he who is lost in dreams beware." This painting is about a man with an impossible dream. The boat is way out in the forest, the rigging is rotten, and rats have gnawed holes in the keel. Instead of jewels, the man's hat has empty settings. This was such a melancholy painting that I added a kingfisher, a mythological symbol of the soul unbound.

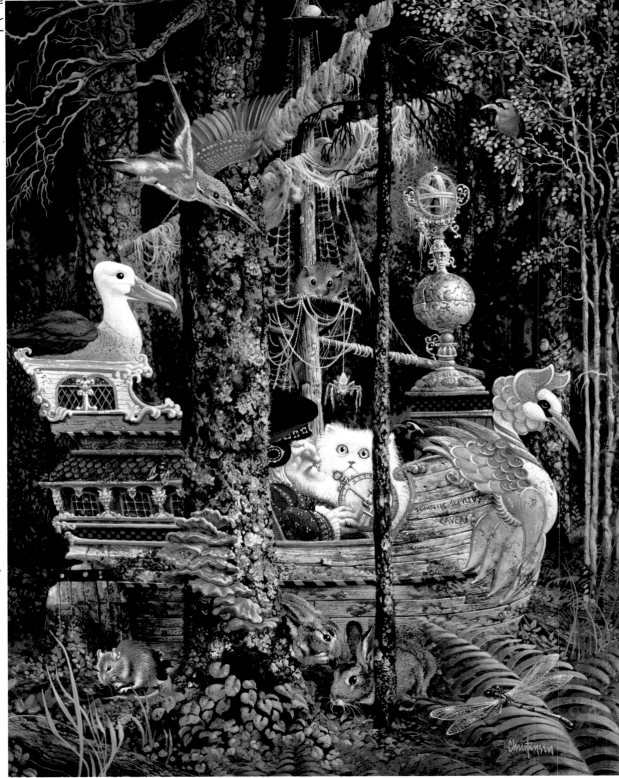

The Judging of the Fruit

Who better than bureaucrats and experts to have a little costuming fun with. If each layer of clothing adds to your self-importance, these guys are close to cornering the market on pomposity. And, of course, being experts, they'd need specialized tools. The fruit may not be of great quality, but it's been properly measured, weighed and inspected by the experts.

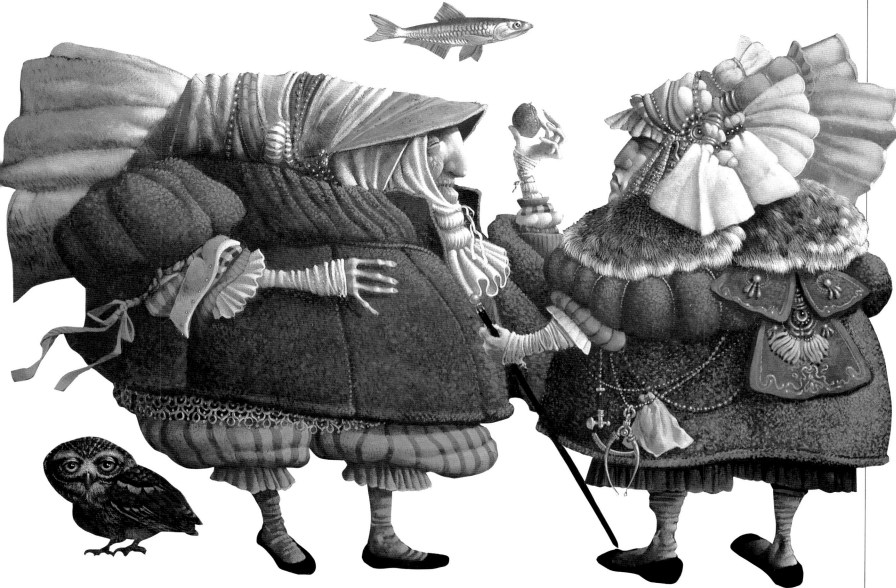

The Sage

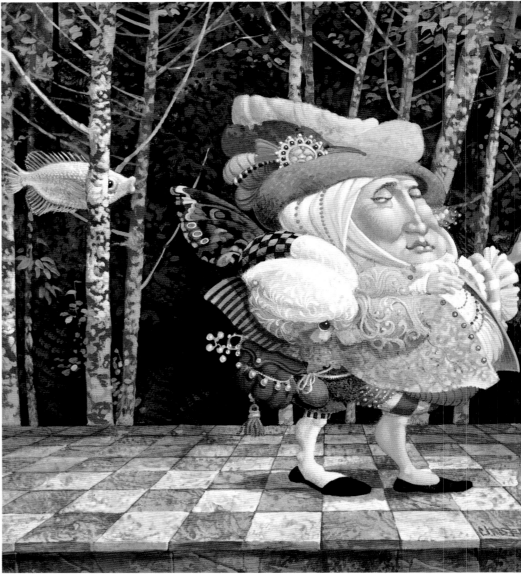

Vincent and the Kissing Gourami

Vincent hasn't actually seen the gourami, but he senses it lurking. Is it planning to kiss him? The whole situation makes him anxious.

A CERTAIN LACK OF FAITH.

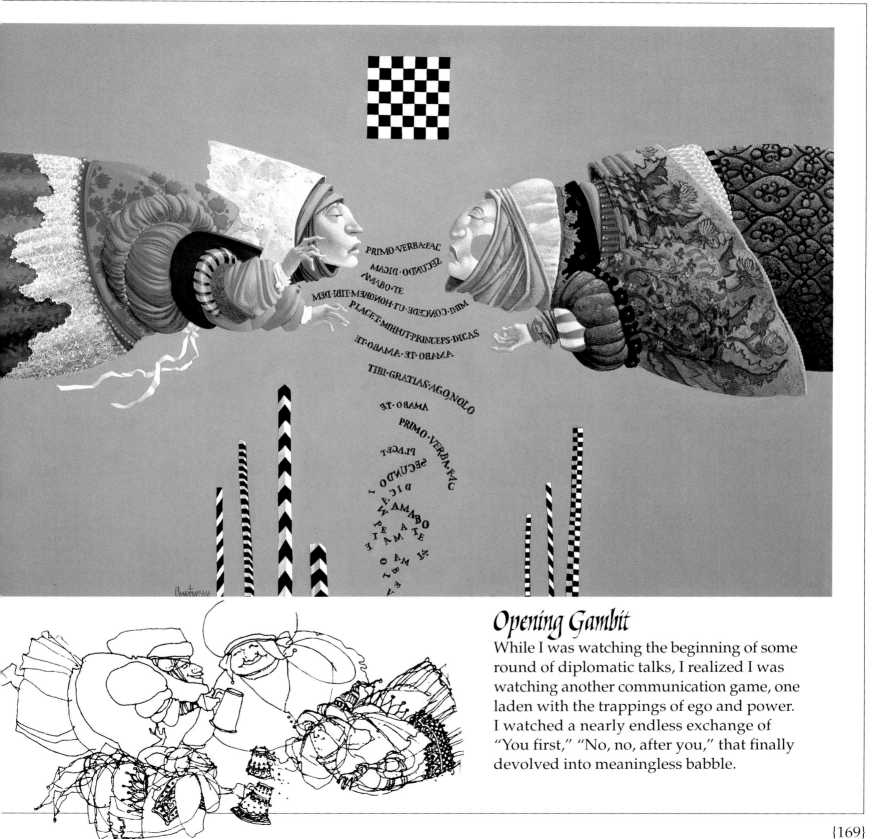

Opening Gambit

While I was watching the beginning of some round of diplomatic talks, I realized I was watching another communication game, one laden with the trappings of ego and power. I watched a nearly endless exchange of "You first," "No, no, after you," that finally devolved into meaningless babble.

Comrades, Cohorts & Collaborators

"The best thing you can do for your fellow," said fantasy writer George McDonald, "next to rousing his conscience, is—not to give him things to think about, but to wake things up that are in him; or say, to make him think things for himself."

Fantasy is the art of waking things up, things forgotten or undiscovered, things no one has dreamed of before. The fantastic vision may begin as a solo voyage, but it soon demands companions, connections. It's an extraordinary voyage, not to avoid reality but to add to it.

"We aren't escaping out," wrote Susan Cooper, also a fantasist, "we're escaping in, without any idea of what we may encounter. Fantasy is the metaphor through which we discover ourselves."

She Would Have Been a Much More Pleasant Person If Her Nose Had Not Been On So Tight

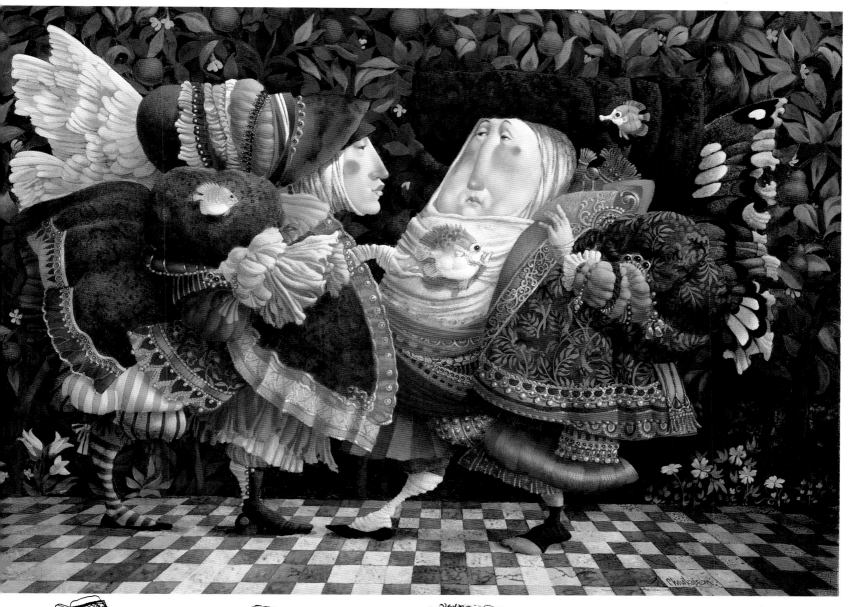

Conversation Around Fish

I like this painting because the shapes, designs, colors and patterns work so well. It's all about the pleasures of wonderfully ornate costumes and fish that float magically through the air.

The Tudor Houseboat

I've used this one a lot in slide presentations because it's a good example of the "What-If" idea: when I was in England I saw examples of Tudor architecture and thought, "What if we had a houseboat in that style?" It wouldn't work in the real world, of course, since this is daub and wattle, which would turn to mud in the water. There's a layer that says something on an ecological level. Insect, mammal, amphibian, bird and human all coexist. These are all real things: a cat, a lady, a frog, an insect and a bird. The scaling is what creates the magic.

The Zanzibar Cat (Detail)

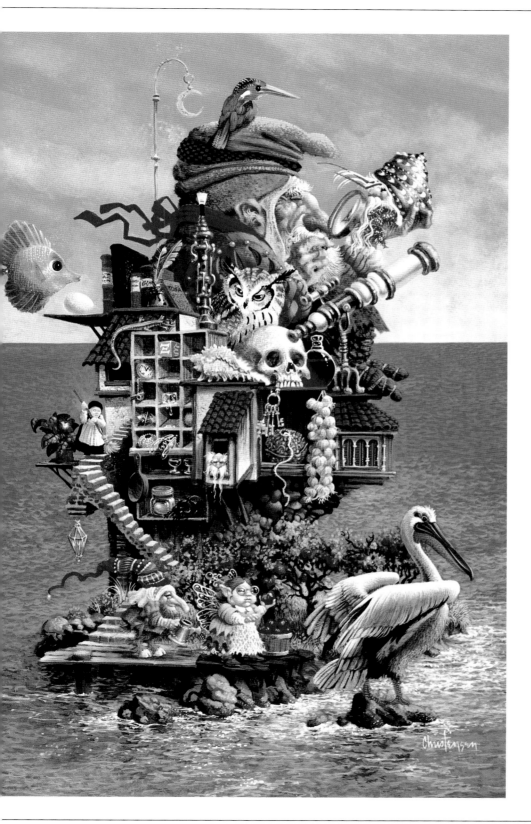

The Collector

This painting was one I did for the cover of a children's magazine. It shows a collector on his little island and it's about taking care of your things. I put in something from all the letters of the alphabet. But I cheated a little. I didn't want the really smart kids to find them all too easily, so I made the letter X a tough one. It's on the children's block in the shelves, but it's in Greek.

Monarch of All He Surveys

If the river is the metaphor for life and the boat is the symbol of our journey, this "king" in his precariously propped up boat may have a little problem. Here are the bust of a Roman emperor, a frog and a haughty Persian cat —all symbols of pride and puffery. Here, too, is a butterfly, symbol of the soul, with a missing wing: a soul unable to fly on in its spiritual journey.

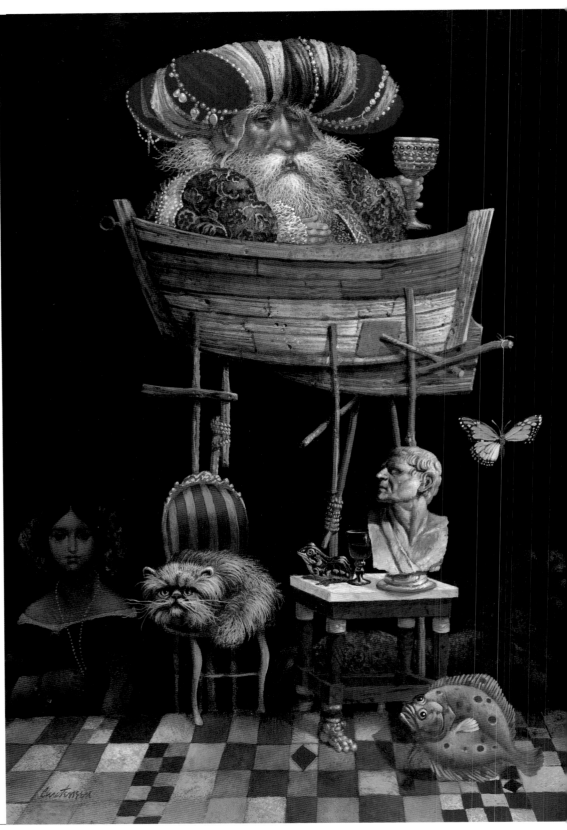

Two Sisters

I began with the idea of creating mirror-image sisters—one good, one bad. What developed was that while one was rich and one poor, both had gifts to offer in the world. This is symbolized by the flowers and Latin words hovering above their outstretched hands. The rich sister can offer charity, the poor one, faith and hope. The challenge is to recognize and use one's own gifts, whatever they are.

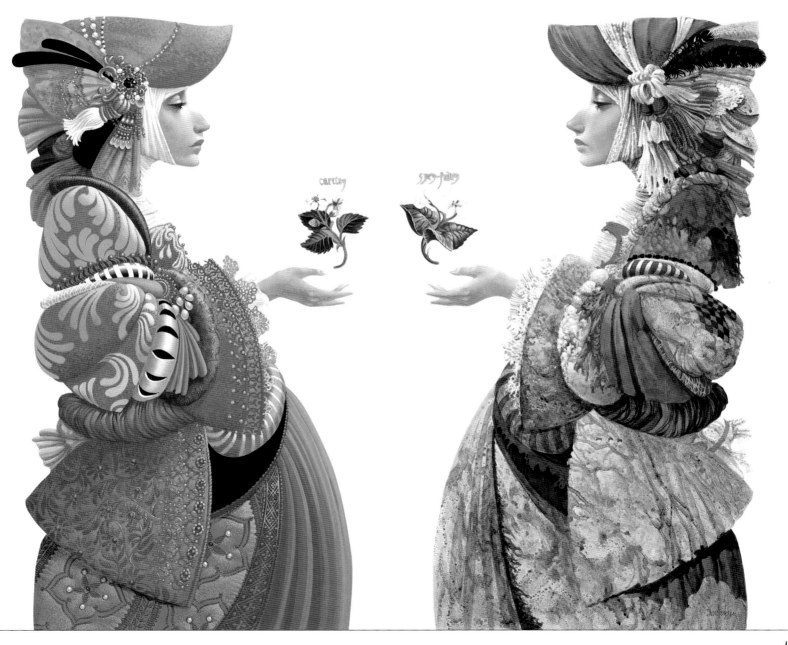

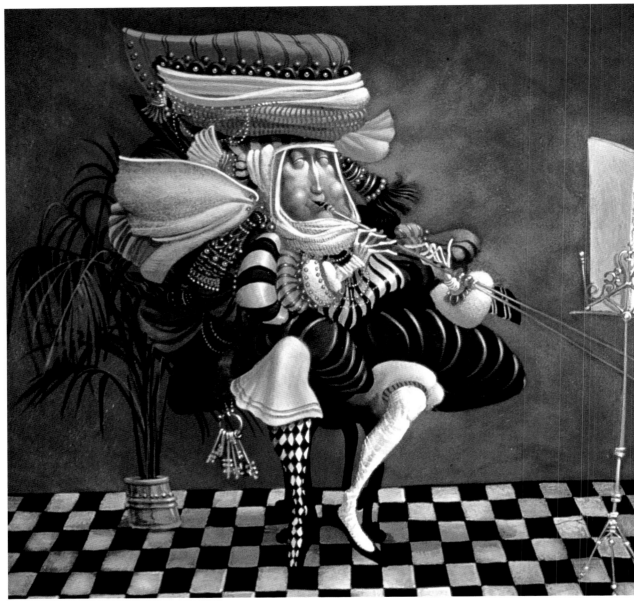

Duet for a Single Musician

Is the glass half full or half empty? I've done a number of musicians, some for the fun of the titles or the instruments and others just for the pleasure of creating an ornately dressed musician practicing his art.

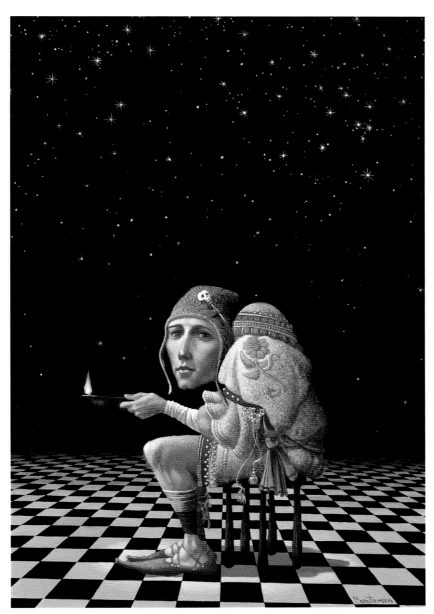

One Light

The infinite checkerboard becomes the whole Earth, and here is the hunchback, the Everyman with his single, tiny light. This is a study of balances and opposites, light against dark; life against death. The flower on his sleeve is life, the pin in his hat is a reminder of death. The main message is to let your own light shine; together we light up the world.

·7· The Artist: James Christensen

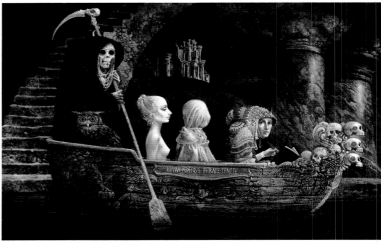

"Sorry I took so long getting to the phone," James said. "I was in the garden cutting roses for my wife." He explained that the previous day had been fraught with annoyances: a tight deadline, a shipping crate that was a half-inch smaller than the painting, a Federal Express pickup made by only minutes. He said he'd been less than pleasant company the whole day, and that the roses were a thank you for her help and patience.

This continuous nurturing of the connections with family, friends and community, as much as his talent, provides a clue to the extraordinary emotional depth found in his artwork.

James Calvin Christensen was born September 26, 1942, in Culver City, California, a small city surrounded by Los Angeles and permeated by the movie industry. MGM's Lot Three was only a few blocks from his childhood home. Christensen first encountered the elusive distinction between reality and the realistic illusion while sneaking with friends onto the backlot after dark. "We'd slip over the fence and into an Old West town, San Francisco during the gold rush or Chinatown, but then walk-

ing behind them we'd see that it was all two-by-fours. All that realistic illusion made a big impression on me."

Drawing was a favorite activity, but James didn't study art in high school. He thought he'd grow up to be a banker like his dad. As graduation neared, however, he realized that the little drawings in the margins of his notebooks were far more important than the notes themselves.

James studied art at Santa Monica City College for a year before entering mission service for the Church of Jesus Christ of Latter Day Saints. For two years, he traveled in Argentina, Brazil, Chile and Uruguay as one of several young musicians who were part of a church musical group.

In 1964, James enrolled at Brigham Young University to study painting and drawing. In his third year, he transferred to UCLA, a move that had much to do with the presence of a young university employee, Carole Larsen. But the romance hit a few potholes, and James returned to BYU. Happily, time and distance worked their magic, and James and Carole were married a few months later.

In 1967, James finished his undergraduate degree and began work on his master's. Carole gave birth

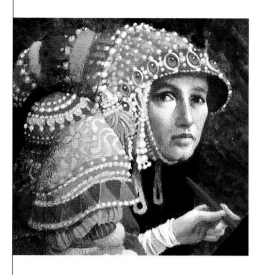

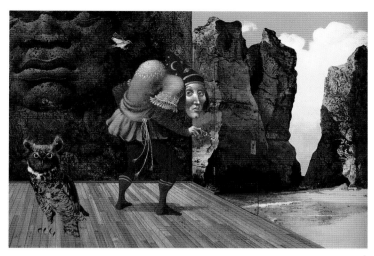

"The Last E-Ticket Ride" (far left), a 1986 self-portrait, deals with the passage from life to death. Aboard Charon's boat, the artist (center, detail) observes and tries to record the voyage. "The Invisible Door" (immediate left) is another allegorical painting.

to their first child. In the autumn of 1968, after receiving his master's degree, James accepted a job as a junior high school art teacher for the Santa Maria, California, school district.

"Those were tough years. I was just trying to make a living, combining teaching, workshops and commercial illustration and portraits. We'd also offer artwork in sidewalk art shows. If we sold a framed and matted lithograph for $30, we felt lucky. Through those years, I always had my 'guilty pleasures'—my sketchbooks—where I could draw people with fish for heads, or wings, or just funny-looking creatures." It was on those pages that a new style began to emerge.

After five years at Isaac Fesler Junior High School, James left teaching and devoted himself to painting, supporting his family with freelance commercial illustration and portraiture. In 1974, when he was offered a job as a designer for the LDS Church's magazine *The New Era*, he moved with his family to Utah. There he continued to develop his fantastical style.

In 1976, the American Society of Illustrators presented him with a merit award for his work "The Invisible Door," an allegorical image about death and the afterlife. This painting gained special importance because it was a fantasy work that was recognized by the art community. Also in 1976, James was offered the position of assistant professor of art at Brigham Young University.

James Christensen's work has been commissioned by *Omni* magazine, Time/Life Books and numerous book publishers. His work has also appeared in the *American Illustration Annual*, Japan's *Outstanding American Illustrators*, and numerous gallery shows across the country. In 1990, he received the Association of Science-Fiction and Fantasy Artists' Chesley Award for "The Fish Walker." The World Science-Fiction Convention awarded him in 1991 a "Best in Show" for "Once Upon a Time," and then in 1992 a "Judges' Award" for "The Royal Processional."

In addition to his work as a fine artist, he is a full professor of art at Brigham Young University. James Christensen makes his home in Orem, Utah, with his wife, Carole, and the four youngest of their five children.

· List of Plates ·